Audience (R)Evolution

Dispatches from the Field

Audience (R)Evolution

Dispatches from the Field

EDITED BY CARIDAD SVICH

Theatre Communications Group
New York
2016

Audience (R)Evolution: Dispatches from the Field is published by
Theatre Communications Group, Inc.,
520 Eighth Avenue, 24th Floor, New York, NY 10018-4156

This publication is made possible in part by the New York State Council
on the Arts with the support of Governor Andrew Cuomo and
the New York State Legislature.

TCG books are exclusively distributed to the book trade by
Consortium Book Sales and Distribution.

A catalogue record for this book is available from the Library of Congress.

ISBN 978-1-55936-541-3 (paperback)
ISBN 978-1-55936-864-3 (ebook)

Cover and compostion by Monet Cogbill and Alexis Capitini

First TCG Edition, June 2016

CONTENTS

PROGRAM DESCRIPTION

FOREWORD

INTRODUCTION

CHAPTER ONE
EVOLUTION AND RESISTANCE

CHAPTER TWO
SEEING

CHAPTER THREE
PLACE AND PLAY

CHAPTER FOUR
BEING

Audience ⓇEvolution is a multiyear program
designed by Theatre Communications Group
and funded by the Doris Duke Charitable Foundation
to study, promote, and support successful
audience-engagement and community-development
strategies for the U.S. not-for-profit theatre field.
Additional information regarding this program
can be found at *www.tcg.org.*

AUDIENCE REVOLUTIONS

Alison Carey and Bill Rauch

Sometime in the late 1980s, we went to our first TCG conference. We were a few years into the adventure of being cofounders of Cornerstone Theater Company, then still primarily focused on working in and with rural communities around the United States. As frequently happened back in the day, artists and institutions at the conference were complaining about our audiences unfairly abandoning us. A gentleman stood up at the back of the house and asked, "If people aren't coming to theatre as much anymore, isn't it possible that we're doing something wrong?" His question was met with silence, and then people returned to talking about being betrayed.

The conversation has changed, and that's great. In 2015, the NEA reported that seventy-five percent of arts attendees reported that they go to socialize. Whether we grab a bite to eat with our audience and community members after an event or not, it's all for the good that we expand our imagination around the central, mutual relationship that sits at the center of the live theatre experience—communication. Reading the essays in this book, a fine truth is revealed: These artists and institutions not only need their audiences but respect and like them. We have moved past feeling betrayed, past feeling like we're doing something wrong, and into the glorious future of at least trying to be with our audiences where they are, physically or metaphorically.

Another thing that is clear from reading this book is that there are lots of different ways of deepening relationships with audience and community, both built into the work and enhancing outward. Learning from the natural world, humans have always had plenty of evidence that monocultures are essentially unhealthy, that so-called thoroughbreds will inevitably fail big when they turn their genetically manipulated ankles. There is inspiration for every artist and theatre in these pages, and the only standard is the intention of our engagement choices: to create an authentic and generous relationship with the people who enter and surround our works of art. The best method is the method that works for you in your moment and place.

Back at that 1980s TCG conference, it was quite clear that there was a concerted political effort to excise the arts from larger conversations about who we were as a nation. We were warned to stay

vigilant, to vote, to fight back. But I don't remember anyone talking about what it would do to artists themselves, how we as a field would internalize the caustic, capitalistic, and white supremacized contempt poured on the heads of artists over the following decades. The problem with being loudly lied about is not just that you can't as easily find the counter narrative, but that you begin to believe yourself that art is not important, that our lives are not a significant part of our social ecosystem. We stopped being vigilant. We let our children suffer as the arts were taken from their schools. We started justifying the arts primarily in terms of their potential as economic engines.

Enough.

Sitting here at the Oregon Shakespeare Festival in 2016, a very big theatre in a very small town that people have been making pilgrimage to for over eighty years, it feels more urgently apparent than at any other time in our lives that the arts, that theatre, is essential to our communal health. We know that theatre helps us to think, to problem solve collaboratively, to love. Those attendees who wanted to socialize ranked learning and experiencing next as the reasons they value the arts. To make theatre, to see theatre, is to climb into other people's realities. Theatre is valuable in and of itself, but it also models the only way human beings have ever dependably made progress into more healthy, equitable societies: the blossoming power of empathy. Society needs theatre.

So, yes, let's go on in our audience revolution. And let's commit ourselves to the most revolutionary manifestation of the change: to continue to drop the bright distinction between artist and audience, the watched and the watcher. Arched above the moments we spend facing each other during an artistic enterprise, there are centuries where artists, audiences, and communities have been and will always be one, standing side by side, human with human, walking together toward the more humane. Theatre makes that walk easier. We need us.

Alison Carey is director of American Revolutions at Oregon Shakespeare Festival in Ashland, and **Bill Rauch** is the theatre's artistic director.

DISPATCHES FROM THE FIELD

Caridad Svich

In *How Did We Get into This Mess?* (Verso 2016), author George Monbiot reflects on the history of neoliberalism from 1938, when the term and its ideological components were proposed by Ludwig von Mises and Friedrich Hayek, through to the current day. Monbiot is not the first author to consider how a great deal of the failure of the political left can be attributed to the complicit adoption of neoliberalism by many nation-states, as well as corporate "peoples," as an irrefutable way of being, rather than merely an ideology that, coupled with free-market forces and privatization, has increased the divide between the have-much and have-littles. In a related volume by Paul Verhaeghe entitled *What About Me?* (Scribe 2014), the systematic and insidious pressures of social and economic equities due to "standardized" neoliberal practices are examined through the lens of individuals and collectives suffering from depression, eating disorders, anxiety, and other kinds of diagnosed and undiagnosed illnesses. Both authors stress the necessity for change for a world order that is seriously out of joint.

Neoliberal meritocracy fuels narratives of power and its acquisition, of Darwinian competition amongst human beings, and, conversely, of those too that are and feel forgotten, invisible, and dispossessed. Art is not separate from its time. It is of its time and, of course, can also transcend its time. If one were to look at works made, say, a hundred years ago, they would by dint of their concerns, however universalist and/or timeless in their intentions, reflect the pressures, anxieties, and overriding political climate of when they were made. Thirty years into the rise of neoliberalism, and the parallel ascendancy of the digital age, our art and the politics around which stories are afforded visibility and which are not are emblematic of the field as a whole, and a lightning capture of who we are, and who we say we might be.

In speaking of and about spectatorship, it is key to speak about dissensus as a necessary element of viewing and experiencing theatre and live performance. Philosopher Jacques Rancière clearly identified in his influential book *The Emancipated Spectator* (Verso 2009) the importance of repositioning the role of the viewer/participant as a body standing within and outside of the event being enacted—a

political body that may or may not be in concert with the ideologies of the presented artwork and/or its aesthetic lean. Rancière asks us to consider the audience as an active viewer that practices dissonance and dissidence when witnessing enacted material, as a way of engaging in a process of free thinking. Through this process of being "emancipated" from even one's own prejudices and biases, and thus having the ability to be critical of not only how and what we see, but how we do so as individuals within a collective, may be one of the ways in which true consensus is ultimately achieved—one that acknowledges differences within a whole, rather than censuring, erasing, or sublimating differences to achieve social equity or parity. If we are to think about theatre as a social, philosophical, and spiritual contract with an audience—then we must need think too that the audience is us. What is the shared experience in theatre? What is the encounter? How do we meet each other in the vibrational spaces between light and darkness, silence and sound, and body to body?

———

This book was born out of a TCG Circle blog salon I curated in the spring of 2015 for Theatre Communications Group and its Audience (R)Evolution program, and partly also in the summer of 2014 when I curated another salon for TCG about audience engagement. For the last ten years or so in the field, spectatorship and the role of the audience has been a growing, if age-old, topic of interest. Conferences, symposia, administrative retreats, academic colloquia, and more have been dedicated to thought, inquiry, and reflection on how practitioners, educators, and administrators regard the audience and, in turn, expect the audience to regard them and their works of art. Much of the overarching discussion around audience engagement in recent times has centered on the role of social media and how audiences watch and listen in the digital age. Many well-intentioned surveys have been conducted on target demographics to suss out an audience's wants and needs so as to create or upgrade spaces and places of art making and production that are more "effective" in their overall reach. This of course predisposes that an artwork is made with clear and intentional efficacy in mind. But this is hardly the case in all circumstances; therefore applying the frame of efficacy to all art is unwieldy at best. Better yet to ask: Who are we trying to reach when work is made,

and to what end, and by which means?

The median age of the subscriber audience that goes to orchestras and regional theatres in the United States is between sixty and eighty. In fact, in a 2015 NEA study, the optimal paying audient at a theatre was an eighty-year-old woman that had a history of attending a specific venue and that also had a philanthropic interest in said institution. If the sharp decline in the last five years overall in attendance at regional and resident theatres existing on a subscriber model is any indication, in twenty years' time, we will see more theatres of this kind shutting their doors permanently or, if not, calibrating new ways to survive.

Demolish theatre. Begin again.

So, to quote Sylvan Oswald, whose essay of the same name is featured in this collection, "let's get punk rock about this" for a second. We know—and I use "we" not in a hegemonic manner, but rather as a way to say, "Hey, we are actually *all* in this as humans and animals and cyborgs on the planet"—that theatre is not dead. The art and act of making theatre has been with us for hundreds and hundreds of years. It is not going to go away just because a subscriber base folds. And we know, and have known for a long time, that the subscription model doesn't work anymore, because, yes, times change and the way in which individuals and groups make decisions about what they wish to see and how they wish to see it also changes. How can it not? Clinging to an idea that audiences will always "behave" a certain way is a fallacy at best. But here's the rub: Do we want audiences to behave? And what do we mean by that?

In a culture that values obedience and order, where do the spaces of disobedience rest? Put it another way: Where do the spaces of resistance lie?

In the act of civic engagement that is theatre making, resistance may be articulated in many ways—through language and its uses, modes of behavior and their expression, the use or disuse of light and darkness, the relationship between signal and noise—and through the choice of subject matter explored or themes and tasks undertaken during a text-based, devised, or non-text-based act of performance. At the center of the act of live art is the body. Usually, the human body. The figure against a ground. The figure in a frame. The figure in relationship to something else, in other words.

This figure onstage—or immersively next to you or holding your hand perhaps—moves through time and space. As it moves from one side of the stage, or the world, let's say, to another, the audience does

as well. That is, their imagination and their memories are set alight. In the best of instances, live performance, whether it is positioned historically and/or is contextualized by practitioners or fellow audience members that have experienced live art before, works on the free space of play in our minds: the uncensored parts of ourselves that can imagine utopia and dystopia simultaneously. Yet it also taps into the space of memory, which is elusive, often contradictory, and suffused with the complicated associations from which emotions stem and a host of other elements which scientists that study how the brain works and how memory is a function of the brain can explain with a greater degree of certainty and expertise. What we know is this: When we are part of an audience, many things can occur—we may be bored, we may remember our childhood, we may think about our day, we may recall an old lover or friend, we may be outraged, offended, scared, thrilled, and overjoyed. We are in a state of flux, but this very state of flux—of potentiality and evolution—opens us up to resistance, or at very least to understand that being together in a space may yield communion or revolt, as Andy Field in his essay in this collection, "Playing in Cities," intimates.

It is this space—the one of resistance—which theatre and live performance activates. As such, within it, at some core level, the act of art making and its presentation explores what poet Alice Notley describes in her influential 1998 essay, "The Poetics of Disobedience," as one that demands that both the poet and, in her analogy, the reader are freed from doctrine so as to have a deeper connection to the self and the world. In Notley's case, the I of the poet and the I of the reader is one of stark poverty, and here she uses the word "poverty" to refer to a radiant being stripped of the trappings and harnesses of dominant social forces. Extending Notley's metaphor into the theatrical realm, when the figure walks onstage, even if it is clothed, it is naked—it is revealing another self or becoming positively other. This estrangement of otherness allows for the act of seeing (theatre in the ancient Greek) to occur, but also the act of listening (from which we define the root of the word "audience"). So, if we are to stage an audience revolution—it must need be one of listening anew as well as seeing anew. It must need disobey known forces in order to see and hear and be what it wants to be or is.

You can try to play to the audience, but why do so when you can be with the audience? Put it another way: Instead of being at each other and at things in our theatre, how about we try being with each other

and things too, if we desire? Might "being with" allow for the necessary act of resistance to take hold? Will revolution then really take place and if so, who will we be part of this revolution—some? All? Will there be a hierarchy? And what will our disobedient, radiant theatre look and sound like? Moreover, how will it touch us?

———

Throughout the pages of this collection, a wide range of voices sound the joy and fury of being in the trenches of the volatile discourse of enacting, staging, and sharing the experience of performance. Carlton Turner and Diana Damian Martin, reporting from their perspectives across continents and countries—he in the United States and she in the U.K.—set the tone and spirit of this volume, as they articulate the difficulty of evolving our art and field within the narrow yet pervasive confines of dominant neoliberal orthodoxies. Extending the challenge to the reader is Melissa Hillman from Impact Theatre in Berkeley, California, as she furthers this book's overall argument for revolution and evolution in our field. What lies do we tell ourselves to keep going, Hillman asks, and by what means necessary? If we base our cultural labor on lies, what kind of civic and moral engagement are we really enacting? Is it a game of smoke and mirrors that we are playing with ourselves? Is it the same game that has let neoliberalism seemingly win hearts and minds in the name of global capitalism?

The social and political—the body politic of the audience-citizenry— is at stake here. Nothing more. Nothing less. And no amount of tweeting and texting will solve the illnesses that trouble the land—the very ones theatre seeks to illuminate, at its best, even when it is simply telling a "little story."

Throughout the book, the insistence on witnessing and representing the bodies of illness at local, national, and international levels is felt loud and clear, from stories of bullying, narrow-minded casting practices, and the reclamation of indigenous bodies in Madeline Sayet and Larissa FastHorse's essays, to the charged and passionate manifestos for active resistance and artful recognition articulated in pieces by Nathan Alan Davis, Jay Ruby, Barney Norris, Kevin Lawler, and Dipika Guha. Telling stories around the campfire, making space for new spaces, listening to the stories of our childhoods and those of our neighbor-citizens near and far away illuminate the cadences

of promise voiced by Itamar Moses, Lisa D'Amour, Katie Pearl, and Ashley Sparks, and those too of Deborah Yarchun, Thomas Riccio, Dave White, Tanuja Amarasuriya, Amparo Garcia-Crow, Kira Obolensky, Michael Hoyt, and Roberto G. Varea. Charting how millennials are not an "other" but an "us" underscores the themes and ideas posited by Justin Maxwell, Applied Mechanics, Jeff Janisheski, Brian Bell, and Jacqueline Goldfinger. The village that is theatre resounds with tales of ingenuity and sustainable "best practices" in pieces by Jules Odendahl-James, Corey Madden, Ana Margineanu, and Callie Kimball. The drum of progress beats through the alternately fiery and gentle-natured considerations of historicized bodies in Deborah Brevoort's reflection and Brian Eugenio Herrera's interview with Tricklock Company's Juli Hendren and Elsa Menéndez. At root throughout all of these pieces (and more from Simeilia Hodge-Dallaway, Lenora Champagne, J.J. El-Far, Clay McLeod Chapman, Jake Witlen, Steve Moore, and Adrianne Krstansky) is the desire for connection for profound human connection in work that is made and shared.

The cultural workers in this book seek a revolution of heart, mind, and spirit. They question who we are and consistently ask that hospitality and its uses be placed at the center of the shared theatrical experience: who is invited, how and why, and how is the body politic made hospitable or inhospitable, depending on a work's intentions as civic and spiritual engagement, to ideas of potentiality and transformation, as well as to stories of human rights abuses and the ecological precarities of land and water. Coursing through the veins of all of these pieces is a belief that the art and act of theatre and live performance matter, as long as we remain vigilant to how the field is treated, sustained, and allowed to change. Sometimes the change comes from within, and sometimes the sparks of resistance emerge from the cries and shouts of those that live among us, and those too that came before. It is in this—the belief in the stories that speak from places of writing, which, after all, are places of knowing that the frontlines of active, collective, and emancipated dreaming will rise.

Audience(R)Evolution

Dispatches from the Field

CHAPTER ONE
Evolution and Resistance

EVOLUTION > REVOLUTION?

Carlton Turner

For me, there is a very distinct difference between evolution and revolution. A revolution orbits the same dynamics. What changes is positioning—who's in power, who's on top. It's like a revolving door—the door doesn't move, it's just a cycle of people in and out of that door.

In evolution the entire being, the entire system, changes; it's a move not just in positioning but in purpose. For me, an evolution marks that you've learned something and you've graduated to a different level, or rather gained a different perspective. Sometimes that means that you are starting over, shifting the entire dynamic and your understanding of something completely. The evolutionary practice is one in which we're constantly seeking transformation, not just transition.

Organizational Evolution > Audience Development

Some of the questions this book asks are really important ones: "When making work, who is it for? Who is making decisions? Who is impacted? How is the audience invited into a process, a work, a building over time?" It's always about the audience—how can we shift the audience, how can we reeducate the audience, how can we cultivate a new audience? But I think that the emphasis on audience is misplaced because this collection is not directed toward the audience; it is directed toward the arts leaders and practitioners. And as leaders I think we need less focus on the audience and more on understanding how artists and organizations can shift their practices to be more relevant to changing times, changing demographics, to all of the shifts that are happening as our communities and our world are changing. We need to ask: How is the organization evolving? How does the mission evolve? How does the purpose of your organization and the work that you're creating, presenting, producing evolve to match the need of an audience at this particular moment in history?

So, those initial questions in reverse would be: Why doesn't the audience member feel engaged? Why do they feel like this work isn't for them? Why are there barriers to their participation in the decision-making process? And what put the culture or the artistic process

so far out of reach of the audience that they feel like they need to be invited back into the process? Because, from a cultural position, the art belongs to the community—it belongs to the culture, not to the artist. The artist is there in service of the culture they are representing. And the arts community has shifted that dynamic to where the audience is in service of the artist or the institution, rather than the institution being in service of the audience.

Thinking about this in terms of evolution: The process of evolving responds to the environment around you. The problem that we're facing as an arts sector, as a performing arts sector specifically, is we've disconnected ourselves from the natural and social environment and created a very insular space in which to make and show art as product. We see this happening with institutions in the ethereal sense—an organization, a 501(c)(3)—and in the physical sense, a bricks-and-mortar building so tied to programming that it's hard for people to think outside of that structure. We see this happening with institutions that weren't necessarily created in response to a demand from the community, but as a way to pay homage to an artist or group, or a particular discipline. And so many of the buildings are constructed as a monument to the ego. In contrast to these systems and structures, the work that needs to happen in the community is driven by need and necessity and the spirit of the people.

Looking at Alternate ROOTS as an example, it's an organization that came out of a very specific space, time, and need—the space being the South in general and the Highlander Research and Education Center specifically; the time being post–Civil Rights and antiwar movements; and the need was to understand how the performing arts are implicated in supporting the struggle for human dignity. ROOTS's founders were asking a question about how to continue, as artists, as citizens, to be engaged in a process of transforming the society around them. If we look back forty years to the organization's founding, or if we look back three-to-four years in the recent history, we see the attempts to answer those questions forming the legacy of the organization.

In the beginning, ROOTS created an aspirational mission: *to strive for the elimination of all forms of oppression.* As a collective, they were trying to embody those words they articulated at the beginning of their existence together. They didn't quite live those words when they first uttered them to each other. But through time, years of being together, they began to actually live and be those principles that they put out as the foundation of their relationship to one another. In the

words of Linda Parris-Bailey, one of ROOTS's founding members, "We hung in there because people had that vision. What we did was agree to struggle together." Those original members chose to make that journey together and to walk with one another throughout that process and to hold each other accountable over time.

Reciprocity > Ministry

In addition to challenging a focus on audience development, I also want to push back against the idea of art as ministry and arts institutions as ministering to communities. Like many Southerners, I also come from a religious community. The church was literally in the front yard of my grandmother's house. So, growing up, I spent a lot of time in church and dealing with ministers, and I saw many of them as disconnected from the people. Even though they were supposed to be the connective tissue between the people and a higher power, often they came across like pretentious gatekeepers.

This idea of ministry doesn't feel like an authentic practice for what the work in performing arts actually is. It's not necessarily ministering to anyone because people know, they come into the world knowing, and ministering to me indicates that someone is providing a more spiritual path or a more right path or a more righteous way of doing or being, and they need to share that or spread that to other people. And to think that's what the theatre is considering itself is a really dangerous idea.

I do feel there is an aspect of ministry that is relevant to this conversation: that people are coming because they feel they are being fed. And that the space you are creating—again, whether it be a virtual, ephemeral space of the ritual you're creating through theatre, or the physical space of the bricks-and-mortar building—is one that people feel comfortable to come to, to share, to be fed, and to be of service to others. There's a reciprocal process where they're coming to be fed and to feed others. The best work that I've experienced has been in that vein where there's an exchange, whether that's an exchange of energies or an exchange of support or an exchange of vision or creativity or even laughter—that there is an exchange that happens. And the audience comes to participate in that exchange. You go to the sacred space knowing that you're going to get something from it and you're going to give something. And that's part of this balance that we should be creating with any type of cultural or artistic engagement.

Holistic Spaces > Art Centers

The concept of arts institutions as holistic community centers sits better with me than this idea of ministry. I think that's what the centers should be striving for altogether—any place that is a public facility should be dedicated to holistic community wellness. The arts is just one place that we can model that in a way that is very rooted and connected to our traditions and our spirit.

We also need to recognize that in order to truly create holistic spaces, you may have to drop the arts from the center. Holistic means the whole being, and art is merely an identifier. It is not the source; it is not the center. Art is a representation of the wholeness that you're creating, that you're fostering, a visual/aural illustration of the culture that you come from and/or are trying to create. A performing arts space is not considered holistic just because the offering is art.

The best example of an organization operating in this spirit would be Ashé Cultural Arts Center in New Orleans. During Hurricane Katrina the space did not flood, and so after the storm, when people came to Ashé, the space was filled with cleaning materials. Mops and buckets and bleach and Lysol and ammonia—whatever you needed. And people came in and were like, "When are you going to get back to producing art?" And Carol Bebelle, Ashé's executive director, was like, "Baby, this is the art. This is what the people need at this moment, and that's what we are going to provide."

There's something vital about that approach—their space is open to multiple forms of engagement that are in support of the community. They're not trying to create something that the community might one day learn to love or understand. Everything they create is in response to the community. This week it may be cleaning supplies; next week it may be HIV testing; the following week it may be a performance around the seven Kwanza principles. It can be whatever it needs to be, based on the needs of the community. That doesn't lessen the artistic practice, but it does strengthen the rigor of being in service to the community.

Reimaging Power > Shifting Power

Ultimately, the question I would ask is: To what end? At the end of the day, when you get a new audience, a different audience, into your space to see your work—what do you hope to shift as a result of that audience witnessing what you're providing? What do you hope to shift in the

world as a result of that work, both as short-term impact and long-term legacy building? Are we waiting on a revolution in our sector, in our society, a shift in who has the power? Or are we looking to model the evolution of practice and reimagine the entire designation of power?

Carlton Turner is the executive director of Alternate ROOTS, a regional nonprofit arts organization based in the South, supporting artists working at the intersection of arts and social justice, and cofounder and co–artistic director, along with his brother, Maurice Turner, of the group M.U.G.A.B.E.E. (Men Under Guidance Acting Before Early Extinction), a Mississippi-based performing arts group that blends of jazz, hip-hop, spoken word poetry, and soul music together with nontraditional storytelling. This piece was coedited by Nicole Gurgel-Seefeldt, Alternate ROOTS communications manager.

COMMUNITY/RESISTANCE: REFLECTIONS ON DISCOURSE AND COMMUNITY

Diana Damian Martin

In *The New Way of the World: On Neoliberal Society* (Verso 2014), Pierre Dardot and Christian Laval present an articulation of neoliberalism as a particular rationality, one that "tends to structure and organize not only the action of rulers, but also the conduct of the ruled." Neoliberalism is defined here as capitalism's contemporary rationality, one that encompasses discourses, practices, and mechanisms, which determine "a new mode of government of human beings in accordance with the universal principle of competition." Dardot and Laval's conceptualization of neoliberalism offers something different from other contemporary discussions on this political phenomenon; the authors examine how neoliberalism has come to signify the fiscalization of matters both private (affect and identity, for example) and public (labor, for example). This, they propose, has come hand in hand with both the increasing privatization of public space and the erosion of the collective in favor of the individual (the entrepreneur as the ultimate form of independence and success).

In this political landscape, cultural discourse becomes precarious, its sustainability tied to economic factors. The few remaining public spaces become battlegrounds for different ideologies of resistance, whilst also at threat from being consumed by homogenizing discourses. At the heart of this is a politics guided by emotions like anxiety and fear, instilled by the ethical dimensions of artistic practice and its personal implications on cultural operators and artists. As Slavoj Žižek argues in a recent article for *The Guardian*, "The only way [the government] actively mobilizes people is through fear: the fear of immigrants, the fear of crime, the fear of godless sexual depravity, the fear of excessive state..." (October 3, 2010). He gives the example of the cooption of language into these mechanisms, explaining the ways in which political correctness acts as an exemplary form of the politics of fear.

Within this landscape of emotional practice, discourse, be it explicitly verbal or not, becomes fundamental to authentic conversations and

transactions of meaning that can instill action and develop a more grounded, sustainable, and resistant cultural landscape. Culture is also the site in which the political and the aesthetic come together, and where temporary public spaces are constructed. It is this temporary construction that also makes them powerful, slippery, not easily grasped by the mechanisms of neoliberalism. These communities become powerful and fluid conglomerations where action, visibility, and resistance can be formulated through different forms of critical discourse; this sees a recuperation of language and affect, stripped away from the ideologies woven in their very fabric.

In a recent interview, philosopher Alain Badiou speaks of how we might conceive of the encounter as a politicized practice, emphasizing that authenticity emerges when we are able to assume that "it is the beginning of a possible adventure" (Verso blog, April 2014). The encounter cannot be accidental, Badiou states; it must be articulated, otherwise it becomes fleeting, moderated by the codes of neoliberalism that structure affective and intellectual engagement. Speaking of the rise of the "micro-milieus" as a form of collective engagement and community formation, Badiou warns against fragmentation and places value in the possibility opened up by seemingly impossible encounters and associations.

Could we regard temporary communities formed in spaces delineated by art practices (and specifically for our purposes here, theatre) as micro-milieus? And could we conceive of these as spaces where discourse might generate alternative modes of being and thinking? Should it be subjected to the productive impossibility that Badiou speaks of? I see this as an exercise in imagination, one that might be situated on the threshold between lived experience, and the encounter with artistic experience, be that mimetic, representational, or simply delineating fragments of the real.

In theatre, we speak a lot about the power of the temporary community—of those gatherings that are implicit in the act of sharing and encountering. Yet the ways in which we might understand iterations of this theatrical condition are very much embedded in the problems articulated above. Here I am thinking about a range of practices, from the spatial, situated work of socially engaged practices that seek to instill a sense of ownership of issues and problems that bypass governmentality, to the meditations on the politics of spectatorship made possible by formal and thematic developments of contemporary theatre and performance practices. Community, in these contexts,

can be both an exercise that politically aligns with the principles of neoliberalism, or it can be the threshold between action and resistance. The radical in these practices is something which defies displacement of power or spatial thinking; instead, the radical becomes amorphous, immaterial, slippery.

Encountering and fostering community is an important agenda of many cultural operators and institutions in the U.K., but this also opens it up to the possibility of becoming simply an exercise in engagement rather than a transformative process. Yet there are numerous projects that have come to operate within the dynamic of community and culture, developing methodologies and processes of practice that implicate the discursive critical and the political into the fabric of the project. These are characterized by an explicit interest in care as strategy of resistance and discourse as method of collaboration and debate. There is also a recurring interest in recuperating public space—cafes, community halls, and governmental and civic spaces are remobilized for the purposes of congregation and deliberation.

Such an example is the symposium co-curated by artist Rajni Shah, "The Radical in Socially Engaged Practices," stemming from the end of her participatory project *Glorious*, in which artists and locals from different regions of the U.K. worked together to create a musical piece. Foregrounding conversation as emerging through both constructed situations and authentic exchanges, the symposium aimed at horizontality, in which participants shed their professional specificity in favor of informed exchange. Meals and provocations formed the core of the exchange, whilst artistic process became a strategy through which sharing might occur. Although knowledge is not necessarily articulated, but exchanged, the symposium poses the question of the role of the immaterial, the undocumented in the construction of radical communities of resistance and thought, taking a similar model to that unofficial, unrecognized academic institutions and guerrilla pedagogy. Increasingly, artists choose to incorporate different forms of assembly that eradicate boundaries between modes of knowledge production. In this instance, the academic and the artistic become intertwined and dissolved.

Festivals have been increasingly interested in carving out public spaces of debate too. The Spill Festival of Performance has developed a national platform aimed at young artists working in performance and live art, taking place annually in Ipswich, the home town of artistic director Robert Pacitti. Its first iteration in 2012 was particularly

centered around the active town hall which was, for the duration of the festival, the hub of activity. This activity was grounded in three main strategies, aimed at inviting participation: the exhibition of Lois Keidan's definition of live art in the foyer area of the hall, marked in vinyl across an entire wall, like a guardian of this cultural practice that hadn't been visible in Ipswich in its recent history. The second was the Live Art Development Agency's Study Cafe, in which visitors to the festival, as well as locals and tourists, could scavenge through a number of themed boxes of critical writing, anthologies, monographs, and artist writings, from body-based work through to contemporary experimental theatre. Finally, there was a digital critical writing program aimed at responding to the work of the festival whilst offering opportunities for investigation into performance criticism for a group of six young writers, which I led in the period of the festival as writer-in-residence.

I was particularly struck by the emphasis on discursive public presence. In the eyes of the festival's director, these different facets of the festival were aimed at engaging with a space that was civic and cultural, public and private: the town hall. That an operating town hall might serve both as cultural and political site speaks of the politics of a field seeking to challenge social norms and assumed codes of conduct. Live art is often accused of opacity and inaccessibility, but when tackled head on, these interventions become discursive and foster public deliberation. The active displacement of these sites of discourse from the centrality of London, in which Spill has been operating for several years successfully, also underlines a radicality of site and discourse and the potential for dissent through critical strategies. This relocation marks an investment of agency not solely into discourse as a formation of a public of opinion, but as a dissensus erupting through collective engagement.

Pacitti outlines his interest in revisiting notions of radicality in the public perception and constitution of live art, capitalizing on the relationship with the local authority and cultural infrastructure built upon the promise of artistic practice as a form of social and economic development. The festival integrated salons in which audiences, artists, and locals could discuss pertinent issues and first impressions of live art and its politics, and under its theme of proximity problematized the relationship between the often peripherally perceived cultural landscape of performance and live art and its wider sphere.

These different modes of enacting space for discourse but also

participation—be it the spatial and dialogic configuration of the town hall's Study Cafe alongside Keidan's definition of live art, the digital framework of the writing program, or the discursive and embodied politics of the salons—located an interest in the active constitution of localities: physical, social, digital. The same can be said for the symposium that accompanied *Glorious*, which also sought a discursive element, a mode of enabling conversation beyond the realm of the practice itself. At the intersection between traditionally constituted political forms of deliberation, the site of that deliberation and crafted architecture of the project is the possibility of a critical engagement with performance and its public perception which constitutes a potential critical act.

Whether this potential tactic of insurrection into the architecture of cultural infrastructure has been successful or not remains to be seen. There is a fundamental question here to be asked about the agents of such an insurrection, and whether we might still think of fields of practice as needing a challenge that emerges from the outside. Such discourses, developed via and in relation to those offered by performance and theatre practice, might be able to construct the kinds of articulated encounters that Badiou discusses and resist the formations of power structures inherent in the neoliberal. That being said, there is much to be said of those core tropes of community engagement—accessibility, action, facilitation—in relation to critical engagement; after all, the aesthetic is a highly complex register of contemporary politics within the cultural landscape.

Diana Damian Martin is a London-based performance critic, writer, and scholar. She is a lecturer in performance arts at Royal Central School of Speech and Drama, performance editor for *Exeunt Magazine*, and a member of Generative Constraints. Diana is cofounder of Writingshop, an E.U.–funded, long-term collaborative criticism project, and Institute of Critical Practice, a nomadic organization that explores the ways in which criticism manifests itself in contemporary performance as a mode of inquiry and production, strategy for visibility, and practice of dissemination.

THE LIES WE TELL
ABOUT AUDIENCE ENGAGEMENT

Melissa Hillman

Over the past several years, the theatre community has become more and more anxious about "audience engagement" and less and less certain about what that actually means. Some people think it means audience participation theatre, which can run from happening-style performance events, to walkthrough shows like Maria Irene Fornes's *Fefu and Her Friends* and Punchdrunk's *Sleep No More*, to hauling unwilling audience members into the spotlight for ninety seconds of uncomfortable awkwardness. Some people think it means enabling the audience to participate in the show's creation in some way. Some people think it means doing shows that engage your local audience by reflecting them in some way—usually season planning and/or casting—and creating events attached to the show, like talkbacks, community outreach events, or a lobby display audience members can add to or interact with.

We don't, actually, have any real agreement about what "audience engagement" entails. The only thing on which we all seem to agree is that it's tied so strongly to attracting young, diverse audiences that it's essentially now code for that, and that it involves some kind of participation from the audience, which we imagine is the key to attracting these young, diverse audience members. Discussions of audience engagement are usually tied to anxiety about the DIY appeal of the internet and theatre's need to somehow tap into that, due to the perception in our industry that young people, especially young people of color, don't go to the theatre but are online all day long.

We hear that theatre attendance is falling, and believe that young, diverse audiences are nonexistent. We talk constantly about how there will be no future for theatre unless we can engage diverse audiences. We're told that "audience engagement" will not only save theatre, but is an ethical imperative, and that we need strategies—at present, some kind of ill-defined participatory model—that will bring otherwise absent and apathetic young people of color into the theatre, inoculating us from irrelevancy.

The main problem with this discussion is that we're pretending

there's just one "theatre," and we know—we all know—that's not true. There's theatre that "counts" and there's theatre left at the rope line. In order to "count," you need money. No other aspect of your company or your work is more important. If your annual budget does not meet a certain threshold, your theatre is not considered important enough to be included in studies, articles, discussions, panels, and everything else from which we draw data determining national trends and important issues. In fact, you even need money to get money. Most grants for "small" theatres have an eligibility requirement of $100K (or more) annual budget, shutting small companies neatly out of both a crucial funding stream and the data gathered from funding orgs. The concerns of big budget theatres dictate the terms of the national discussion about the state of our industry.

In most American urban centers, there's a vibrant, thriving indie scene—small theatres operating on a shoestring budget, paying people a stipend and operating out of ninety-nine-and-under rentals or nontraditional spaces. Think of it as DIY theatre. Indie theatres are now connected via the internet in ways they've never been before. The people working within them now have a picture, at least anecdotally, of the national scene, and can see that indie work all over the country is filled with young people, women, and people of color, both as creators and consumers.

We already know, if we care to look at the indie scene, what draws young, diverse audiences to the theatre, and that a participatory model is no more likely to draw a young, diverse audience than a traditional model if they don't see the work as relevant to their lives, the tickets as good value for money, and the space as one in which they're truly welcome. We don't, however, care to look at the indie scene.

Because we ignore and undervalue indie theatre, we imagine we're discussing issues in "theatre" when what we're actually discussing is a particular segment of theatre—one from which women, young people, and people of color are largely shut out. The indie scene is dominated by women directors, and is much younger and more diverse than big budget theatre. As soon as theatre gets to a certain budget level, the women and people of color both backstage and onstage become much more scarce, and the audiences—and the programming—get whiter and older. We bring white male playwrights, directors, designers, and actors from indie theatres (and even grad schools) into big budget theatres—theatres that "count"—far more often than we bring in women or people of color. The conversations we've been having about

that glass ceiling and its impact on the audiences we draw are crucial.

But we should also be looking at the explosion of diverse performance already happening all over the country in the indie scene and considering why big budget theatres aren't replicating that, instead of pretending that young people and people of color have mysterious, unfamiliar needs and require some new kind of participatory theatre to show up.

Big budget theatre's financial dependence on older, well-heeled donors and subscribers results in a lot of programming that reflects that demographic, currently largely forty-plus and white. There's just not enough grant money to release every big budget theatre from dependence on subscribers and individual donors. Big budget theatres are faced with the need to serve both the older, whiter community upon which they're inextricably financially dependent now, and the younger, diverse community they need to attract in order to be financially viable in a more demographically diverse future. Common approaches include slotting one "young" or "diverse" play (and leaving the rest of the season as is), creating special under-thirty pricing, and stabs at defining and implementing "audience engagement" in talkbacks, parties, and lobby displays. Sometimes the one "young/diverse" slot features a production that incorporates technology and audience engagement, like projecting hashtagged tweets during the show. And because we have stats from larger theatres, we know that none of this is working—none of this is permanently increasing young, diverse audiences at big budget theatres.

One groundbreaking new play by a young black playwright, for example, might attract a younger, diverse audience, but that audience won't come back to see the rest of that season if it consists of a well-worn play by a white man, a London import written and directed by white men, a classic helmed by a middle-aged white man, and a middle-aged white solo performance, especially if that's what that company's season always looks like and has looked like for the past twenty years. One hot new black play isn't going to pack that season—or even that one play—with young people of color, even if there are "opportunities for audience engagement" or an under-thirty deal that discounts tickets to next to nothing. People in a huge theatre sitting in the cheap seats understand the hierarchy of audience. And even if seats are general admission, the twenty-two-year-old college student in torn jeans knows what his worth is to the theatre as he sits next to the rich white couple with their name in gold in the lobby. He knows he's a tourist in someone else's

world. He'll see that one play and then go right back to the storefront or underground theatre he's been going to all year.

There's no secret formula or magical new participatory technique that will create a young, diverse audience. The "secret" of indie theatre's ability to attract that audience is simple: Tell the stories that the audience wants to hear, all the time; charge realistic prices; and create a welcoming environment—one that truly values them rather than fetishizes them but otherwise treats them as unimportant. Is that realistic without dismantling big budget theatre's financial dependence on that older, white demographic? I don't know. Will that older, white demographic continue to financially support theatre that doesn't consistently treat them, their stories, and their interests as more important than those of any other demographic? I don't know.

Either way, it's unrealistic to continue to ignore the national indie theatre scene in discussions of diversity. Recognition of the work in that scene, the artists in that scene, and the audiences it attracts will immediately change the terms of the discussion. That means decoupling "importance" from "money," and it means being realistic about when we're discussing who gets paid, when we're discussing what work gets done, and when we're discussing what kinds of audiences we attract—because those are all different discussions. Diverse work is getting done. Diverse audiences exist. The issue is that diverse artists—women and people of color—are not getting the big money gigs, not that the work isn't happening *at all*. The issue is that young, diverse audiences aren't attending big budget theatres, not that young, diverse audiences don't exist *at all*.

If we're going to have productive discussions about diversity, even coded as "audience engagement," we first need to stop pretending that there's one discrete "theatre community" that's all failing in the same way. We need to stop pretending that a lack of diversity in big budget theatre is a lack of diversity in "theatre," as if people of color cannot create theatre unless a big, white theatre bends down to help them. We need to stop pretending that a lack of diversity in big budget theatre audiences is a lack of diversity in "theatre audiences," as if young people of color have no theatre unless a big, white theatre creates a space for them. You can't stop young people of color from making art. It's happening everywhere, all the time. You can't stop young people of color from consuming art. It's happening everywhere, all the time.

The discussion we need to have is why we accord so much more importance to money in our art than any other consideration, and why

we (perhaps therefore) reserve big budget gigs and the disproportionate attention we accord to those stages largely for white men. The discussion about audiences we need to have is why a young, diverse audience packing the house every night at an indie theatre is considered worthless, but a handful of young people of color in an otherwise all-white LORT audience is prized, congratulated, and rewarded with a $65,000 grant for audience outreach.

The main concern about diversity in our industry isn't creating art that attracts young people and people of color—we have that already—it's creating art that keeps the upper echelon of theatre makers employed in a changing demographic environment. That's not necessarily a bad thing—people need jobs—but let's have this conversation in more realistic terms, including recognizing that we largely reserve those jobs for white men. We need to face up to the fact that we enormously undervalue the work of women, young people, and people of color because so much of it happens below a certain budget, and we perpetuate that undervaluing by keeping them there.

We can start having a more realistic discussion about issues of our changing demographics, and what we can do to address them at all levels, by recognizing the work of indie theatres, and the women, young people, and people of color that populate them. You don't need to invent a new kind of participatory theatre to attract diverse, young audiences. Go see the theatre they make and see, recognize it exists, and let's start the conversation there.

Melissa Hillman is the artistic director of Impact Theatre in Berkeley, California. Impact Theatre was founded in 1996 and specializes in new plays by emerging playwrights, introducing work by writers such as Sheila Callaghan, Steve Yockey, Roberto Aguirre-Sacasa, and Lauren Yee to the Bay Area. Melissa holds a Ph.D. in Dramatic Art from University of California, Berkeley, and has taught at U.C. Berkeley; California State University, East Bay; and the Berkeley Rep School of Theatre. Melissa blogs about theatre and culture as Bitter Gertrude.

IT TAKES A VILLAGE TO RAISE
A THEATRE

Jules Odendahl-James

For her 1996 book *It Takes a Village* Hillary Clinton borrowed from an African proverb, the premise of which being that raising children is an interdependent process. The nuclear family unit is just one part of a critical social web that surrounds and propels a child forward through life—a life we hope will be marked by empathy, intelligence, equity, challenge, and resilience. To describe the recent work of the Ladies of the Triangle Theatre (LoTT), I am borrowing her borrowing. LoTT argues it takes a village to raise a theatre, particularly a theatre we'd like to see marked by the characteristics Clinton imagines for the world's children. And just as Clinton's manifesto argues for a reinvestment in the communal, so do we. Such a commitment means relinquishing control, foregoing tradition, and cultivating new, untested partnerships. It means crafting reciprocal investments between onstage and offstage communities sometimes in pursuit of work that may have little direct connection to a conventional theatre production. It means examining standards of achievement for the ways they embed inequity under the guise of "quality." It means risking decades of the way things are for an uncertain future of the way things might be. And it might be the key not just to the theatre's survival but to a whole new way of its being.

LoTT, an advocacy group focused on gender parity in the theatre community of "the Triangle" area of North Carolina, was founded in the summer of 2012 in conjunction with a *HowlRound.com* series exploring the contours of theatre cities across America. The group's initial co-organizers, Devra Thomas and Sylvia Mallory, seized this moment to offer local women-identified theatre makers a space to discuss the specific constraints and opportunities they experienced. As that initial group talked, we all learned quickly that shared gender identification did not mean shared gender experiences across our artistic lives. Over the past three years, it's been complicated to craft an action plan when the group's membership is so diverse in perspective, fluid in participation, and broadly inclusive in its mission of "supporting women in the Raleigh/Durham/Chapel Hill theatre community."

In forging future plans, what has also emerged for me, as LoTT's research director, is just how much existing structures of theatrical production seem profoundly incompatible with the complex lives of a theatre-making community comprised of a majority of artists who make their economic living in fields outside of the arts. This is a reality in our area somewhat obscured by an extremely flexible definition of the term "professional." While tensions over compensation and budgets have not reached L.A.'s ninety-nine-seat-plan battle level status (Charles McNulty, "Debate heats up over proposed ninety-nine-seat theatre plan," *Los Angeles Times*, Feb. 20, 2015), the economic realities of holding job one in a non-arts industry and significantly smaller economic job two in the theatre drive many of the choices and the visions of artists in our community. Add to that list a third job as spouse/parent/caregiver and the ranks of who can participate in theatre making, *what* they do, and *how* they do it gets exponentially more complicated.

In the late winter/early spring of 2015, some members of LoTT were called together by another member who was also the artistic director of a small theatre season within a larger community arts center, which has been a hub of making across the performing and visual arts for over twenty-five years. Like most centers of this kind, it is bursting at the seams with use and demand and running out of short-term solutions to maintain its aging if beloved building. To answer this need, it had embarked on a major campaign to build a new facility. Developers of other arts complexes in the area had been engaged to imagine a building and the arts community was solicited for its input. This was a moment of intense anticipation and trepidation. There have been too many examples of how new buildings overburden and sometimes even evict the companies they were built to house, or how the pressure of repaying such capital expenditures requires said companies to abandon any impulses they might have had toward lower ticket prices, riskier artistic ventures, or community-integrated programming.

At our brainstorming table, these worries were articulated, but we decided it better to seize this moment and dream a new structure of community performance, one that could attend to the specific needs of women-identified artists and, in turn, intervene and innovate on the issues of parity, inclusivity, accessibility, and diversity that animate our work individually and collectively. After all, we make up a large percentage of the center's educational and administrative staff, not to mention its clients and audiences.

At the center of our proposal was the idea that the center's relationship with "resident" companies would be short term, project based, and strike a balance across performance forms. This could level the playing field between established and emerging companies, would incentivize interdisciplinary collaboration, and make a space for those artists at any stage of their careers whose life situations require entering and exiting theatre-making systems at variable times. A central component of the application process for residency would be the unique collaborative models companies articulate between themselves and the various educational components of the center, as well as the communities beyond the center itself they will bring into the performance-making process. Companies would be encouraged to imagine intergenerational performance projects, so that families of artists could work together on pieces that, like Soho Rep's *Washeteria*, would be "artistically rigorous performance of all ages."

Ultimately the goal would be to expand the vision for what comprises a theatrical performance, a community collaboration, and the sustainability of the center for both artists and audiences. The center would invest its capital to support these proposed innovations and give companies who would invest in the larger organization a space to build their identities in a more robustly integrated way, as *community theatres* under an entirely new model of what that term means, what those companies would produce, and who would gather together to make and experience the performances.

At that moment last spring, ours was just a vision document. Significantly, it did not address looming issues regarding the economic capital required to invest so deeply in human capital. And now in the late spring of 2016, we know a vision document is all it will remain. After being turned down for new building plans by the local board of aldermen and under new management, the community arts center suspended indefinitely its theatre production arm. The woman who gathered us together to brainstorm saw her employment hours cut, which also truncated her capacity to make artistic decisions and build networks. Not only is any new vision for theatre making on hold, there was no 2015–16 theatre season at the center beyond rentals to local companies with previous reservations on the books.

It is difficult not to see this turn of events as heartbreaking; however, the document's creation offered LoTT a chance to imagine the utopic future where we would not just advocate for institutions to change, but we could help implement specific structures for that change. For

me, it was one small way to put to use the data I have collected and analyzed over the past few years that illustrates how constrained and constraining our current systems are for women-identified artists as well as artists of color, for theatre makers at either extreme of age (young or old) and with any physical or intellectual challenges. The recent turn of events is a stark reminder of the omnipresent constraints on artists who lack access to the kind of economic capital that gives a safety net to their artistic risks, including the very fundamental risk of pursuing artistic careers.

Fundamentally, these limits fuel other limits. When there is collective dismay within this field over:

- the lack of diversity among regular theatregoers and the lack of numbers for younger people who place theatre in their circle of cultural consumption;
- the stories, personal and public, about artists, particularly women-identified, who disappear from artistic communities after having children, losing a day job, experiencing an illness, or managing care for ill family members;
- the racially uninformed casting choices excused by a supposedly "limited pool" of performer options;
- the continued lack of inclusion, diversity, and parity in theatre seasons across institutions;
- the censorship or artistic limitations of material available for Theatre for Youth, accessible theatre for those with physical and intellectual differences, and Senior Theatre

we must realize that these things will not change without a fundamental reconceptualization of how institutional theatres, big and small, alternative and mainstream, structure the selection, making, and presentation of creative work.

To raise a new kind of theatre will require sacrifice from multiple parties. To embed gender parity, diversity, and inclusion into more than just the season titles on the marquee will require a willingness and ability to risk money and time to transform the perception of theatre as either a luxury good or a profession of the entitled. Until that time, even if we are not losing money, we are already failing, both ourselves as artists and those who might join our ranks and in turn those who are and who would be our audiences.

Jules Odendahl-James is a scholar/artist who works as a director and dramaturg primarily in the Triangle area of North Carolina. Her research interests are in digital dramaturgy, documentary theatre, sci+art collaboration, and the visibility of and parity for women and artists of color in contemporary American theatre. She tweets @naturalreadhead.

ACTIVATING AUDIENCE: THEATRE OF RADICAL INCLUSION

Applied Mechanics

"Sit back, relax, and enjoy the show"—not a very big ask as far as engagement goes. As theatre makers, we talk about what makes an engaged audience, and how to make audiences feel like they're a part of the work. But maybe audiences don't know how important their participation is. Perhaps audience members who show up to theatre don't want to be told to sit back and passively receive something but, rather, to step up and actively encounter something.

Applied Mechanics has been developing new forms of audience engagement within our work since our inception, and we've come to see a different kind of audience, made up largely of people under forty. In Applied Mechanics's work, many stories unfold simultaneously and the audience is free to explore the world and watch who—and what and how—they want. Our plays take up large rooms or whole buildings in live diorama, surround-sound style. This particular brand of immersive theatre appeals to people who grew up on video games and internet: We have seen a great interest from younger audiences in plays that they can walk through, not just watch. Our work gives the audience agency and includes them in the landscape and architecture of the invented world, making them members of a temporary community. We deliberately invite the audience in as a fundamental and active part of our aesthetic practice. We say, "Yes. We are all citizens together. You are not a passive observer. You are part of the world. You are a vital part of the work. And we're so glad you're here."

In the summer of 2014, we brought this experiment to a new level by making admission to our piece *We Are Bandits* free for all audience members. Billed as "a punk-rock feminist fantasia," *Bandits* was initially inspired by the actions of radical feminist activist art group Pussy Riot. In the early development stages of the process, we started asking ourselves, "How can we make this piece not only depict but also behave like a Pussy Riot action?" The first answer was clear: It had to be free.

One result of this was that *Bandits* had one of the most diverse audiences we've ever seen, in terms of age, race, class, and social

strata. Attracted by our unorthodox marketing techniques inspired by activism—wheatpasting images in the street, guerilla performances in parks, hooking into activist social media networks—we were able to attract an audience that looked like Philadelphia: older folks who identify as gay and teenagers who identify as queer; black college kids and Asian grandmas; people in wheelchairs and on crutches; non-English speakers; members of Occupy; stylish literati; and a troupe of women in their early twenties sneaking up the back steps so that they could see it again and again.

We produced the piece on the top loft floor of the Asian Arts Initiative, an amazing cultural and community organization that holds a great space in the crossroads of several interesting neighborhoods in Philadelphia: Chinatown, Northern Liberties, and Poplar, and an easy walk from Center City and Old City. This undoubtedly contributed to the audience diversity, as did the frame of Asian Arts, as did the free tickets. But part of what was amazing about the diverse audiences was what they were participating in.

The sense of energized community was palpable. Night after night, a diverse group came together to experience the piece—not just by watching professional actors on a lit stage, but by participating in the events of a story that included them, was about them. *Bandits* creates an urban landscape as rife with conflict and hungry for change as the world we live in, asking, "How is it possible to effect change in our contemporary American moment?" Audience members for *Bandits* were invited to live punk concerts, protests, intimate parties, communal art projects, and tête-à-têtes with famous dead feminists, in a cityscape that shape-shifted around them as the stories unfolded. *Bandits* was a raucous call to arms, a celebratory punk prayer, a wild adventure fueled by the radical spirit. And our audiences were part of this radical spirit. They were part of the call for change, the acts of resistance, the tragedy of thwarted action, and the triumph of transcendentally radical moments.

Theatre has the power to engage us and unite us. We all know this. Immersive theatre puts pressure on the audience to actively participate as players in the imaginative world. It can be an exercise in citizenship, a simulation of the togetherness and agency that is possible in our daily lives. *Bandits* united its participants, if only for an hour or two, as radicals, feminists, activists—citizens of an imaginary America.

Applied Mechanics is a Philadelphia-based experimental ensemble that has been making original theatre work since 2009. Their aesthetic is inspired by dioramas, theme parties, choose-your-own adventure books, zines, feminism, collectivity, and social-justice movements. They have created nine immersive performances and seven participatory parties. Ensemble members are director Rebecca Wright, designer Maria Shaplin, performers Jessica Hurley, Thomas Choinacky, and Mary Tuomanen, and performer/stage manager Bayla Rubin. They share a home-cooked meal at every rehearsal. Visit *www.appliedmechanics.us.*

BACK TO THE FUTURE

Deborah Brevoort

I make an ongoing effort to get my non-theatre friends to attend the theatre. I have convinced some to join me in buying season tickets to different companies and others to join me for individual shows. When I travel, I try to take my friends in cities around the U.S. to see the shows at their area theatres. I am sad to report that my efforts to turn my friends into regular theatregoers have been largely unsuccessful.

When I asked my friends why they wanted to cancel our season tickets (or not go to the theatre at all) they gave me a variety of answers. Here are some of the things they've said: The plays didn't "grab them." The shows were "boring." They "wanted to feel moved, but didn't." One friend complained that the plays we were seeing didn't have an "aha" moment." Another said that they wanted "something more." Another said, "Where's the takeaway?" Many of them said that they wanted to be "left with something," and the plays we were attending didn't leave them with anything.

The bottom line? My friends didn't have a good time at the theatre.

I have heard these same sentiments expressed by my theatre and writer friends as well. Many confess that they're not going to the theatre much these days. I can't count the number of times I've heard: "TV is better," "The best writing is on TV," or "I'd rather stay home and watch TV." Our conversations invariably turn to the compelling stories and characters found in shows like *Breaking Bad, House of Cards*, or *Homeland*. These shows, and others like them, are spawning the liveliest cultural conversations taking place in the country. I take solace in the fact that most of these TV shows are being written by playwrights.

So what is going on here? And how can we change it? I want to avoid the obvious issues of money: People watch TV because it's cheaper than buying theatre tickets. While cost is an important factor, I don't think this is a money problem at heart. It seems to me that something else is going on. I suspect that it has to do with the marginalization of the theatre in the larger culture. We are turning to TV because it offers us a good time; it gives us a good story; it moves us; it leaves us with something—in short, it touches us in a way that theatre does not.

To begin the conversation about how we can put the theatre back on the cultural map for the general public, I'd like to look backward.

I recently studied early American theatre and performance through Lynn Thomson's America-in-Play theatre company. Rummaging through the dustbins of early American theatre history opened up new ways of thinking about the theatre that might offer some clues and insights. I made several compelling discoveries about our theatre history.

The first is that we have an extensive folk drama from early America that consists of comedies and farces. (Who knew?!) Second, the early playwrights who wrote these plays played a seminal role in forming our national identity. (Who knew again?!) Third, going to the theatre was central to early American life; everyone attended, from all walks of life. And finally, serious drama—not just comedies—had an important place on our populist stages of long ago.

Let's start with the first item: early American comedies. Written shortly after the Revolutionary War, our early comedies share two features: The first is a character named Jonathan, a rough-hewn, uncouth, uneducated fellow from the backwoods of America, who plays a recurring role in many of the plays. The second is a repeating story (a comic situation, really) that chronicles Jonathan's travels to New York City where he encounters refined, aristocratic English types. In these plays, unschooled Jonathan is always pitted against an overeducated Englishman and outsmarts him.

What is significant about Jonathan is that he was the first American character to be created on the American stage. He appeared at a time in our history when our identity was being formed and we were attempting to define for ourselves who we were as a nation and a people. What is significant about his repeating story is its comic underpinnings. Humor, it appears, is part of the American DNA.

What is most exciting about Jonathan is that he was created by playwrights! Born in the theatre, he quickly leapt off the stage and entered the culture to become of staple of American humor and the subject of cartoons, songs, political essays, and newspaper editorials. Early America embraced him. In the end, he was a character made by many hands. Each region created their own version of him. There are Vermont Jonathans, Southern Jonathans, and Kentucky Jonathans. The character was informed by many cultures as well: Irish, German, French, Hungarian, Spanish, African, and Persian. He later morphed into Yankee Doodle, and then he morphed again into Uncle Sam. The pictures we see today on the "Uncle Sam Wants You" posters are Jonathan.

The reason that Jonathan played such a central role in creating and developing our national identity is because theatre was central to early American life; everyone from every segment of society, educated and uneducated alike, attended. George and Martha Washington went to the theatre every week. So did working people, Negroes, churchmen, and prostitutes. The theatre housed a microcosm of American society. Shakespeare's Globe Theatre comes to mind, as does the Theatre of Dionysus.

Theatre in early America was populist. This means it was also unruly. The American audience was a noisy crowd—so noisy you would not have been able to hear the sound of candy wrappers through the din! The audience was also vocal. If they didn't like an actor, they would boo, hiss, and stomp. One British observer noted, "The egg as a form of dramatic criticism came into use in this continent."

Conversely, if an audience liked an actor, they would stop the show and make him sing a popular song. It was not uncommon for the audience to demand that the actor playing Romeo "take the poison twice." Early American theatre was interactive theatre—in the extreme.

In addition to being unruly, our early theatre was also sophisticated. Shakespeare was often the main attraction. A typical performance looked something like this: The evening would begin with an American farce, followed by the first two acts of *Richard III*. Jugglers would come onstage during intermission, followed by Chinese dogs performing tricks. Then, the rest of *Richard III* would be performed, and the evening would end with strong men performing physical stunts.

This format for theatrical performances was in place for over a hundred years until a class system began to emerge when Shakespeare was removed to expensive theatres for the educated (and wealthy) class and taken away from the common folk. The notion of a "legitimate theatre" or an "art theatre" took hold in America, which sought to emulate European culture and present Shakespeare and other plays in their purity, without the jugglers and animal acts.

The idea behind the art-theatre movement was that popular forms of entertainment were dangerous because they had the potential to infect and destroy higher forms of art. People looked upon Shakespeare as sacred and pure and the theatre as serious and lofty. Entertainment became a dirty word; American folk comedies disappeared from the stage. A cultural hierarchy developed which continues to this day. People were excluded through dress codes and ticket prices, and strict rules of behavior were implemented and enforced.

Several things struck me as I was exploring this early American material.

The first is that when the theatre turns its back on the popular audience it loses its power to impact a culture. The reason that Jonathan had the impact he did was that theatre was at the center of early American society. It wasn't reserved for the educated and wealthy; it was attended by everyone.

With the notable exception of Lin-Manuel Miranda and *Hamilton*, I'm hard-pressed to think of a single playwright, theatre work, or theatre company that has that kind of impact today. The cultural hierarchy that drives most of the contemporary theatre means that we have removed ourselves from the general audience. The result is that we don't impact the culture significantly. In the words of Ronald Davis, theatre has become "a symbol of culture, not a real cultural force" like it used to be in early America.

I also realized that the ability of the theatre to impact a culture is directly tied to the amount of pleasure it provides. The day that theatre stopped providing the audience with a good time was the day they stopped coming and the day we lost our power. It is also the day the audience lost their willingness to embrace serious works. Don't forget that the centerpiece of those unruly early American theatre performances were plays like *Richard III* and *Hamlet*.

It also occurred to me that perhaps one of the reasons television is at the center of American culture today is that TV programming has replicated the format of early American theatre performances. A perusal of prime-time programs reveals the same diversity found in the early American theatre: There are sitcoms (farces), serious dramas, and variety shows. There are animal acts, too, on late-night TV. (Remember Stupid Pet Tricks on David Letterman? Wild animals on Leno? The tradition continues with Jimmy Fallon's animal exhibits.) Obviously, this is a format that works—it has captured the attention of the contemporary audience just as it captured the attention of our forebears. If we want to win back our audience, perhaps we should consider reviving it in some way.

I propose that we go back to the future by using early American theatre performance as a guide. Let's put the jugglers back in conversation with Shakespeare. Let's give the audience a good time! And how about producing more comedies? And when we're doing serious drama, why not open them with comic "curtain raisers" and bring back the animal acts during intermission?

The highbrow/lowbrow distinction has not served our theatre well. It has relegated playwrights, and the theatre, to the margins, and it has sent our audience members back to their couches where they can watch more entertaining, diverse, and compelling stories on TV!

This doesn't mean we have to lower our standards. On the contrary, it means we have to expand and get better at what we do. Zeami, the Japanese Noh master, insisted that the Noh artist must be *equally committed* to pleasing the audience and achieving artistic mastery. These two things may feel contradictory, but they are not mutually exclusive.

Zeami also reminds us that there are always two audiences present: those who see only with their eyes and those who see with their hearts. It is the job of the theatre artist—and the playwright—to aim for both. "To perform in front of an audience of people with different tastes and to capture the heart of them all is the basic task of theatre."

If theatre wants to be a cultural force again in the U.S., we must pay attention to what Walter Kerr described as the "natural appetite of the audience for a wide, constantly changing, unpredictable menu." And don't eliminate the sweets, he warned. Eclecticism and a hodgepodge of high and low forms is not a menace to the theatre's wellbeing or purity; rather, it is a sign of simple joy in the medium.

That joy keeps the theatre alive—and gives it the ability to leap, like Jonathan, off the stage and into the culture.

Deborah Brevoort writes plays, musicals, and operas. Her plays include *The Women of Lockerbie, Blue Moon Over Memphis* (a Noh Drama about Elvis), *The Blue-Sky Boys, The Poetry of Pizza, The Comfort Team,* and *The Velvet Weapon.* Her musicals include *Crossing Over* (Amish hip pop), *King Island Christmas,* and *Coyote Goes Salmon Fishing.* She is published by Dramatists Play Service, Samuel French, Applause Books, and NoPassport Press. She's an alumnus of New Dramatists and a cofounder of Theatre Without Borders.

INSIDE OUT

Corey Madden

Like most theatre folk, I spent years working indoors in the dark. Then, about fifteen years ago, I realized I had to get out. Outside, that is. I don't know whether it was because of a vitamin D deficiency or because I was burnt out from twenty-five years in tech rehearsal; but I knew I couldn't work inside resident theatre's boundaries anymore. Truth be told, I'd been edging my way toward the stage door for years, collaborating with dancers, adapting short stories for the radio, and staging projects in museum galleries. But when I founded L'Atelier Arts and began making multidisciplinary work on beaches, in parks, and in public squares, I felt liberated as an artist.

I became fascinated by how creating work in real locations activated the audience's role in creating stories. Blurring the distinction between life and art, and between audience and maker, brought me new perspective. It also allowed me to face a contradiction: I had become an insider in a vocation in which remaining an outsider seems essential. This realization spurred me on to the next chapter of my life and career.

For thirty years, I lived in Los Angeles, a vast landscape defined by human movement. Like most people who live there, I came from somewhere else. Compared to the East Coast and the South where I'd spent the first twenty-five years of my life, Los Angeles seemed so expansive and diverse that its creative possibilities seemed limitless. And, indeed, L.A. is a kind of blank canvas.

Starting more than a hundred years ago, artists from around the world flocked to Los Angeles to shape new identities to their own designs. Beginning with the film industry's back lots, the landscape of L.A. has been made and remade by visionaries in the arts, architecture, and design. Today, Los Angeles is a world capital where arts, culture, and entertainment are central to its economy and identity.

Los Angeles has a reputation as a destination for people seeking enlightenment, escape, or refuge, and over time has become a city of enclaves. Across the L.A. Basin, from Baldwin Hills to Pico-Union to Simi Valley, Angelinos of every cultural background and economic status have established tight-knit communities. From Beverly Hills to Glendale to Compton, these communities assert boundaries of race, class, and culture, often casting a threatening "Other" into their

place-based narratives. Thus, despite its reputation as a progressive city, L.A. is also a metropolis with invisible yet immutable boundaries that limit people's perspectives and lives. This contradiction is at the heart of what makes Los Angeles a great and terrible place to live.

Artists have long been known as outsiders and consummate border crossers, who engage with people of disparate identities. My generation of artists, seeking cheap rents and nontraditional spaces, established creative practices and homes in Venice, Downtown, and Echo Park, places that were otherwise hostile to outsiders. Painters and playwrights shared turf with homeboys and the homeless, together creating an urban experience that was fresh, funky, improvised, and unpretentious.

This was L.A. culture at its best; but sadly, it was too good to last. Real estate developers bought up much of what was authentic in these neighborhoods, replacing it with fantasy architecture to be consumed by high-end hipsters.

When artists and working class people are forced to leave a place they made themselves, something fundamental is lost.

From my increasingly disaffected vantage point, I began to see the parallels between the gentrification of neighborhoods and gentrification of resident theatre. In both cases, I felt like I was losing what had been my home. Created by upstarts and renegades, the resident theatre movement was sustained by improvisation and innovation for decades. Eventually, to better support the work, big, shiny buildings were built, and before long our collective efforts became focused on maintaining those walls. Creating boundaries and restricting access was efficient; but over time privilege, opportunity, and funding went mostly to the insiders. Those who objected were either barred or cast out. As vibrancy vacated the premises, commodity culture filled the void. To find I had become an insider on the outs with American theatre was painful, but it was among the best things to happen to me, because it spurred me to found my own creative start-up and helped me learn to maintain the critical balance where the artist thrives.

For those who live a lifetime in only one location, identity is deeply rooted in place, and often narrowly prescribed. This is as true of Broadway theatre folk as it is of good old boys. Three years ago, I couldn't imagine leaving Los Angeles to live in North Carolina, less than a hundred miles from where my father had grown up in a boarding house his grandmother ran for travelling tobacco salesmen. After his university training he fled the South, never to return. Having gone to

school there as well, I was frankly scared of what moving to a place associated with my past would mean for my future.

In accepting a new job, I faced leaving behind everything that had defined me: my children, friends, creative projects, and California, that sunny, forgiving place which I had learned to love. In the months I spent moving emotionally and physically from one state to another, I learned that when you leave home, dislocation becomes a part of your identity. More importantly I realized that turning your world inside out imparts a fresh perspective and new opportunity.

Today, I'm bringing what I've learned as insider and outsider in the field to the work of the Kenan Institute for the Arts by building creative community. In one sense this implies making space for artists to grow and prosper. In a larger sense, however, it refers to how artists through their creative practices contribute to reimagining and revitalizing communities and our American culture.

Living here in North Carolina, I have discovered just how much place really matters. Because while gentrification threatens to push artists out of cities like Los Angeles, towns in North Carolina are practically begging artists to take abandoned real estate off their hands. In every town across the state, storefronts and old mills sit empty, while empty historic houses and churches decay. To recover from the ravages of deindustrialization and the Great Recession, towns need the vitality and local jobs that the arts provide far more than they need another fast food franchise or a pork-processing plant.

In towns where artists have been welcomed, creative place-making is transforming communities. Today, in North Carolina the creative economy rivals the pharmaceutical and manufacturing industries in its economic impact. Travelling across the region, I marvel at the creative places developed by artists over the last fifteen years: The River Arts District in Asheville, Elsewhere in Greensboro, and the entire hamlet of Saxapahaw. Urban centers, like Raleigh-Durham-Chapel Hill are being transformed by musicians (and chefs), while rural towns like Floyd, Virginia, and Wilkesboro, North Carolina, are being sustained by their hugely popular music festivals.

In Winston-Salem, where I live now, artists have been creating community for fifty years. Novelist John Ehle spurred the state legislature to found and fund University of North Carolina School of the Arts (UNCSA), the first public conservatory for the arts in the United States. Local artisans founded, and still collectively run, the renowned Piedmont Craftsmen. Dozens of artist-driven business

helped to revitalize downtown, while today a coalition of artists, community members, and organizations is working to strengthen the arts ecosystem to attract new creative industries and strengthen existing artist enterprises. The Kenan Institute for the Arts plays the role of intermediary and partner to all of these efforts, providing resources and space, its new Creative Community Lab, where diverse creative leaders can connect, envision, and incubate their ideas.

While artists across the state work to reimagine North Carolina's future, we are also vividly experiencing just how much place matters after the state legislature passed HB2, restricting transgendered individuals' public access. The most intimate of places, our public restrooms, have once again become a battle ground for human rights. This decision strikes at the very heart of our creative community, casting us as pariahs, rather than equal members of shared society. As scores of corporations and individuals refuse to set foot in the state, invisible and enduring lines of conflict reemerge across our country. No matter where we live, place-based narratives, especially divisive and discriminatory ones, adversely impact our American way of life.

When communities perceive a threat, their narratives can take on a protective and aggressive tone. As Americans we know all too well how hateful narratives can provoke violent, even deadly actions. For this reason, it is critical that our storytellers are emboldened to question our deepest-held beliefs about place and identity. The most sacred space of all is the public sphere.

Our religious, political, educational, and cultural institutions should be where our experiment in Democracy safely resides. Of late, however, this is where inquiry has been squelched. The more entrenched our institutions and narratives become, the more insidious and self-serving our actions will be. Artists, as boundary crossers, erase the invisible boundaries between insider and outsider, using art to bring perspective to life.

Sometimes we have to leave the places we love. We have to become the outsider in order to speak freely about what's gone wrong. As artists we must embrace the contradictions of place making. While we deserve spaces for our work, we must also be mindful of the risk of barricading ourselves inside our own enclaves. While we deserve to be outraged when attacked, we must also be willing to bring compassionate perspectives to our conflicts, if we hope to liberate American culture from its repressive past.

Today's rising generation has a commitment and passion for building community, a passion born from their belief that they would rather be creative outsiders than elite insiders. Every day, I am privileged to witness these young people taking on the grand challenges of our time, improvising and innovating solutions that we never, in our wildest dreams, imagined possible. I hope that my generation will grant them greater and greater access to the big, shiny buildings. Let the visionaries remake them, and by doing so revitalize us all.

Corey Madden, the executive director of the Thomas S. Kenan Institute for the Arts, brings thirty years of creative leadership in the performing and visual arts to her position. Madden served as associate artistic director of the Mark Taper Forum from 1993–2007. During her tenure she led a wide array of artistic programs and initiatives to serve diverse artists and communities, as well as developed and produced more than three hundred world premieres. In addition, she is an award-winning writer and director in theatre and film and the founder of L'Atelier Arts, which creates multidisciplinary and site-specific projects around the world.

TEACHING STUDENTS
TO CREATE FOR
CONTEMPORARY AUDIENCES

Jacqueline Goldfinger

A young Hispanic student hangs out shyly near the door of my classroom after the first day of class. As I exit, she whispers to me, "Professor, can I write a bilingual play? My other teacher said that that wasn't real theatre relevant to American audiences."

Two playwrights meet at a public master class that I'm leading. Both graduated from a well-regarded theatre program. They are laughing and discussing how they read the exact same plays in their contemporary American theatre course. They graduated twenty years apart.

I'm mentoring an undergrad playwright who has endured three years of rigorous theatrical training. He can't name one playwright under the age of fifty who has world premiered a play within the past five years except Sarah Ruhl, who "is cool" because she put a vibrator in a play. His contemporary touchstones are Williams, O'Neill, and Hansberry.

All of these situations are real.

All of these situations are terrifying.

All of these interactions are common in my experience as a travelling teaching artist.

Why are we encouraging students to write plays for audiences that are dead? Would a student painter only be educated in the aesthetic of Picasso and his contemporaries? Would an emerging graphic designer only be trained in wood block print and never touch a computer? Would a young architect only visit the Colosseum, Great Wall, and Eiffel Tower? No. That's ridiculous. Teaching artists in other disciplines look at me with incredulity when I describe the limited engagement my students have with contemporary theatre—which I define as works that have world premiered within the last ten years. When I began teaching at one well-known institution, I was the first professor to introduce students to any work post Paula Vogel's 1997 *How I Learned to Drive*—a piece that I love and have taught but is

almost twenty years old.

We seem to be intent on intentionally stifling young voices by limiting their exposure to what is possible in the Now of theatrical space.

Please don't freak out. Or do. Maybe it would make the discussion more vibrant and that would lead to more productive results. I am not suggesting a baby-with-the-bathwater situation. I am not suggesting we excise well-regarded, well-known texts from our syllabi. They are a vital aspect of an artist's education. Our Mozart. Our Cage. Occasionally, our Bieber. (What? You never read a play that, no matter what your teacher said, you absolutely knew was terrible at any point in history?)

But too often an overemphasis on well-established texts leads to an absence of today's texts and theatrical viewings in colleges and universities. As a result, we are only exposing our students to ideas, aesthetics, and forms that audiences have often already absorbed and moved beyond.

Audiences come to theatre for many reasons, but the core of their experience is connection—with stories, with characters, with each other, with an experience, with an intellectual idea, with living, breathing, exuberant energy. Otherwise, they'd just stay home and watch Netflix in their pajamas for $8 a month. And we don't write for dead people. We don't write for audiences that lived in the '40s or '70s; even if an audience member was alive in the '40s, they are a different person today than they were at that time. We should be training students to create for the Now person. For the vibrating soul.

Let's leave the O'Neill, the Mamet, the Wilson, the Greeks, the Shakespeare, even the Shepard (whom I love more than my luggage) in the literature classes, in the theatre history classes, in the script-analysis classes. Let's keep our playwriting workshops and contemporary theatre classes current, vibrant, electric with possibility. Let's commit to encouraging young creators to engage with the today's American theatre scene; before creating our syllabi, let's take a look at what's world premiered within the past five or ten years, emphasize those works, and then supplement our syllabi with recommended reading/viewing lists of older work.

Jacqueline Goldfinger is a playwright, dramaturg, and teaching artist. She teaches playwriting and dramaturgy at University of Pennsylvania

and University of the Arts. Her plays have been developed and/or produced by the Kennedy Center, La MaMa, FringeArts, Orlando Shakespeare Theater, Barrington Stage Company, Philadelphia Theatre Company, and Arden Theatre Company, among others. She is a New Georges Affiliated Artist and her work is supported by Yaddo, the Independence Foundation, the National Endowment for the Arts, the National New Play Network, and the Sewanee Writers Conference. Visit *www.jacquelinegoldfinger.com*.

ANCIENT TECHNOLOGIES FOR
MODERN TIMES

Jeff Janisheski

Theatre is an ancient technology. A body. A stage. An audience. A communion.

This communion can be with an audience of one or thousands. It is the quality of the communion, not the size of the crowd that matters. This is the focus of my work as a teacher and director: how to make that connection between the live bodies of the performers and those of the audience more charged, electric, and alive.

I have been training actors for over twenty years around the world: from Sydney to Seoul to St. Petersburg and throughout the U.S. Regardless of the country or language, I concentrate on the actor's art and the craft of that connection with the audience. As a teacher my work in terms of "audience engagement" revolves not around marketing or media, but around the alchemical reaction between actor and spectator: An event unfolds in time and space that transmutes into something greater. It might move us, entertain us, challenge us, enrage us, but it must engage and change us.

To achieve this alchemy, my students train intensively in a range of methodologies, texts, and media: from Butoh to Viewpoints to Stanislavski; from Chekhov to Chikamatsu to Chuck Mee; from theatre to TV to film. Ultimately, however, they are training in only four things: people, space, time, and text.

My students are constantly learning how to listen to, observe, and collaborate with: people (their collaborators, scene partners, characters, and the audience); space (the rehearsal room, set, world of the play, and world around them), time (how they treat time, the time period, the rhythm of the piece, and their physical/vocal "musicality"), and text (the script or score, its historical context, and the signs and conventions that surround theatre). Students explore these elements through a variety of exercises: e.g., early in my training I have students directly—and in a detailed way—observe the physical life of people on the street and then perform those in nonverbal performance "études" or sketches.

Thus, for me, "audience engagement" has a subtler meaning than marketing or media outreach. I train students to deeply engage with

people and everyday life. An actor is a keen observer of life: someone who fearlessly and compassionately engages with the totality—the terror, tears, and treasures of our hearts. The goal is to create work that is deeply human, deeply connected to the stories and struggles that draw us night after night into the darkness of the theatre.

To do this, I train my students in three core skills: being *truthful*, *transformational*, and *theatrical*. Actors must create truthful, three-dimensional portraits of their characters. An actor transforms from moment to moment, role to role, and medium to medium. And an actor needs to explore, exploit, and explode the theatrical potential of the stage. When a performance is truthful, transformational, and theatrical, it has the power to engage, attract, and sustain audiences.

This last point—of creating work that is more theatrical—is a crucial one. The question for me is not how theatre can connect more to current technologies (iPhones, the web, etc.) but how can theatre be more *theatrical*? How can theatre and the actors involved create indelible memories—memories that are burned into the brains of the audience? For that is what theatre is: a memory machine. It is a maker of permanent memories through an impermanent medium. That is what theatricality means to me. This doesn't discount the use of current technologies: These are just one more tool in a theatre maker's toolkit.

When I rehearse a play I also have my actors ask themselves, "Why this play? Why now?" In 2014 I staged *Antigone* in Sydney, Australia, at the National Institute of Dramatic Art where I was head of acting. In my rehearsals with the ensemble of first-year undergraduate actors we examined the contemporary Antigones of our society and wove monologues from Edward Snowden, Chelsea Manning, and Nadezhda Tolokonnikova (of the Russian punk rock group Pussy Riot) into the tapestry of the overall text. We did this to address that central question: Why *Antigone*, why now? For me, this is the play of our time. It asks us to examine who is standing up against the state. Who is speaking up against power and the establishment? And whose side are we on? But before we could engage the audiences in those kinds of discussions the actors needed to ask those questions themselves.

This book is about ensuring the deep, human communion between actor and audience. For me, as an educator, the issue of how to draw in an audience and engage them brings me back to first principles. If anything, I want to make theatre that is more ancient, not more digitally connected—more primal, not more plugged in. That fundamental,

electric connection between audience and actor doesn't require any router, Wi-Fi, or social media: It demands committed, fearless actors and theatre makers who are keen observers of humanity, clear prisms for the play, and deep thinkers about the nature of life and the art of the theatre.

Jeff Janisheski is a teacher and director who has worked throughout Asia, Australia, England, Russia, and the U.S. He was head of acting at the National Institute of Dramatic Art in Sydney, Australia; artistic director of the National Theatre Institute at the Eugene O'Neill Theater Center; associate artistic director at New York's Classic Stage Company; and cofounder of the New York International Butoh Festival. He trained extensively with Anne Bogart and Butoh's Kazuo Ohno. Visit *www.jeffjanisheski.com.*

BUILDING BRIDGES

Dave White

As a playwright, international artist, faculty member, and scholar, I find myself with membership in numerous communities. My natural inclination as a playwright is to learn about and participate in various communities, and theatre provides the perfect opportunity to do just that—most recently my work *Dance on Bones*, inspired by experiences with jazz in Russia, connected theatre artists, filmmakers, dancers, musicians, and illustrators. By connecting to the numerous communities evoked either topically or pragmatically by the work, I found an audience, knowledge, like-minded collaborators, funding, and people that connected me to my craft and other communities around the world. Yet the ideas of what a community is continues to change, and as it does I find myself wondering if I really understand what a community is and how it functions in the twenty-first century.

Before addressing the idea of community, I must admit that I am filled with more questions than answers. I find myself between communities, atop a metaphorical bridge between communities I've known and communities I want to know, but do I even know what community means? I have a general idea of what a community is, but what about the specificities of community and how a community interrelates with other communities? How are communities connected and how are those connections supported and maintained? How many connections can we support? These ideas compel me to explore the idea of community, new ways to build bridges, and new ways to maintain the bridges I have already constructed.

Often community is defined by geographic identities intertwined with culture. With a theatre organization, geographic location is often the most apparent idea of community and defines everything from season selection to marketing to fundraising. This investment in the local is important for building audiences, and there is a necessary commitment to this idea, but there's also a certain xenophobia hiding around the edges. Organizations, artists, and audiences can become insular and stagnant rather than engaged. Communities can exist in isolation, but for how long? With no bridges in and no bridges out, the community becomes a world unto itself, and it is difficult for

outsiders to navigate an insular world. Who doesn't know an instance of when this has been true of our own work, our local theatre's work, or even theatre as a whole? Connections to local communities who offer new insights and perspectives are what sustain each individual community; we need to connect locally, but we need to be diverse in our local connections, engaging new audiences by connecting them to the themes and ideas we are presenting.

Fortunately, communities are not only defined geographically, but also by people's interests, hobbies, or jobs. One feature of these interest/job-based communities is that while they give a sense of belonging, they separate the individual from society at large. Making theatre for a new community means recognizing how that community's needs are distinct from our community's needs and distinct from society as a whole. In addition, we need to discover where that community's needs overlap with our community's needs. Recognizing the individual needs of diverse communities helps us to build bridges between communities; discovering the commonalities allows us to further strengthen the bridges that have been created. By building strong connections, we can create a network that spans the larger society by linking geographical areas, interests, passions, and people.

If connections between communities are bridges and communities are land masses, then society is the deep, churning sea that our connections span. Sometimes a big enough wave comes along to sweep the tide deep into a community and we see the popularity of a community-based idea rise as society discovers what the community has already known. More often, the interactions are gently lapping waves of society's passing interest. When the perception of success is money and societal embrace, it can be discouraging to only see occasional interest without widespread acclaim, but when I shifted by focus to using my work to serve communities, my reward is more valuable than money. I have put my skills as a playwright to use serving communities in a variety of ways, including:

- creating work about a community via performing ethnography;
- writing (not necessarily autobiographical) original works about my experiences as a way to share stories about people not often seen onstage, connecting audiences and artists to potentially new communities;

- sending work abroad to see how different ideas resonate with different global communities;
- creating interdisciplinary works that gather unique groups of people with a variety of skills, because what might seem idiosyncratic on the page opens up an opportunity to connect different groups of artists, from musicians to computer programmers.

And while each of these ideas can be employed in a variety of ways, they all connect communities and build bridges between our theatres and the people and places to whom we have something to offer and have something to offer us. Fostering new collaborative connections enables our current project to present a greater diversity of performance mediums and styles as well as ideas, and, with our globe-spanning technology, we are able to incorporate global collaborators into our work.

In the twenty-first century, it is easier than ever to connect with communities around the world. The technological revolution has exploded our idea of community. Contemporary communities are as real online as they are in on terra firma. Finding a community to connect with based on interests or jobs is easier than ever, but bridges that are quickly built are often the first to go when the waters rise. Perhaps this is a generationally limited perspective, but what I have noticed is that creating connections online may be easier than ever, but truly being a part of a community, maintaining connections, requires a melding of the old and the new.

Online communities can be fleeting and fickle, and if connecting virtually via social media is my sole means of contact, then I quickly become disenchanted with this medium and yearn for a personal (if not a physical) connection, whether it be via Skype or across a table. When communities do manage to forge a physical connection (yearly/monthly/weekly) via face-to-face meetings, then the community grows and flourishes—hence the popularity of the "-cons," be it for theatre (TCG, KCACTF, ATHE, SETC, etc.), comics, film, etc.—and the people attending the events tend to return to their other communities refreshed and rejuvenated. The online world can support the bridges that have been created by physical connections, but do not seem to offer a suitable replacement for the bridge themselves.

Communities in the twenty-first century cannot afford to dismiss either the physical or virtual realm. The social media revolution has

changed almost all aspects of what we do into marketing and just as marketing is necessary to connect audiences with the work we are presenting, social media allows us to connect with audiences around their interests as well as their geographies. Clips of shows, scripts, dramaturgical insights, and photos are all shared and exchanged online, which creates a sense of closeness even over vast distances. In the past several years, I have been fortunate enough to spend time abroad in Russia, Slovakia, and Uzbekistan. In each of these places I have felt lucky enough to be a part of the community, if only for a moment, but now I can keep in contact with those communities virtually, which fuels my art by seeing images and stories about the work happening abroad and my desire to return to them for a visit. For now, we stay connected because of our love of theatre, cinema, or music. We can communicate without a translator by building our community around the things that we love as well as the things that we do.

Maintaining our communities and connections requires effort. Even for our local communities, we must take the time, show the interest, invest our skills, and be a part of helping our community grow. With the ability to connect readily available, I have experienced community fatigue, being overcommitted, being connected to many different communities, but not able to serve any one community well.

Building bridges that span long distances is even more difficult for many reasons—funding, the pull of our local communities, and the uncertainty of when we will meet again—but it also provides innumerable rewards in the diversity of people and ideas that can connect us as a global community. And so I stand on a bridge, society below, churning dark and deep, and wonder which direction I should go. These ideas fuel my thoughts of how I can invest fully in the communities that have already invested in me, how I can foster and maintain deeper connections, and how I can build better bridges.

Dave White's plays have been presented in the U.S., Russia, and Uzbekistan. He teaches playwriting at Towson University while researching intersections between story, music, technology, and theatre. Dave was raised in the Ozark Mountains, but lives in Baltimore. Follow along on Twitter @davewhitewrites.

let's get punk rock about this

Sylvan Oswald

It's ironic to talk about evolving audiences in a field that sometimes feels behind the larger cultural conversations. As a transgender person, I've never felt more relevant in mass media. But when I look at theatre I feel invisible. I've turned to producing my own web series just to have the conversations I want to have with my audience. Also, making the series was a lot of fun, and I didn't have to wait for the gears to turn in my favor. Just me and my iPhone, making it happen.

So do we need to evolve audiences or our business model? I don't run a theatre, so I can't begin to understand the enormous pressures our leaders are under. I have a tremendous respect for the art of raising money. But sometimes it seems like artists, institutions, and audiences are siloed. How can we make theatres the central cafes of cities and towns? How can engagement feel immediate, unmediated, real?

Also not news: This field is rife with elitism and struggles to maintain a diverse profile. There are not enough women, gender nonconforming people, or people of color in leadership positions, and there are not enough plays by writers from those groups on our stages.

As an (am I still, really?) emerging artist from an underrepresented group, my stake in this conversation is to consider how theatres might be nimble enough to reflect the urgent questions in mass culture and how theatres themselves can incorporate a wider range of new voices.

Jeff Jones's 2004 *Brooklyn Rail* article, "How to Build a Better Mousetrap," comes to mind. He relays an anecdote about ladies from Westchester getting schooled on the bus trip down to the city to see the Wooster Group—and then loving the show. Jones proposes more curatorial presence in theatre lobbies and brochures—a more dynamic marriage of marketing and dramaturgy. More "humanities" programming, as Soho Rep and other theatres have begun to incorporate. Props to Raphael Martin, who brings in fascinating guest speakers with broad appeal, as if he worked at NPR and not a sub-ninety-nine-seat house below Canal Street.

Combine Soho Rep's approach to content with About Face Theatre's associate artist program under Bonnie Metzgar. A team of the theatre's artist-family was given a leadership role as a literary committee (and sometimes welcome wagon) in selecting scripts for a works-in-progress

festival. Recall how the photographs displayed around Lynn Nottage's *Ruined* at Manhattan Theatre Club brought home the reality of her play's world. Then, add some bass notes from the Foundry Theatre's many activist programs foregrounding community-artist dialogue. (Yes, I'm mashing up MTC and the Foundry!)

Theatres could welcome a diverse crew of emerging artists and activate audiences around current events by empowering those newer artists to lead what we might call "encounters." These encounters could be almost anything the theatre and artist dream up.

(Footnote: what's the fastest-growing type of theatre in L.A.? Immersive. Audiences forget qualms about braving the nation's worst traffic to come out to theatre-as-event! Granted, most of these events do not take place in theatres. But what can theatre-theatres steal from this?)

Let's speculate that a renowned transgender playwright is receiving a production at a major Off-Broadway or regional theatre. Perhaps together with that artist or with a somewhat-emerging artist (conveniently, I'm available) a theatre could organize a wide range of concurrent programming. The already-known lobby displays and program notes may now be too easy to ignore and, let's face it, aren't a conversation. What are some modes of dramaturgy that would pop out and make audiences see them with new eyes? Is there a zine stuffed into the program? A hot mess of photocopied images and thoughts from a more-emerging artist in tribute to one more established? How about an artist-led field trip to a gallery showing thematically related content? A preshow picnic in the lobby? A neighborhood tour, a rehearsal demo, a flash party? Can we let our engagement get a little punk rock?

Yes, you would have to pay artists for these acts of radical hospitality. It's hard out there for all of us, not just the ambiguously gendered at bewildering career stages, but for you artistic directors, staff, and established artists too. Let's dismantle the silos and get real about our commitment to diversity by getting to know the artists and audiences around us. By deputizing emerging artists we can create new field leaders (aren't we all supposed to know how to self-produce now anyway?), while also creating richer and more spontaneous relationships with our communities.

Sylvan Oswald is assistant professor of playwriting at University of California, Los Angeles, and resident playwright at New Dramatists.

ONLY FOR "BLACK" SHOWS: BLACK AUDIENCES ON STANDBY

Simeilia Hodge-Dallaway

There is something quite disgraceful about the audience-engagement process in some of the leading theatres in the U.K. Britain prides itself on its multiculturalism, growing significantly more diverse over the last two decades, and its population is predicted to rise by almost ten million over the next twenty-five years. However, the antediluvian values and practices have not changed, and those who are culturally diverse remain on the periphery, excluded from key decision-making processes and only made to feel welcomed at mainstream theatres for specific productions.

How do I know this to be true? Well, I have been approached on more than one occasion by reputable mainstream theatre establishments to increase their audience capacity for "specific" productions. These "specific" productions tend to be classified as "black plays," which arguably or inarguably calls for a "black audience." Suddenly, their predominately "white" audience is not good enough. This radical act of staging a "black play," written by a contemporary black playwright, triggers the realization that their audience does not reflect the writer, characters onstage, and/or the "race" theme depicted in the productions.

So, in pops me. A young thirtysomething black female with a longstanding relationship with the Black, Asian, and Multi-Ethnic (BAME) community. As I enter the main artistic office—contrary to the diverse faces of the front-of-house and bar/kitchen staff—I immediately become the token black person in the room. There is no genuine interest or effort made for formal introductions or light conversations; we all know why I am here and that this is a temporary measure. I am employed for as little time as possible, to create as much temporary change as possible.

Instead I am confronted with either overly politically correct conversations or the crudely put inquisitions from the head of marketing: "What do you people want?" "How much would you people pay for a ticket?" "How can we get you people into the theatre?"

Ironically, the two most important questions are never asked, which are: "How can we work together (with BAME theatre companies and

audience-development consultants) to build a sustainable relationship with BAME audiences?" and "How can we make our audience-engagement process more inclusive and fruitful throughout the year?" It is assumed that black people will only see black shows and, more alarmingly, that black audiences are always a new audience on a low income, which again justifies the reason for them being invited one or two times a year. Or perhaps this is a way to control the number of engagements with the BAME community. Irrespective of the rationale, the fact remains that BAME audiences are treated differently on a show-to-show basis.

I have a strong passion to support my artistic practitioners and to encourage more people from my community to feel a part of a building that, as taxpayers, we keep alive. However, this tokenistic gesture of community engagement leaves me feeling completely disgruntled, pondering why such an important aspect of theatre making is unashamedly allowed to continue in this way. Only a very small handful of theatres have succeeded in creating healthy and sustainable engagement with culturally diverse audiences, namely Theatre Royal Stratford East (East London), Bush Theatre (West London), Tricycle Theatre (North-West London), Drum Theatre (Birmingham), and Contact Theatre (Manchester). The commonality of all these buildings is their understanding of the importance of building a genuine relationship with a diverse audience from grassroots level upward and how this can only bring richness to their building, practice, and work. The work in these buildings is supported by culturally diverse members of staff and/or those who acknowledge black audiences as their local, regular-going audience, embrace the black artistic community in their program of work, and build further opportunities for diverse communities throughout the year. These are the points articulated to theatres who fail to adopt the same approach, which fall to deaf ears.

This dismissive approach is not lost on the audience. One theatre in particular has lost their BAME audience altogether. The local BAME community recognized the theatre's "game play" and refused to be used in this way. I have heard numerous times by marketing departments that "it's too difficult to engage with nonwhite audiences," concurring with the recently suggested attitudes of white South African actor Janet Suzman, who boldly stated, "Theatre is a white invention, a European invention, and white people go to it. It's in their DNA. It starts with Shakespeare...they [black people] don't bloody come.

They're not interested. It's not in their culture, that's why. Just as their stuff is not in white culture." Let me start by addressing the notion that theatre is a white invention. Perhaps one should dig a little deeper than Shakespeare; it's like believing that Christopher Columbus discovered America. One should acknowledge the ancient Egyptian theatre—in particular the Egyptian mystery plays—or the griot tradition in Africa. (My mind wanders to Ridley Scott's whitewashed cast in his *Exodus* film. I digress.) However, this inherently racist attitude is far deeper than the number of BAME audiences; it feeds into the programming and employment of the decision makers in mainstream theatre buildings, with fewer than one out of ten nonprofit organization leaders from a BAME background in theatres across the U.K.

But I ask the question: If I can single-handedly increase the audience by over one hundred people from the BAME community in a limited number of days by applying basic marketing and networking techniques, what is the skillset of those who are permanently employed in the marketing departments of mainstream theatres? Why do they fail so miserably?

Simeilia Hodge-Dallaway is the founder and managing director of Artistic Directors of the Future (ADF); author of the first monologue book for black actors from black British plays, *The Oberon Book of Monologues for Black Actors*; theatre director; producer; audience-development consultant; and former manager of the Royal National Theatre's Black Play Archive. Simeilia is currently working on a second monologue anthology with the support of Bloomsbury Publishing, entitled *Audition Speeches for Black, South Asian and Middle Eastern Actors*, due to be published in June 2016.

FOR LOVE OF THE CEREMONY: THOUGHTS ON AUDIENCES AND NEW-PLAY FESTIVALS

Nathan Alan Davis

What if, in the not-so-distant future, every region of the U.S. were to have a high-profile spring festival similar to the Humana Festival, wherein several brand-new plays are fully produced in repertory? Can we only handle one major festival like this? Would multiple festivals diminish each other's importance? Or would they enhance each other? I would like to believe the latter is more probable.

And what might this do for our audiences? Those we already have and those we want to attract?

———

The theatre is and always has been a place of ceremony.

Our discourse around what is or is not "entertaining" and/or "engaging" is prone to becoming both too complex and too reductive. Reflexively, and perhaps necessarily to some extent, we look at potential audiences as consumers. We try to solve the puzzle of how to reach them through the ever-shifting lens of trend, of what is considered topical, of what we believe we know about them via their demographic profiles. I wonder if through all this we risk losing sight of the fact that people always have and always will gather in public (and pay admission, if they're able) in order to collectively experience the familiar. The long game is to make the ceremony of seeing a play more familiar to a wider range of people and to give the audience an active and essential role to play.

———

Last year (2015) I was at the Skylight Theatre in Los Angeles during the opening weekend for my play *Dontrell, Who Kissed the Sea*. Just before the lights dimmed for the Sunday matinee, a couple slipped in, each of them carrying a full meal: burgers and fries from the restaurant

around the corner. They sat in the front row of the intimate theatre, inches away from the playing space, and ate as they watched. I was very happy that none of the staff at the theatre stopped them and confiscated their meal. And thankfully there were no theatre etiquette vigilantes in the audience to glare at them and tell them to put their food away. I wondered what might have happened in this scenario at a larger, fancier theatre. Would someone have stopped them? Given the choice between eating lunch and seeing the show, would they have chosen lunch? I am not arguing that eating a full meal while watching a play is somehow virtuous. In fact, when I write plays, I tend to take the audience's silent, concentrated, non-burger-eating attention as a given. But if we do want to diversify our audiences we need to expect them to participate in ways that are familiar to them. Inappropriate behavior in a theatre is a surefire sign that the people we say we want in the audience are, in fact, there.

Is a new-play festival not the perfect setting for people of diverse backgrounds and ages to come to the theatre with a relatively clean slate? To create a unique culture then and there?

When you come as an audience member to a new-play festival, your role in the ceremony is heightened and the context for any one play you see is broadened. You anticipate adventure over and above perfection. You come expecting to compare and contrast, to gossip and debate, to experience and celebrate something *new*. (To be fair, new-play festivals do not hold a monopoly on these sentiments. But they do tend to concentrate and increase them.)

Should we not take every opportunity available to create that rarified atmosphere in our theatres?

Some cities have multiple prominent theatre companies that produce new plays. In that environment—and with a saturated market—it is easy to see that a Humana-esque new-play festival would not be a good fit. But there are many large regional theatres that are tasked with serving and engaging an entire metropolitan area. In some of those cases an annual—or even biennial—festival of fully produced plays in repertory could be a means of galvanizing local, national, and even international

artists, donors, and community organizations around the theatre. More importantly, it could create an energy and enthusiasm that comes from the consciousness that one is taking part in a vital cultural event.

———

In the summers of 2014 and 2015 I helped to organize a new-play festival in my hometown of Rockford, Illinois. It was a very humble effort; we had no budget whatsoever. The end result each year was a short evening of staged readings of ten-minute plays. The festival came together by a mutual whim as I was in Rockford working with the local arts council during those summers and began collaborating with a director who was in the midst of starting a theatre company. Despite our lack of resources and experience as we planned the festival on the fly, the response from the community was wholeheartedly enthusiastic. We underestimated audience turnout the first year and ended up with a standing-room-only crowd. One key component of the success was that we presented the works of local writers alongside the works of national writers. There was a sense of pride and importance and a palpable feeling in the room that something was *happening*. Our audiences for those evenings were not only big, but *wonderful*. Most of them were not regular theatregoers. (Sustaining that kind of turnout and enthusiasm over the length of an extended run would have been another challenge, of course, but the response was nonetheless encouraging.)

I am convinced that a new play—a play that needs to be heard—has a certain identifiable energy. There are some plays that are timeless. And by virtue of their timelessness they remain with us. But even plays that are not timeless have their time. We owe it to ourselves, our audiences, and the theatre as a whole to tell the stories of now and thus to continue to expand the boundaries of the form.

———

Much work is being done, and much more remains, to make our theatres and our audiences more demographically reflective of society as a whole. Parallel to that necessary and urgent task, we need to build a framework for the creation of brand-new cultures and perspectives. We will only be vital to the rapidly evolving cultural fabric to the extent that we become a place for artists and visionaries and dreamers of all

backgrounds to flock to when they want to bring something fresh into the world. How do we get there?

In order to navigate this road together we need to collectively envision the theatre we want and its place in society. What is the ceremony of the theatre of the future? And how can we plant its seeds here and now? And might those seeds be our new-play festivals of all types and sizes? Are we nourishing them enough? Do we need to plant more? Do they have enough light?

Nathan Alan Davis's plays include *Dontrell, Who Kissed the Sea, The Wind and the Breeze, The Art of Bowing, Nat Turner in Jerusalem*, and *The Refuge Plays* trilogy. He has been awarded the Steinberg/American Theatre Critics Association New Play Citation, the 2050 Fellowship at New York Theatre Workshop, and the Lila Acheson Wallace Fellowship at the Juilliard School.

ASK YOUR ARTISTS

Larissa FastHorse

As a playwright working on a play with the artistic department of a theatre, I am sometimes asked to talk a bit with the education department and the audience-engagement department. In my mind those three departments are trying to achieve the same thing: Grow audiences that are engaged with and enlightened by the art. However, the truth is those departments often work in columns of separate funding, strategies, and organizational structures that keep them from fully supporting the goal. As an artist I am all about that goal. I love growing engaged audiences. I want to be a part of it. When I believe those departments are not clear on how to move forward around my play and they aren't asking me, I go into communities on my own, find new audiences and educational partners, and bring them to the theatre.

I realize not all playwrights are interested in that kind of one-on-one audience building, but I encourage you to ask your artists for help, because you will be surprised at how many are not only willing but excited to do that work. A lot of us have been brought up in an "artist-as-activist" world. We want to touch community and be of service. We are also creative people and have ideas for how to bring audience and art together in new ways. I just did a project that brought together my passion for all of these things and offer it as one example of many that your artists will bring to you.

Cornerstone Theater Company commissioned me to write a play for their Hunger Cycle. I was assigned a topic that the ensemble wanted to explore. I wasn't thrilled about the concept, but a job is a job. My topic ended up being covered in an earlier play, so they asked me what I wanted to do. I took a risk and told them my dream project. The result, *Urban Rez*, is an immersive experience built from three years of story circles with the Native American community of and in the Los Angeles Basin.

The final experience utilizes professional and community actors in the Cornerstone tradition. However, the difference is that I crafted a piece that equalizes script, audience engagement, and education. The experience is set in a fair where there are booths that are scripted characters and booths of actual educators, culture bearers, and community service organizations. Much of the time they do and say their own thing, completely without my input as playwright. I originally

wanted the audience to have the option of never hearing a word of script and still have a fantastic time. My director, Michael John Garcés, convinced me that there are essential stories our audience needs to hear, so we have a hybrid of "real" experience and script that is highly effective. This can happen because the engagement and education booths are so compelling and truthful that they stand on their own, not watered down as separate activities around the "main event" of art. All three elements work together seamlessly because they all come from one artist-led vision, not separate departments.

Urban Rez has had a profound effect on the Native American community as both participants and audience. Watching the fairgoers is like watching a cross section of America with many races, ages, gender identities, abilities, economic levels, and theatre comfort levels. It has made all of my art, engagement, and audience dreams come true.

Even in a company as fluid as Cornerstone, it took work to reframe what is considered a "theatrical experience," who the audience is, and how to continuously engage me, as the artist, in all of these areas. I don't know if a theatre company will let me work this way again, but because Cornerstone asked, we found an idea that has engaged, educated, and built a new audience in an exciting way, while fulfilling me as an artist. As I've talked to fellow artists about this project they immediately say, "I've always wanted to _____." "My dream project is _____." And tell me exciting ideas I'd love to see. So I encourage you to ask your artists. They are as excited about this work and your audience as you are, maybe more.

Larissa FastHorse is an award-winning playwright, director, and choreographer based in Santa Monica, California. Larissa was awarded the National Endowment for the Arts Distinguished New Play Development Project grant, Joe Dowling Annaghmakerrig Fellowship, American Alliance for Theatre and Education Distinguished Play Award, playwriting residency at the William Inge Center for the Arts, Sundance/Ford Foundation Fellowship, Aurand Harris Fellowship, and numerous Ford Foundation and NEA grants. Larissa's produced plays include *Urban Rez, Landless, Average Family, Teaching Disco Square Dancing to Our Elders: A Class Presentation*, and *Cherokee Family Reunion*. She is a current member of the Playwrights Union, Directors Lab West 2015, and Theatre Communications Group board of directors, and is an enrolled member of the Rosebud Sioux Tribe, Lakota Nation.

GUEST IN HOUSE AS GOD IN HOUSE: HOSPITALITY AS PRINCIPLE AND PRACTICE FOR ALBUQUERQUE'S TRICKLOCK COMPANY

Brian Eugenio Herrera interviews Juli Hendren and Elsa Menéndez

BRIAN EUGENIO HERRERA: Why do you think hospitality has become so central to how Tricklock crafts its relationship to its audience?

ELSA MENÉNDEZ: When I first came into contact with Tricklock about fifteen years ago, I encountered a group of very committed, very passionate people who were simultaneously prioritizing the creation of new work and a particular dynamic of collaboration among artists. Several Tricklock company members had recently come back from an experience with a company in Poland called Gardzienice, and they brought something they picked up there—a principle which they translated as, "Guest in house is God in house." That totally resonated with me, and I immediately saw that it was exactly how they were creating work.

JULI HENDREN: I really feel like "Guest in the house is God in the house" is the kernel of everything we do. And I see the guest in our house being the audience. You wouldn't have someone just come into your house and just ignore them. You wouldn't keep your distance from them. You wouldn't be like, "I'm going to be over here making my dinner, you just do whatever you want and watch me."

ELSA: It's an idea of building connection and building bonds. Part of interacting with your audience is about engaging them as collaborators as well. As a result, I feel like the audiences in Albuquerque have been willing to come for different rides with us. And that includes seeing work that they didn't like, or were shocked by, or didn't understand, or whatever, as well as work that they liked and supported and spread the word about. This wide range of experiences has cemented our deep, loyal connection with our audience.

BRIAN: Can you talk about touchstone moments in the company's history where you really felt the formation of this reciprocal relationship with your audience?

JULI: Excavations is probably the best example.

BRIAN: What is Excavations?

JULI: Excavations is when we are working on a new devised piece and we do an open work demonstration. Wherever we are in the process, we invite the audience to come in. We typically stay out and mingle with them as they sit. At some point we get up and say, "Here you go," and show what we've got so far. Then we do an open feedback session, guided by a couple of pointed questions. And we always have wine and cheese and whatever to continue the conversation after the formal feedback session. We take all that into the notes that we use to get into the next stage.

BRIAN: And an audience can join in the Excavation process multiple times—usually no fewer than three—before a full production is mounted?

JULI: Yes. Excavations has become an institution within our company— this idea of, "Come and watch where we're at right now, what we've got, because we want your feedback on it." And I feel like we have created a really open space where people can be really honest and tell us what they think is working. We really do take notes and then we really genuinely do pull out that notebook when we go back into rehearsal and we really do incorporate that feedback into the work. And I've definitely heard it reflected that our audience feels like they're in every show, that they're excited and proud to be a part of the shows being made. I wouldn't say that our Excavations process is unique but it's definitely something that's critical for us.

ELSA: We believe that it's imperative to use theatre to evolve our notion of connection. We build opportunities for those connections around our theatrical offerings—through the preshow moments of having wine and conversation with company members, and then postshow receptions where we spend not just an efficient half an hour with our audience, but a couple of hours after the show really breaking bread

together. We also incorporate it into our festivals by always looking for multiple opportunities for the community to connect with artists outside of the actual theatrical exchange. We hold "welcome dinners." Artists are hosted and toured around by local community members. We feel all this expands the experience of what art is. To use Juli's image about inviting a guest to your house, you don't just stay in the kitchen. You go into the dining room and the living room and out back and you look at pictures. Same idea. There are lots of different aspects of the experience of creating a relationship with the audience.

BRIAN: That way of welcoming and holding space for artists to come together is such a big part of why Tricklock holds such a distinctive place in the Albuquerque arts ecosystem. Folks definitely seem as invested in that experience of coming together as artists in community as much as they are in seeing the work.

JULI: Sometimes people will look at the festival program and go, "This looks interesting to me; this one does not." Sometimes it's people's work schedules that get in the way. And it's lovely that they do feel like they feel they can just come to a gathering and meet the artists.

ELSA: We've also had local community members who have developed real bonds and relationships with artists outside of our company. One family, who have been very involved with Tricklock for many years and have hosted many international artists, recently developed such a bond with a Spanish company that they went to Spain and they spent most of their time with this Spanish company. Tricklock didn't necessarily develop the same connection with this company, yet these community members are in regular contact with them, which is extraordinary.

JULI: Tricklock is also deeply committed to the next generation of artists and has always been involved in various forms of education. And what I love seeing is when we have high school and college students also experiencing this exchange. We've had students of ours that we brought on to do tech for a particular company and then that company brought that person out to continue working on their show in New York and things like that. I hear often throughout the year about people all over Albuquerque who have kept connection and correspondence with different Revolutions artists. And that is pretty awesome.

BRIAN: But Tricklock doesn't just stay in New Mexico. How does the company take this ethic and practice of hospitality on the road?

JULI: It's usually kind of the same idea. We're not the kind of group that pops in, does the show, and then pops right out. Even if we're somewhere for just a short amount of time, we try to see the place where we're staying, culturally. And we make sure, wherever we are, that the message is out there that we really love to meet the audience and talk to them about what they saw. And we usually end up with a pretty good gathering. Recently, we toured Poland and, for every single show that we did, someone got up and said, in Polish, to the audience, "If you'd like to meet the actors after, please stick around." We would just make sure that to have some wine and some beers and, one time, there wasn't really a space for it so we just set up in the parking lot. And about twenty-five audience members stuck around and we stayed out there for hours, just talking and hanging out. And through that we met a potential artist I'm looking at to bring next year for Revolutions. It's a space we make sure to create.

ELSA: I feel like one of the practices of being a gracious host is also being a gracious receiver. It's also being a gracious, um—

JULI: Guest!

ELSA: Exactly! And that's the other side for me. When we travel, we are very conscientious of our host and have a heightened awareness of being gracious guests in whatever country or situation we're in. I think it's important for us to keep that alertness to that ability to receive, to be grateful, and to allow the host to give and to feel the power of that.

JULI: And we always bring gifts from New Mexico. Even if we're not necessarily being properly produced, even if all we're getting is a cut of the door, or something like that. We always bring bottles of really good tequila; we bring dream catchers; we bring Piñon Coffee. And we make sure to give out these gifts as thank yous. We put great effort into being good ambassadors not only of the U.S. but of New Mexico and as artists.

BRIAN: Do you sense whether the social media turn has had an impact on the value hospitality has for you and for your audiences?

JULI: Watching everybody friend everybody on Facebook throughout the festival is pretty cool. A nineteen-year-old University of New Mexico student who took a free workshop with an artist saw their show and became incredibly inspired—and then they're friends on Facebook, and I see them post: "Thank you so much. You changed my life." I mean, the fact that we're able to see that while it's happening is pretty amazing. I also feel social media has certainly helped our international tours, because we tend to do smaller places, funkier stuff, not necessarily giant festivals, so simply being able to do press that way. There's just more ways of connecting.

BRIAN: I should say that being able to watch the company go to Poland or Uganda via social media is almost like participating in the Excavations process. I know I end up tracking your trips because it's fun to vicariously see what you're off doing and to know that you'll be bringing work back in some way.

ELSA: It definitely expands the experience. And not just with photographs on Facebook, but also with us taking the time to reflect and post our thoughts online. In the past, we might have done that in our journals and maybe shared that with each other, but now we tend to share those reflections and experiences with more people in real time. There's quicker access to the deeper layers of what we're going through when we're abroad.

BRIAN: So the practice of hospitality informs the work of making work, too?

ELSA: Yes. The relationship with the audience is becoming part of the work that we're producing. I'm thinking about my experience with *Cloud Cover* (2011) and how its foundation lay in the "Guest in house is God in house" mentality. And in *The Glorious and Bloodthirsty Billy the Kid* (2004–13), there is interaction with the audience from the second the doors open to let the audience come in to sit, and that energetic dialogue is imperative throughout that show. And even in *Finger Mouth* (2012) and its many moments where the audience is interacted with and observed.

BRIAN: Speaking as an observer, and as an audience participant, I guess, Tricklock shows do ask you to become part of the world created

by the ensemble. Sometimes, as in *Cloud Cover*, that relationship is made explicit. But even when it's implicit, it's palpable. We are all here in this room together right now.

JULI: I think of the great example of *Cloud Cover* where Elsa chose to do it in such a tiny venue. There's an intimacy that you can't get away from. You're so close and the space becomes like a living room.

BRIAN: Speaking of intimacy, it's a lot of work to be a good host and a good guest. How does Tricklock's hospitality ethos sustain internal relations within the company?

JULI: At the first postmortem meeting we had after our 2015 Revolutions Festival, that was the very first thing I said as artistic director. I said, "We worked so hard to take care of everybody so much during the festival. Let's try to make sure to carry that through the year with each other." It was a good reminder to make sure that we are taking care of ourselves as well as we take care of everybody else.

ELSA: Probably because we are so conscious of our hosting mentality, we actually do take care of each other way more during the festival than we do during the rest of the year. Everybody's kind of charged up around supporting and thanking and praising each other during the festival because it's such an intense time. That heightened level of hosting and that heightened level of producing spreads amongst ourselves and also among our guests and our audience during the festival. We're still discovering how to take that out of the festival bottle and let it spread throughout the rest of the year.

Tricklock Company is a professional theatre based in Albuquerque, New Mexico. Though originally founded in the early 1990s, beginning with the turn of this century, Tricklock dedicated itself to devising work to tour nationally and internationally. While touring, Tricklock scouts for companies and artists that might not otherwise be seen in New Mexico to present as part of the company's annual Revolutions International Theatre Festival.

Juli Hendren is the artistic director of Tricklock Company and the curator of the Revolutions International Theatre Festival. Juli is an

actor, writer, director, and teacher, with a focus on devised work, clown and physical theatre, and international productions. She has performed, taught, and produced theatre in the United States, Canada, Europe, China, and Uganda, and is deeply invested in world connections through theatre.

Elsa Menéndez is a writer, director, producer, and performer with Tricklock Company and the director of education at the National Hispanic Cultural Center (NHCC). She has spent the past thirty-five years working in theatre around the world. In 1992 she cofounded BOOM!theatre, a theatre company within a men's medium security prison comprised of individuals serving the longest sentences. Elsa served as associate artistic director/co–artistic director of Tricklock from 2004–09. She is the founder and director of the Circo Latino and Circo Radical summer youth institutes at NHCC.

Brian Eugenio Herrera is assistant professor of theatre in the Lewis Center for the Arts at Princeton University. His work, both academic and artistic, examines the history of gender, sexuality, and race within and through U.S. popular performance. He is the author of *The Latina/o Theatre Commons 2013 National Convening: A Narrative Report* (HowlRound 2015), and his first book, *Latin Numbers: Playing Latino in Twentieth-Century U.S. Popular Performance* (University of Michigan Press 2015), was awarded the George Jean Nathan Prize for Dramatic Criticism. He is presently at work on two new book projects: *Starring Miss Virginia Calhoun* and *Casting: A History*.

CHAPTER TWO
Seeing

I'LL BE YOUR ONE-WAY MIRROR: CROSSING THE FOURTH WALL

Clay McLeod Chapman

There is an invisible partition that theatre has raised for itself—a one-way mirror of sorts, much like that familiar chestnut employed in police procedurals. When one side of the mirror is brightly lit, spectators can view from behind the darkened side, but not vice versa.

Let's play out a *Law and Order* scenario here: Our suspect is in custody, already in the interview room, in the midst of an interrogation by our trusty detectives. The district attorney watches on from behind the one-way mirror, free to observe while remaining anonymous, outside and inside at the same time, safe inside the shadows, reflective and transparent, and completely inculpable all at once.

Our suspect senses someone is watching. Whoever our accused's audience may be, the mirror hides their identity, but he knows he is being studied. He can feel their eyes upon him, silently scrutinizing his every word from behind the glass.

The mirror isn't fooling anybody. Someone is there.

Someone is always *there*.

Our suspect stands up from his chair and directly addresses the person behind the mirror. It's always an unsettling moment for our district attorney—to be called out like this. *They've been made!* For that brief instant, the partition no longer exists. They are dragged out from the shadows, unable to hide any longer.

How did the suspect even know they were there?

Truth is...they always know. The one-way mirror is a lie, a subterfuge of safety in which the prosecutor can bear witness to an event without being implicated.

Theatre has its own one-way mirror.

The fourth wall protects its audience. Yet that sense of safety runs the risk of creating a certain complacency in theatregoers, a lack of engagement in the living, breathing being gesticulating before them onstage.

Theatre is not an interrogation room. It is not an aquarium. And it is most certainly not a television set.

Theatre should implicate its audiences, make them complicit in the performance onstage. They are as integral to the show as the actors are, so why dim the lights and hide in the shadows?

Take the moment Richard III leers at the crowd. The heart skips a beat. That level of engagement activates the audience. At its most powerful, the moment can prompt each and every audience member to ask: *Is he speaking to me?*

Imagine an entire show with that level of interplay. Storytelling at its rawest has always forgone the fourth wall. Performers such as Spalding Gray, Eric Bogosian, Laurie Anderson, Danny Hoch, and Penny Arcade actively stare their audiences down. Rather than divide and isolate themselves, these artists have pushed that invisible partition as far back as the very last seat in the house and manifested an atmosphere that nurtures the intimate relationship between audience and performer.

The thrill of eye contact is there. The threat of being called upon is there. The jolt of being drawn onto the stage, crossing through the fourth wall, is always there.

This level of audience-performer interplay is something that I have always personally aspired to capitalize on within my own work. For nearly twenty years now, *The Pumpkin Pie Show* has been a labor of love that I have often described as a "rigorous storytelling session." At its heart, the show is a rotating set list of short stories that I have written, performed onstage alongside my cohort Hanna Cheek. A first-person narrative is merely a monologue waiting for an actor to give it voice—so we take these stories that begin their existence on the page and breathe life into them onstage. Part campfire storytelling, part boxing match, part shamanistic ritual, *The Pumpkin Pie Show* has established itself as an all-points artistic hodgepodge of both theatre and literature.

Rather than draw a line that divides the audience from the performer, we have always considered our audience to be our silent scene partner. Storytellers are essentially the "deliverers of content." All that is ever asked of our audience, unaware of the material, is to merely respond naturally. By creating this dialogue through monologue, we have the ability to strip away those elements that we find extraneous to the tale being told, conjuring up an atmosphere of "creating something out of nothing," as well as focusing on that ethereal connective tissue between the one telling the story and those listening.

Packed with enough emotional intensity to feel like a rock concert rather than merely spinning a yarn, *The Pumpkin Pie Show* is pure bedtime stories for big kids. Our shows have always felt more akin to watching a rock and roll band than a play; we apply the performative elements of a rock concert within a small black box space. No two shows are ever the same, no matter what the set list of monologues may be. If the audience changes—so should our stories. The text may remain static, but the performance of them fluctuates, thanks to the varying reactions from one audience to the next.

Theatre should not be safe. The audience should be held accountable for what unfolds onstage. Culpability gets the blood flowing. It engages the audience.

Film doesn't hold its audiences accountable for what they watch. By the time the lights dim, the content is static. The characters onscreen will never factor in one audience's reaction for the next. Their performance is frozen. There will be a screening of the new tentpole flick at noon today at the local Cineplex, regardless of whether or not I buy a ticket.

Film never needs its audience.

Theatre does.

What leg up does theatre have left over film other than the direct link between content and spectator, art and audience? Why not capitalize on this relationship?

Audience: Why hide behind the one-way mirror?

Performer: Rather than pretend we don't know we are being watched, why not call them out? Why not look through the fourth wall and see who's out there?

This is not an argument for audience participation. This is more than merely advocating direct address.

This is an argument for storytelling. Build a bonfire at center stage and invite the audience to circle around.

This is an argument for intimacy. For black boxes. Embrace the small house. Draw a clear distinction between theatre and film and push away from the current Cineplex trend of our massive Broadway houses. Less spectacle—more intimacy.

And look at each other.

I want to see the whites of my audience's eyes.

Clay McLeod Chapman is the creator of the rigorous storytelling session *The Pumpkin Pie Show*. Publications: *rest area, miss corpus,* and *The Tribe* trilogy—*Homeroom Headhunters, Camp Cannibal,* and *Academic Assassins* (Disney). Film: *The Boy* (SXSW 2015), *Henley* (Sundance 2012), and *Late Bloomer* (Sundance 2005). Theatre: *Commencement* and *Hostage Song* (with Kyle Jarrow). Comics: *Edge of Spider-Verse, The Avengers, Amazing Spider-Man, Ultimate Spider-Man, Vertigo Quarterly: SFX,* and *Self Storage.* He is a writing instructor at the Actors Studio MFA Program at Pace University. Visit him at *www.claymcleodchapman.com.*

MAKING EYE CONTACT
WITH MILLENNIALS:
THE EPHEMERAL AND THE VISCERAL

Justin Maxwell

Theatre rarely prioritizes the things that it does best, which keeps millennials unaware that we offer them something they want.

Last weekend I attended a play and a dance performance. At one event, the guy behind me tried to mansplain the value of modernism to his bored date, and they didn't return after the intermission. The second show was great. This week, I'll sneak out to a staged reading, if I can keep my eyes open and still think straight after a day of reading student essays and plays. These three shows cost: $30, $15, and $0, respectively. I'll also spend forty-five minutes in my car, to and from the shows. Conversely, according to my mathematically perfect browser history, I watched twenty-three clips on YouTube, Fail Blog, Hulu, and Netflix in the twenty-four hours around the two shows from last weekend. These clips were all fundamentally free; they were all watched on my comfy couch with the company of my cat (who is indifferent to mansplaining); and they could be paused and returned to later. In fact, the first thing I started watching in that twenty-four-hour timeframe was also the last thing I finished watching. That's what my media consumption looks like, sans iTunes, Pandora, and text-driven sites like *HowlRound* and *The Onion*.

With all that media, I'm still a dedicated theatregoer. If I include dance and performance art, I see about a hundred shows a year. However, my world is not the world of my undergrad students. For these young adults, disconnection from social media sincerely represents an existential threat to their sense of self. For me, it's a relief. For them, high quality entertainment is free and ubiquitous. They have no idea what theatre really is or what it is capable of. Moreover, students attending high school after No Child Left Behind was implemented in 2002 receive unrelenting indoctrination into a culture of passivity and disengagement.

Last year, I forced a class of thirty non-theatre-major university sophomores to attend any two shows at the New Orleans Fringe

Festival. They were not expecting the art-party they encountered. They didn't know such things existed. Two students described the event as the most important thing that had happened in their lives, but theirs is a culture of hyperbole. Many students previously disconnected from the class became abuzz after the experience. Even students who didn't enjoy the specific work they saw still became hungry for what theatre could offer. I hadn't expected such good results; I didn't realize how thirsty they really were after surviving our denuded K-12 educational system. The new audience is out there, but it doesn't know we exist; it doesn't know that what we do is possible, and it has been trained to not look.

Politics aside, part of the problem is our fault; few theatre makers (myself included) readily connect with millennials, and when we do, we don't often deliver what they need. In promoting theatre, many of us try to cut through the noise of social media and entertainment with more noise and entertainment. For millennials, direct human connection trumps all media promotion. One common reason students take my sophomore-level elective in the first place is that their friends took it previously. Theatre makers, in my experience, highly value personal connection. Yet personal connection means even more to millennials than it does for my generation—I'll be 40 in June—and we struggle to understand exactly how much they value it.

As part of a stipend, one of my MFA playwriting students came to that sophomore class to promote our university's study abroad program. When I asked him to promote his upcoming one-act play at the Elm Theatre here, my undergrad students were quite impressed. They weren't impressed by what the young writer said, but by his presence: a real person who made a real thing in the room with them—a rare treat in their electronic lives. More important, there were nine of my students in the audience on the night I attended the Elm's festival, and a few more were turned away at the door because they arrived at a sold-out show five minutes before the curtain. The festival organizers had done all the things one would hope a well-run festival would do to promote itself. Given that nine people in a sixty-seat house were there because of an impromptu three-to-four-minute talk (and probably twenty students total for the four-day festival), the results of direct connection outweighed the rest of the traditional advertising campaign, which had zero penetration into the lives of my students. A little personal connection went a long way. My millennial students went to that play because they met the guy who wrote it.

Similarly, at some point during the semester one or two students will reveal having seen one of my plays (or having a friend who has), and this direct connection will invariably increase class participation for the whole group, for a few weeks at least. The participation increases because their perception of me shifts from being some sanctioned "expert" (which means nothing to them) to being a guy who actually makes a thing like what they're studying. They care more because there is suddenly a flesh and blood connection to the abstract material. My students grew up immersed in an internet full of experts and quasi-experts that are hard to tell apart, especially for someone systematically denied critical-thinking skills. The way to connect with people who are infinitely interconnected isn't media—it's the immediately human.

These students, born and raised in the digital age (and educated in the contemporary American idiom), believe theatre to be the most sterile productions of Shakespeare, and maybe a little Ibsen, or some long-dead "Greek dude." They don't know the unique things our artistic form is capable of; they don't know why theatre isn't merely the dusty progenitor of film and TV. Unfortunately, too many theatre producers (or maybe theatre donors) don't know either.

Back in the 1950s, experimental filmmaker Maya Deren said that filmmakers should leave stories for the dinosaur of theatre because film could jump across time and space. A footstep could start in an asphalt parking lot and come down in a meadow. She understood the unique things about her art form. (Deren ignored film's ability to be monetized—unlike Hollywood, whose focus on monetization has led film to become the dominant place of storytelling and narrative convention, which is well explored in the *Wall Street Journal* article "The Pay's the Thing: Playwrights Find a Lifeline in Television," March 8, 2015.) Like Deren, Banksy is successful as a visual artist because he understands what that form can do. Banksy knows that simple, well-placed visual images can cause us to re-see a piece of urban landscape and its sociocultural context. I rarely see theatre that emphasizes its most unique elements. Both Banksy and Deren succeed because they understand the core aesthetic problem for an art maker is in creating an experience unique to the artistic idiom.

The best theatre is ephemeral. Miss it, and it's gone. If you miss the next production of *Hamlet* in your city, what are the odds you never see *Hamlet* again? *Hamlet* is not ephemeral. Even if it isn't playing locally, it is on Netflix right now, and YouTube will deliver it to your

couch complete with the snarky postmodern gloss of *Mystery Science Theatre 3000*! In Chicago and New York, the Neo-Futurists' ever-changing *Too Much Light Makes the Baby Go Blind* is ephemeral. If you miss it this weekend, it's gone. It won't be the same next weekend; if you go once a month you'll never see the same show. In New Orleans, the ongoing show *You Don't Know the Half of It* regularly fills the house because it makes the most of our ephemeral art form by pairing off-book actors with improvisers. Consequently, the show teeters on the edge of catastrophe, and keeps the audience engaged because whatever happens next will never happen again.

The best theatre is visceral. It is of the physical body, being in a physical space. The NOLA Project, here in New Orleans, staged a processional retelling of *Alice in Wonderland* in a large art museum's sculpture garden. Audience members could follow one of three characters. Space, location, and the body (of both audience and performer) became intrinsic to the performance. Plus, since there were three paths, many audience members attended three times. Similarly, Brooklyn-based Aztec Economy performed *Butcher Holler Here We Come* at the New Orleans Fringe Festival several years ago, and the production lit a small space exclusively with headlamps worn by the actors. Performers were always within a few feet of an audience member. At one point an actor was running and shouting. He turned off his headlamp, plunged the whole room into darkness, and I could hear him working for breath somewhere very near me. It was a moment of unique tension tied directly to our real, physical bodies. No other genre can do that.

It is well past time to stop focusing on story as our primary artistic element. Stories happen easily on television. There's damn good TV that tells stories. They've got it covered. Conversely, we need to avoid physical spectacle without substance, or we fall from art into entertainment. The artsy looking Cirque du Soleil already dominates one end of that spectrum, and the NFL dominates the other end. We need to prioritize giving our audiences three things: Give personal, give intimate, give immediate.

Millennials don't come to the theatre because they don't know what we can do, and we don't tell them eye-to-eye. When they do come, we often give them what they can get on television. Thus we set ourselves up to compete with television and film. We can't. We shouldn't. The problem is that too many theatre makers sincerely believe they do the things I've been talking about. They do not. We need to offer new

work, written within the last five years, ten at the most. We need to do work that's not being done within 250 miles of us. We need to do work by living authors, who live in our city. We need to avoid work that is primarily about a character that wants something. Make breaking these rules a conscious choice.

If I were an ambitious young producer who wanted to attract millennials to an upcoming show, I'd first make sure my online presence was sharp—ready to reserve tickets, offer clear information across social media platforms, and have a web page that is actually user friendly and up-to-date (this-second-to-date, not this-season-to-date). Then I'd reach out to every college professor within a reasonable drive that might be teaching a class on theatre. I'd find the ones amenable to having the writer, director, designer, or actor come in and talk to the students. Then I'd send folks off to meet the classes and talk about the show, offering students what discounted tickets I could. While such networking is initially labor intensive, the connection is made for the next show, and the next, and the next. Millennials desperately need to look us in the eye, and the classroom is one of the few places where they still physically congregate.

Justin Maxwell is an assistant professor at the University of New Orleans, where he teaches playwriting in the MFA program, the Creative Writing Workshop. His plays have been produced in New York City, Minneapolis, Chicago, and cities across Canada. Justin has published prose in a variety of journals including *American Theatre* magazine, *Contemporary Theatre Review*, and *Rain Taxi Review of Books*.

SETTING THE TABLE

Lenora Champagne

I. Liveness and Engagement

Can one ever assume a "living relationship" between art and audience? We can bring audiences to the table, but whether they eat is a function of their own desire and appetite, or taste for what we have made, for them, and for ourselves.

As artists, we have to make work that has urgency for us. Sometimes that coincides with social concerns, but we aren't social workers or priests. I don't think theatres have a ministry, or a duty to the community, although I think it can be enriching for both theatres and communities to become engaged with one another. Of course, I have witnessed many a play, solo performance, or production that seems to explore the spirit and to speak from it. I think, for instance, of work by Meredith Monk, or a dance by Anne Teresa de Keersmaeker set to music by Steve Reich. I felt a movement of the spirit within the work and within me when witnessing it. (Music and dance, especially, can have that effect.)

In September 2014 I had an intimate experience of the vagaries of the relationship, with varying degrees of liveness, that one can have as a performer with an audience. As part of the Crossing the Line festival (in this case a collaborative production between the French Institute Alliance Française and P.S. 122) I performed in a work by Argentine writer/director Fernando Rubio on a Hudson River pier. Fernando has toured this work internationally, and his is an interesting model. He writes and stages the productions, but keeps them technically simple and conceptually interesting. For this piece, *Everything by My Side*, seven women lie in seven beds. A single audience member joins a performer in the bed, lies down, and hears the text, spoken, sometimes whispered, by the performer.

The range of audience responses was fascinating. Some people closed their eyes and never opened them, not even looking when they left the bed, lying rigid the entire time. Other people teared up at a passage that had resonance for them. One young boy wouldn't leave the bed until his father intervened. Some people said thank you when they left—one woman enthusiastically exclaimed that she was so glad to have

met me, even like this. Of course, she had not met "me," but we had shared something significant—the stirring experience of being moved by liveness, by words voiced that were meaningful to the auditor in this intimate and yet completely public setting.

I've thought about how this project distills theatre into its essence: a space of exchange. A small space—a single bed—it's all we need. That, and a story to tell that can resonate with another. If the audience member isn't open to the moment, it's hard to say the experience is one of liveness, for either party. But if the spectator is open, the performer can be moved, too.

This is no solution for the American theatre as an institution, but it was a valuable reminder to me of how potent the theatrical experience can be when it is an exchange (and not primarily of money—tickets were $5). I believe that theatre that offers ordinary people a degree of participation in the experience—as occasional performers, or perhaps breaking bread or raising a glass together—is very appealing to people in this digital age.

I think of what Diller Scofidio + Renfro did with the new reconfiguration of Lincoln Center—it's all about opening up the building and connecting it to the street, making inside and outside more porous. I think we need to do that with our theatre buildings, and I think we need to do that with our theatres themselves. Some people will never allow themselves to engage, but so many others are hungry for being touched, or moved, or blown away by important ideas and images, possibly presented in radical ways. Theatre has always been a place of dialogue and exchange, a place where debates about how to live have raged. We of course will see that continue on our large stages—because traditional audiences are still interested in sitting down and watching, being moved from a distance. But I suspect that the young, diverse, and nontraditional audiences we want to have exchanges with may prefer to stay moving and talk back, to engage with live art in a livelier way. If we want to bring those audiences in, we may have to go outside—perhaps to a pier on a river, where one is apt to be strolling anyway on a beautiful day.

II. Theatrical Collaboration and Audience "Evolution"

First we have to get people to believe that evolution and climate change are real. Whoa! Doesn't everyone who goes to the theatre believe that? In New York City, yes, and likely most places. But how do we get the

deniers into the house and shift their perceptions? I don't have the answer, but I know that you have to reach them when they're young.

I've never made theatre for children, but I was first hooked on theatrical magic as a child, when the scrim color shifted as Bloody Mary sang "Bali Hai." I thought her beautiful voice made the scrim change color. No matter, the theatrical experience has promised wonder and fascination for me ever since.

Do I think we need to seduce audiences with musicals? No, but I think wonder has its place in moving people from their complacent views and opinions into areas where they may initially be uncomfortable. If we can get audiences engaged in relationships with unlikely partners—I think of New York Theatre Workshop's program where teenagers are paired with elderly people to interview one another and each write a play based on the other's experience—real exchanges and shifts in viewpoints can happen. If we can get young people engaged, and then somehow get their reactionary parents involved, maybe we can slowly move the national conversation to a more progressive place.

III. What Is Made, and How

As an independent artist who has had work presented and produced in a variety of settings, and who has sometimes benefited from grants funding, I find myself increasingly looking outside "theatrical institutions." Yet I am unwilling to resort to crowdsourced funding as an alternative. I'm stubborn, perhaps, in insisting that government funding for theatre is a national responsibility and that access to the arts is essential to an informed and enlightened citizenry.

My work isn't didactic; it isn't full of lessons and morals—but it is passionate, enlightening, and filled with wonder. Should your tax dollars contribute to it being out in the world, or is that strictly the purview of philanthropists and corporations? Can a number of theatres (let's say small theatres) across the country band together to apply for a large grant (let's say a federal one, from the NEA) to feature independent artists from their communities, who then travel to at least one other small theatre to show work and share ideas? Or, more radical—how about if the independent artists apply for the grant and choose the theatres? Artists have their own relationships with their communities—their concerns are perhaps more often than not incidental to the institution's. There are different paths to connecting with communities—and with individuals who experience themselves

as more attached to their cell phones than to their zip code.

One of my students attended a performance at La MaMa by Yara Arts Group, about a city in Ukraine under siege, where audience members had to give up their cell phones and house keys. Everyone was at least momentarily disoriented and uncomfortable. I think that kind of disorientation and discomfort can be useful, if not vital, to reorienting and enlivening perceptions and perspectives, as well as relationships between art and audiences.

Meanwhile, I still sometimes love a big, expensive spectacle with great production values and compelling acting and direction. I like even more an intimate experience of subtle changes, with astute, innovative writing. I think there is room for the whole smorgasbord of possible theatrical experiences in America. We're a big country, with room for everyone at the table.

IV. How Do We Come Together? Who Gets to Set the Table, and Why?

These days, it takes effort to maintain a sense of live community. As everyone knows, media has changed the way we experience the world. Now, my students in solo performance class all want to involve the audience. They want to share experience, to have even a fleeting experience of community.

If you're hoping to engage audiences under forty, encouraging eating and even dancing together *between* artists and audiences in your space, not to mention offering the public a chance to participate in the art-making process themselves, is likely to create more interest and excitement. It is less unusual now for artists to recruit nonperformers to be participants in their work. I've participated in a project that included both professional performers and regular people (with 600 Highwaymen) and recommended others for projects when I wasn't available. Why? It's rewarding. It extends your world.

Community-based theatre experiences have altered my idea of what can happen in theatre, and how theatre experiences can alter your perception of daily life. At the tenth annual NoPassport Conference (March 2016), Lisa D'Amour spoke of her experience, with Katie Pearl and other collaborators, of spending blocks of time over two years in a community of two hundred people in Milton, North Carolina, to make a play and stage a theatre experience in the town, for the town, about the town. Early on, she momentarily was taken aback when she

realized that the people sitting at her table were Tea Partiers. And then the meal, and the conversation, continued.

How do we make theatre for those aunts who send us prayer cards; those uncles who tell reactionary "jokes"? How can we entice others to join us at the table?

Maybe we first have to sit at their table and break bread with them, before we invite them to the one we set. In a world where we can surround ourselves with "people like us," we perhaps need to seek out engagement with people who are different. Don't overlook inviting them to the table—maybe you can make it potluck, so that everyone contributes something. If they won't come to the theatre, think about setting the work elsewhere—on a pier, on a riverbank, in a park. It can be a picnic. Just don't forget the food—something nourishing, thought-provoking—gather round and chew on it. We can aspire to create an experience people will want to continue discussing after they leave the table.

Lenora Champagne is a playwright, performer, and director. She edited and contributed to *Out from Under: Texts by Women Performance Artists* (Theatre Communications Group, 1993), and has been published by Smith and Kraus, Performing Arts Journal, and the Iowa Review. She is professor and coordinator of theatre and performance at Purchase College. Her play *TRACES/fades* is published in *Plays and Playwrights 2009*. Her newest book is *New World Plays* (NoPassport Press, 2015).

CHALLENGING "EXCELLENCE" IN AMERICAN THEATRE

Richard Montoya

Late last year Culture Clash had just closed the sprawling *Chavez Ravine: An L.A. Revival* for Center Theatre Group (an eventual Ovation Award winner for production of the year), while only weeks later opening the more muted and self-directed *Muse & Morros* at ArtsEmerson in downtown Boston (named one of the top five productions there by *Fuse Magazine*). While *Chavez* spanned five decades of L.A. history, *M&M* required smaller brush strokes from the CC toolbox to etch in detailed monologues of real people and true stories from the margins of America.

Your CC brothers of a certain age are moving swiftly across the U.S., keeping pace with the day's headlines on race and class. In this, our speeded up time and endless news cycles, we're reporting our urban excavations back to an audience as fast as we can. There are three Latino men onstage in the American theatre tonight, and they're not the janitorial crew or hiding from Donald Trump! Though we very much respect all the maintenance sciences and custodial facilitators even making their stories a part of our theatre.

While *Chavez* played to sold-out houses, fostering nightly discussions about race, class, gentrification, communism, gender, baseball, and, in the end, a sense of shared activism or justice inherent in the body of our work—we were often perplexed by a sort of riddle: If a show could unite and inspire an audience, how then do we better understand and dialogue with critics, donors, board members, and frontline technical staff who are often the very ones defining, running, measuring, and holding up the gold bar of excellence against which much of American regional theatre is measured? How do we as the hot-blooded creators of our own work better assert ourselves clearly without offending those with whom we work closely, whose political views may differ from ours, and who react to our nation's crises differently than we? Do they care? Can we make them care? This we call the show inside the show—the play within the play—full of actors who, yes, look different than us.

David Dower of ArtsEmerson helped us dissect this riddle over a

cocktail following a show there as we were bracing for impending bad reviews for *Muse & Morros*. We've been receiving horrible notices for a decade now, complete with some borderline racists language, like the graduate student reviewer who entitled himself to use the term "Chink-y-face" in a New Haven review of *American Night* at Yale Repertory Theatre.

We began to break down the very apparatuses of American theatre and an institutional notion of excellence that theatre makers like Culture Clash may not neatly fit—a culture of excellence, built by and maintained by critics, donors, subscribers, and academia, and carried out by theatre staff.

Mr. Dower unlocked for us something we were doing without realizing, perhaps: Along with others, we challenge and question the very apparatuses that hold up U.S. regional theatre. I suspect we may be carrying different measuring sticks with which we measure the importance of our works as well. It's a many-fronted battle, too—nuanced, polite, yet bloodied at times.

Following a *Chavez Ravine* Kirk Douglas Theatre town hall, moderated nightly by the committed Public Engagement Crew at Center Theatre Group, Luis Valdez was asked a question. I paraphrase his response here: Valdez asked the audience to consider what theatre or playwright defines us most as a nation. Noting Kabuki theatre of Japan and its early masters, Shakespeare for the U.K., the Greeks and Brecht certainly flashed in my mind, and I wondered who we are as a nation through the prism of our theatre? Certainly Wilson, Albee, Miller, Shepard make sense—but so too must Nottage, Kron, Alfaro, Miranda, Guenveur Smith, and Son!

We'll continue to take to the nation's stages as we did the nation's streets to claim *our* history, our justice, until we see ourselves reflected in our nation's history and in her theatre, which was one of Valdez's sharp points.

Building and sustaining audiences will always be a challenge—but so too is demanding diversity of those who review, those who sit in the board room, those in stage management, and those in the Ivy League MFA theatre programs.

Every regional theatre is a culture. Some cultures are vibrant and inviting and some are dead zones of old ideas so set and rigid in their ways they push you out the stage door before final tech is completed. Some operate on a near pay to play basis—if the resident artistic director does not direct your play, your (new) work will never see the

light of stage specials—whether you wanted that director or not.

Culture Clash flourishes in the vibrant cultures of theatres and institutions that invite us to contribute to and challenge a more fluid and changing definition of excellence—as is true of Yale Rep's James Bundy, Oregon Shakespeare Festival, and the Getty Villa to name a few.

ArtsEmerson is also such a fluid space to work, and may be leading and inviting the conversation. Their idea of excellence still is evolving, allowing a group like Culture Clash to be a part of a definition with what is onstage, but also in public engagement, community outreach, and even marketing. The excellent *Tristan & Yseult* left here with a singular production, while the much smaller *Muse & Morros* was allowed to shine along side it. We received no less attention and support from the artistic, academic, and amazing technical staffs here.

Neither were we looking over our shoulder or worried about comparisons so much as enjoying a presenter allowing us to *be*—to do our thing, strut, engage, build, and find an audience here.

And we leave here better artists, energized and with a spirit renewed in the power of theatre and those that create, produce, and manage. Dower and Polly Carl and crew allowed us to contribute to their idea of excellence with our nightly ritualistic and ceremonial wrestling with Ferguson, Isis, Trump, and the borders of countries and gender.

Transforming the theatre is what I mostly saw at ArtsEmerson under this leadership. They are honest and ethical, too, in their transformation. Our comrades from ArtsErmerson and *HowlRound. com* are expanding our grasp, deepening our work, our voice, with the depth of their toolbox, wisdom, and educational capacity freely offered *up*, giving us agency and tapping our shared authenticity and commitment, which The People in the outlying neighborhoods and barrios sense and feel with a wisdom all their own. Boston can still be a tough town on people of color. We've known David Dower nearly all of our thirty years, and we owe him a cocktail and a *salut*, *along with* the young, brilliant kids we met from Roxbury to Hyde Square and the Latino Theatre Commons—a huge thank you for a true and rooted exchange. GRACIAS!

Hey, Father Greg Boyle, the tireless Jesuit/angel of East L.A. and former roommate of Bill Cain, is a knowledgeable theatregoer. Surely we can trust his higher notion of excellence. He recently sent

this note backstage:

> Give my *felicidades* to everyone at *Chavez Ravine*. It was
> a tremendous evening.... Thrilling, moving, hilarious, and
> a completely engaging time.... A sacrament and liturgy....
> Everyone felt called to connect once again to each other and
> to their own awakened hearts.
>
> As always, I'm humbled by the kindness you guys extend
> to me (and the Homies).
>
> Count on me for anything. Ever. Much love, G!

Father Boyle's words embolden us to consider, challenge, and create our own notions of excellence in American theatre.

Richard Montoya is an L.A.–based playwright/filmmaker. He is cofounder of the trio Culture Clash and solo author of *Water & Power*, *Palestine, New Mexico*, *American Night*, *The River*, *Federal Jazz Project*, and *Anthems*. Collaborators include Sean San Jose for *Nogales*; performer/writer Roger Guenveur Smith for a project for Center Theatre Group; and Diane Rodriguez. He is a Sundance Institute alum, an Annenberg Fellow, and a McDowell Colony Fellow. Feature films: *Water & Power*, new films, and failed TV projects.

THE DREAMS WE MAKE

Madeline Sayet

Is it worth selling tickets if it's hurting people?

This question initially popped up due to the current prevalence of redface on the American stage, instead of authentic indigenous representations. But that is not where the question ends. Bullying is prevalent in theatre; it inflicts mental and emotional harm as it moves within and amongst our circles. Spaces that we imagine as spaces of light and healing thus become incredibly destructive.

The word bully originally meant lover. How did it devolve? How did we? We came into this business to inspire. But with the power to create comes the greatest power to destroy.

We create dreams. We place people in a dream state while wide awake. But with the power to create dreams comes the power to evoke hatred and destruction and nightmares. Carelessness is not affordable. Those dreams become nightmares when we forget to operate with respect.

Art and politics are entwined. We must be ever listening to our environment. Diversity and inclusion ensure balance—acceptance for everyone in the sacred hoop, in the circle, in the world. The world's greatest plays are those that incorporate the whole world around the storyteller: the good and the bad in a way that creates new ways of listening to the world around us—listening with respect. In a business where we construct universes, moving people around like pawns, it is very easy to let objectification dominate the narrative.

Especially when we have fewer and fewer players to work with. We all know it's cheaper to produce a play with a five-person cast than a fifteen-person one. When Ethan Zuckerman spoke at the TCG Audience (R)Evolution conference, he cited a steady decline in trust in the government that has been escalating ever since the decision was made that instead of one government representative for every 30,000 people, it would be one for every 700,000. People want to be heard. Could limits in cast size have created similar effects?

The personal relationship in theatre is not only communion with the actors, but with the rest of the audience. The potential audience is the entire community. We go to the theatre for a shared experience. Every breath we take, every chuckle we utter, shifts that ever-changing

artistic landscape. It is a space of heightened listening. It is one of few in which we still turn off our cell phones. How do we listen back?

When I speak at a conference, people frequently approach me afterward with the compliment of how "articulate" I am. I am a director, who frequently lectures at universities. It is my job to be articulate. But in the context of diversity and inclusion this particular compliment sticks in my mind funny. No one says that to male artistic leaders.

The compliment is inextricably linked to the societal assumption that young women are predominantly inarticulate. It brings a particular image into focus for young women: one of weak-mindedness, wanness—inarticulate. An ingénue.

When I was sixteen, I was cast as Juliet in a production of *Romeo and Juliet*. Thrilled, I immediately began work to lose fifty pounds for the role.

Why?

No one told me to do it. But the image of Juliet seared into my imagination was a girl who looked nothing like me. No amount of talent would make me her. It was an external concept.

As bit by bit I vanished, some people were concerned, but most complimented me for how good I looked and wanted to know my secret.

My *secret* was how often I was fainting. Because my life didn't mean as much to me as looking like her.

I would never look like her: an imaginary thing that had been constructed as the ideal that I wanted to embody and to inspire other girls to be like.

I wanted to be beautiful, so I could die for a man.

That ideal makes us inarticulate. Our brains malnourished on the dream of being someone who can only be fulfilled by others. Many of my friends have serious health problems now because of time spent fasting in the hopes of looking *correct* onstage. Because of the time we spent on self-loathing instead of self-care.

How many girls dream of being onstage? How many girls follow these same patterns? How many of them are brilliantly articulate, but not valued for it? This is a story many of us share.

Juliet was originally played by a *boy*. There is no reason that that image should have waiflike female forms attached to it.

A close friend of mine who is in her early twenties was recently cast as the mother of a teenager on a television series.

Unrealistic ideals much?

It took me a long time to realize that I could effect more positive

change in the world by *doing* than by *looking* right—if all of the commitment and precision of not taking another bite was put into my work instead.

I grew out of it, because of the strong women I saw around me in the world. Many don't. Is it not our duty to provide examples of those women on the stage? Agency: How do we de-objectify ourselves and others? It is necessary to create with respect.

Have you ever seen a character casting description that does not reference looks, weight, race, gender, disability, age, etc.—but simply says: "powerful," "confident," or "brilliant"? Think of what amazing creative choices would open up if we were able to cast the human being, not the outward appearance.

How are we hurting ourselves? Can you see the bullying? The times when self-loathing is instigated? If we cannot, perhaps we need to rediscover how to listen. All the noise in the world right now makes it truly difficult. But, if we do not reflect our audiences with respect, they will leave us.

"Is it worth selling tickets if you're hurting people?" The stereotypes and caricatures of redface are a barbaric practice left over from a perceived need to dehumanize a race of people for arcane nationalistic propaganda. Those days are gone. People need neither utilize those depictions nor become so afraid they remove all Native representation from the stage. Both are equally nullifying. The latter means ignoring Indians. Those who are ignored lack perceived value. Ignoring people is also bullying.

So is there another path?

Juxtaposed with the idea of bullying in theatre, is that of Story Medicine. I define Story Medicine as an act of healing or deeper understanding ignited by the sharing of a deep, personal truth. Human-to-human connection.

An example is Kansas City Repertory Theatre's production of *Hair: Retrospection.*

I never understood *Hair.* My mother loved it, but I could not see beyond the generational divide. When this performance began, I was shocked that only part of the cast was young. This brilliant production tracked the narratives of performers who had been in the original production back in the sixties. As they stepped forward and shared their hearts, I developed a love for the story and songs in a way I never could before. Their truths took me on a journey to a time and place, a way of living and understanding the world I never knew. Story

Medicine. Or as my great-great uncle, Chief Tantaquidgeon, used to say, "It's hard to hate someone who you know a lot about."

Let the stage mirror the world. Let it expand our imaginations and ways of knowing. The majority of people are told there is no place for them onstage. These so-called minorities are the majority. Checking boxes is not holistic. Tiny knives are cutting through society, breaking us apart. What we are looking for in the American theatre is *balance*.

Breathe in. Breathe out.

Expanding our ways of listening can bring in new audiences who never knew theatre was a place for them. Find the Story Medicine. Put everyone in the circle. If we listen to each other's stories, with open hearts and respect, we will find stories we could not imagine on our own, that increase our oneness as human beings. We will find balance and a safer world for all of us—a world where we are allowed to exist and dream together.

In *Sliver of a Full Moon* by Mary Kathryn Nagle, the Native women who testified to get the Violence Against Women Act passed step forward and share their stories of survival with the audience. They are not performers. They are sharing their truth. These stories changed the world and enabled a move toward protection for Native women. Story Medicine.

Shakespeare's brilliance was in adapting the classics to fit the needs of his moment in time. In nuance. In listening. In catering to all his possible audiences.

Taken out of context, the work changed. When America was colonized, we indigenous peoples had vast oral traditions, stories that changed each time we told them to an audience. The colonists prized the Bible and the work of William Shakespeare. That bridge began the American theatre.

Our importance as artists lies in our ability to sculpt the narrative of our times. In our ability to listen deeply to the now. We can make this a time for healing. Stories have always been used as medicine in the world.

Balance.

Breathe in. I am.

Breathe out. We are.

Is it worth selling tickets if it's hurting people?

We can't know who we are hurting if we do not listen—if everyone is not allowed to speak. Maybe if we listen with an open mind and open heart, we will hear something more clear, concise, and articulate than

we could have dreamt up otherwise. But we must listen with respect.

I played Juliet again this year, without the old preconceptions. She is not inarticulate. She just gets ignored.

So drop your expectations. Drop your agenda—your need to make everything work perfectly, as you move the puzzle pieces around onstage. Just for a moment bring back the respect. Listen. And feel how freeing and expansive it is.

Madeline Sayet is a TED Fellow, a recipient of the White House Champion of Change Award, a National Arts Strategies Creative Community Fellow, a Van Lier Directing Fellow at Second Stage Theatre, and the resident director at Amerinda Inc. (American Indian Artists). Recent directing: *The Magic Flute* (Glimmerglass Festival), *Macbeth* (New York City Parks), *Daughters of Leda* (IRT Theater), *Powwow Highway* (HERE Arts Center), *Sliver of a Full Moon* (various), *Miss Lead* (59e59), *The Tempest* (Brooklyn Lyceum/Sylvester Manor). Upcoming: *Poppea* (University of Illinois), *Winter's Tale* (HERE). BFA Theatre, M.A. Arts Politics, New York University. Ph.D candidate Shakespeare and Creativity, the Shakespeare Institute.

WHEN YOUR PLAY IS SET IN A
YARN-BOMBED HARDWARE STORE

Callie Kimball

My play *Alligator Road* premiered last year at Mad Horse Theatre Company in Portland, Maine. It centers around a white woman's act of reparations for slavery. It's set in central Florida's oldest hardware store, where Kathy, a recent widow, has yarn-bombed all the hammers, saws, and paint cans. It's a gesture of whimsy before she hands the store over to a stranger. But when Kathy's daughter arrives, she'll do anything to stop her mother from throwing away the family store. It's a comedy that unravels ideas about privilege, entitlement, and the price of freedom.

Working on this play with Mad Horse Theatre was an absolute thrill in terms of community engagement. Because the set was a yarn-bombed hardware store, we had a huge army of knitters working feverishly to create cozies for all of the tools and props in the store. We had only four actors in the play, but a dozen knitters!

P.S., I'm white. What made me think I was qualified to write a play about reparations? I was worried my play would embarrass me by landing squarely on the continuum of white savior movies. But I kept writing, because I believe when we talk about race we have to be comfortable not having answers—that there is value in questions. We have to forgive ourselves and each other if we say the wrong thing. Basically, we have to be open to learning—which requires humility.

I love putting characters in extreme situations where they have to think on their feet. With *Alligator Road*, I want an audience to watch average people stumble through discussions of race while guarding their self-interest. This is not a didactic play. I want people to take a ninety-minute ride of negotiation and defensiveness, and to leave the play thinking about race from a wider point of view. It helps that Kathy, the woman who gives away this hardware store, is a deeply flawed character with less than pure motives for giving away the store. It also helps that desperate characters are often funny characters. When an audience is laughing, their guard is down.

But back to the yarn. Before I tell you how we folded the glorious Portland knitting community into our process, I want to share the

spark for my play and what it sprang from, so that when I tell you how the play operated in our local community, you'll have context.

A Fur Coat, a Train Track, and Yarn

The spark for the story that became *Alligator Road* came in 2012 while I was still in New York. I was living with no kitchen and two cats in a studio apartment on the Upper East Side, and had just finished grad school while working full time.

I had long noticed in my neighborhood that the people running the grocery and drug stores and guarding the boutiques along Fifth Avenue were mostly people of color, while the customers were mostly white. No one seemed to comment on this; everyone just stood on both sides of the cash register, accepting that this was how things were.

One day, I was on my way home from a spa on Madison Avenue, thinking how weird my life was—that I grew up on welfare but was now a person who had just been to a spa on Madison Avenue. It was a beautiful day, and as I walked I thought about the neighborhood I lived in compared to more diverse neighborhoods like the Bronx or Washington Heights, where I lived when I first moved to New York. I remembered how invisible I had felt in the Heights, until someone took care to explain to me that no one wants the kind of trouble that comes from messing with a white woman. At the time, the explanation felt bizarre and sad to me, but I couldn't say it was wrong, because how could I know? Maybe as a white person I was a symbol of everything that was wrong with gentrification. I'll never know, because a few years later I moved closer to work, in a neighborhood where my neighbors were largely white.

Anyway. These were the kinds of things I noticed on my long walks through the city.

As I was walking and thinking how people of different races are treated depending on context and geography, I passed a white lady in a fur coat. And suddenly, I realized *I* was assuming that people like *her* didn't think about race other than whatever stereotype you might ascribe to A White Lady in a Fur Coat. And I wondered what would happen if such a woman *were* to believe in reparations for slavery, and decide to give away her family fortune. How would her children react? This seemed like the spark for a play I could spend some time with.

I soon realized that the story would have more relevance if the white woman were resolutely middle class, a small business owner. I knew

that if I made her wealthy, it would be too easy to dismiss her, to write her off. Rich people are great for satire, but not for what I hoped my play would do.

A few days later, I was in Long Island City to see a show at the Secret Theatre. One of the things I love about New York is that because you walk everywhere, you get a peek at the city's infrastructure. I was walking beneath an elevated train track, and I realized everything on that street had been built by working-class men, men who brought their lunches and drank coffee and took smoke breaks while they built everything I was walking on and past and under. And I started thinking about my play, and how a woman who owns a hardware store might have something interesting to say about reparations, about buildings, about entitlement and inheritance.

And then the yarn-bombing hit me. I always look for layers to fold in, and I especially like to smash juxtaposing elements against each other. That's how one of my favorite beats in the play came to be.

> KATHY: Well see, here's the thing. The men, they go and build everything. I mean every home or store you see, that you drive by, has been put there by the hands of men, brick by brick, block by block. They've poured the concrete and hung and sanded the drywall. And these men, they die, but the buildings, they stay. And that got me to wondering, what do women make? Well, women make clothes and pretty things—
> CANDACE: Oh my god you are SO.
> KATHY: No I know I know, not every woman, and there are women carpenters and they're not all lesbians, et cetera et cetera I know—BUT in the traditional way of things for thousands of years up until real recent—I mean your Gram sewed all my clothes when I was little and that was as late as the seventies. So back to my point, all these men die but their buildings live. But women die, and the things they make die, they fray and disintegrate into thin air. There's nothing left, their legacy is invisible. And they made everything with such love...and sometimes anger, but mostly love I think. And so it just seemed kinda, I dunno wild to me, just a lark, really, I thought what if I cover all these tools and ladders and buckets of paint with beautiful bright yarn. It just seemed...I dunno...

You have anything like that? A hobby?
LAVINIA: I like to press dried flowers into pictures.
KATHY: Oh! I've never heard of that. You mean like...
LAVINIA: Into designs. Like, patterns.
KATHY: Oh. That sounds nice.

What's curious about this beat is that Kathy never once considers, in her contemplation of what women make, that they make babies. They make people. But being a mother doesn't really track for Kathy, and that part of her character is revealed by what she leaves out of this monologue.

So. Now you have the ingredients that sparked my play—a white lady in a fur coat, an elevated train track, and yarn-bombing.

Yarn Party!

Fast forward to the start of rehearsals. Director Reba Short and I quickly discovered that we were on the same page about how to work together. It basically came down to respecting each other's swim lanes, and more than a few bottles of wine—also known as Collaboration Juice. One of the gifts Reba gave me was two weeks of table work so that I could hear the play, bring in new pages, and listen to the actors as they made discoveries and asked questions. This is gold. I don't always get this, but when I do, boy will I use that time.

During those two weeks, The Knitters arrived. I don't think I've ever seen twelve people more excited to have a reason to knit. And boy did they have a big reason. We needed an entire set to be covered in yarn. This was a job that only they could do for us, and we all knew it. People like feeling needed—sometimes we forget that, I think.

The knitters sat in on our first few readings, and so they heard new pages as I brought them in. Our Knitting Wrangler, Megan Tripaldi, checked in with them on breaks, but otherwise everyone quietly worked and listened. It was a surprising and lovely thing to have women of all ages (and one man!) surround us while they knit, a ritual circle between our creative work and the outside world.

The knitters responded and laughed just as an audience would, which was a terrific gift to my playwright's ear, confirming certain choices and pointing me in new directions. After each reading, a few knitters would usually linger to offer thoughts or ask questions before scurrying into the chilly dark with their knitting homework.

Of course, the time soon came to start rehearsing in earnest. We let

the knitters have their own room in the theatre where they could gather and knit and get to know each other—they called it a Bitch-n-Stitch. I confess I was torn about which room I wanted to be in some nights.

Bit by bit, pictures of their creations would make their way to our rehearsal room, where we would squee over them. A photo of one of the most fantastic pieces, a sledgehammer in a knit cozy, made its way into our publicity materials.

When we headed into tech, we wondered if we had enough power tools, but we definitely had enough knitted material! Megan took all of the knitted rows and stitched them together to wrap each tool in the store, including a table saw. We invited our group of knitters to a special preview performance of the play, so they could see the result of their hard work, and also see how the play had changed—it had a whole new ending from what they had heard when we started.

Having a committed group of knitters creating the set dressing and being part of the process from day one added an extra layer of meaning to the process. The fact that some knitters were beginners, while others were more experienced and had fancy knitting tools didn't matter, because Kathy, the woman in the play who's knitting everything, certainly doesn't have to be a good or even consistent knitter. It was terrific watching these generous souls come together to help build the world of our play, and in doing so, create a community for themselves.

But Wait! There's More!

Another unexpected outgrowth of this production is that Megan Grumbling, an English professor at Southern Maine Community College, had her students read my play and then come to the show. Afterwards, I visited her class to discuss their response to the play. Some of them had never seen a play before, and so we talked about the process of getting a new play on its feet. When we got to the meat of the play—reparations and entitlement—their candid questions and opinions were refreshing and challenging.

We had even more outreach happening—we were featured on a local TV news arts segment the day we opened, and we reached out to our local NAACP branch as well. We had a talkback after one of the matinees, and while we discussed inviting experts or scholars on the topic of reparations to participate, we decided to tread lightly because not everyone could agree on how to frame the discussion. I do think there's a huge opportunity for future productions of the play to involve

a larger and more diverse community in programming complementary audience-engagement events.

It was exciting to be part of a theatrical happening in the Portland community that blossomed in so many unanticipated ways. The production had a groundswell of interest and support from people in our community who otherwise might not have come to the theatre. The fact that this play trades on the unrealized dreams and mistakes of women made it even more meaningful that a group of women came together to build its world. Sometimes it feels like women are invisible in the theatre; you have to look to find them in support roles backstage or as minor characters onstage, even though reports show it's often women who decide what plays to see. It felt like this play was for them, the people who so often connect us biologically and socially, who stitch together meaning and keep things from unraveling.

There was a wonderful, transformative sense of purpose and power that supported the whole endeavor. My hope is that by watching characters they might identify with, our audience left the theatre with curiosity and fresh ideas of how to talk about the complex issue of reparations.

Callie Kimball's plays have been produced and developed in New York, Chicago, L.A., and D.C., at Team Awesome Robot, Halcyon Theatre, Lark Play Development Center, Drama League, the Brick Theater, Project Y Theatre, Absolute Theatre, Washington Shakespeare Company, the Kennedy Center, Mad Horse Theatre Company, and elsewhere. She's received a MacDowell fellowship, a Playwrights' Center Core Apprenticeship, the Clauder Gold Prize, a Ludwig Vogelstein Foundation grant, and the Rita and Burton Goldberg Playwriting Award two years in a row. She earned her MFA at Hunter College, under Tina Howe and Mark Bly. She splits her time between New York and her home in Maine, where she teaches playwriting at the Maine College of Art.

RELAXED PERFORMANCES, "CRIP TIME," AND ACCESS FOR ALL

J.J. El-Far

In January 2014, Emily Colson and her twenty-three-year-old son, Max, who has autism, made news when they went to see the *Muppets Most Wanted* in a cinema in Kingston, Massachusetts, a suburb south of Boston. As the movie started, Max had an outburst, and his actions attracted the unwanted attention of the other moviegoers, who quickly turned on the pair, eventually jeering them right out of the theatre. Colson tried to explain that her son has autism, but the response she got was, "Why should others have to suffer?" Colson wrote a blog about her experience, which prompted her community to stand up to this kind of intolerance, and as a result, they rented the theatre for a private screening of the movie for more than three hundred young people, many of whom had learning or social disabilities like Max. Awesome.

In the last few years, families in the U.S. have benefitted from a surge in "autism friendly" and/or "sensory friendly" offerings in not just cinemas, but theatres as well. Notably, Theatre Development Fund has made major strides with their Autism Theatre Initiative, which provides unique access for families with autistic children to Broadway shows such as *The Lion King* and *The Curious Incident of the Dog in the Night-Time*. They recognized a need from an exponentially growing community, where, according to the CDC, one in sixty-eight children (one in forty-two boys and one in 189 girls) have autism spectrum disorder (ASD). Many theatres in the U.S. have adopted similar policies, offering subtle changes to production elements, chill out rooms, and visual story guides to create a welcoming experience for these families, so often ostracized from participation in cultural events.

But what about other people, namely *adults*, who also have other disabilities that make it difficult to sit still in a darkened theatre for an extended time in "hushed reverence"? British performance artist Touretteshero, a.k.a. Jess Thom, has become a leading advocate for a new kind of policy that builds on these offerings to include a broader range of people with disabilities. She challenges theatres to consider if they are really as inclusive as they claim and, if not, who are they excluding? Thom, whose involuntary Tourette's tics have made for

some uncomfortable situations in her theatregoing past, believes that the British practice of Relaxed Performances offer a real solution for anyone who falls into this wide category.

Relaxed Performances (R.P.) have been championed by U.K. theatres like the National Theatre and the Royal Shakespeare Company. These performances provide a relaxed attitude toward moving around during the performance and, as the National Theatre puts it on its website, "the atmosphere is, perhaps, the opposite of the quiet carriage on the train." The National Theatre not only considers the needs of audiences with these kinds of sensory and communication disorders, it really sets the bar high when it comes to providing access and inclusive practices to accommodate individuals with visual and hearing impairments, as well as providing detailed information and accommodating individuals with physical disabilities. If you have ever spent time with someone with a physical disability, you realize how important this information is, and the fact that it is clear and easily found on the National Theatre's website allows for greater access all around. What's more, they don't take a "one size fits all" approach to accommodating different disabilities, understanding that different challenges require different tactics. It is this kind of active, intentional inclusion that we in the American theatre talk so much about and still have trouble implementing.

In 2014, the British Council supported a collaborative event between the U.K.'s Live Art Development Agency and New York City's Abrons Arts Center called "Access All Areas: NYC." The day featured speakers, performers, and artists with various disabilities (such as Mat Fraser) showcasing their work, and offering a kind of portal into the daily reality of living with a disability. Things like restroom access, door handles, table height, and, significantly, the time allotted for breaks and transportation, were considered. Throughout the day the presenters referred to themselves as being on "crip time" only semi-jokingly, revealing that when it comes to actually getting around and participating in public life, people with disabilities sometimes have more involved in their transportation. Thus, venues and companies that "get it," know that they have to either give more than a ten-minute intermission to accommodate their entire audience, or make special provisions for those who require assistance. My infinitely supportive and wise mother joined me for this event. As a teacher for special needs students, some of whom have autism, some who are in wheelchairs, and some with various other developmental disabilities, she found

herself really connecting with the concepts of "crip time," as well as Relaxed Performances. "Why don't we have this here?" she asked. *Great question, Mom.*

In October 2015, the British Council invited staff from the education, marketing, front of house, and artistic programming departments of several major theatres including Brooklyn Academy of Music, the Public Theater, and Lincoln Center, as well as Theatre Communications Group and Theatre Development Fund, to a two-day intensive training with Include Arts, led by Kirsty Hoyle, the U.K.'s leading expert on implementing Relaxed Performance. In attendance were also representatives from the Colchester Arts Centre, the National Theatre, and Shakespeare's Globe, who have each adopted the R.P. policy, and could speak about their own experiences with it on a peer-to-peer level with their U.S. counterparts. The result was very positive, with BAM and Lincoln Center now each taking up R.P. for their future shows. What's more, TCG invited Kirsty and the British Council to lead another training session at its annual conference in Washington, D.C., to spread the idea and encourage more theatres to take up the policy. To further this end, the British Council will also roll out a new program offering bespoke training sessions to American theatres with Include Arts beginning fall 2016. (O.K., yes, shameless promotion—but cool, right?)

In the American theatre, we spend a lot of time thinking about marketing and audience development. We wonder how we can make the theatregoing experience more cool, more comfortable, more flexible, more competitive, and more active for the audience. What about starting with accommodating the large population of people who simply cannot access or participate in the theatrical experience due to physical or developmental disabilities? This is more than an issue of targeted marketing, more than simply building wheelchair ramps and calling it a day. It is more than conventional or even expanded understanding of "diversity" and audience development. The challenge with bringing people to the theatre, even people without disabilities, is only half about how we reach them. The other half is about the experience they have once they get there.

What rights do these members of our audience have when it comes to their experience of attending the show? Above all, they have a right to be physically comfortable and have the same basic access to the production as everyone else. Producers should consider our audience's level of comfort and access as a crucial element of the theatrical

event, because even if the play is extraordinary, no one will be able to appreciate the story if they are mortified from being unable to climb steps, can't find or access the toilets, or cannot see or hear what is happening. The role of the producer is to attract and then take care of the audience. They are the ones throwing the party and everything from the transportation, to the accommodation and refreshment, to the other people we interact with while there are the responsibility of the host; these things all matter. The producer must think through this entire journey to make it exciting and innovative so that people have something to look forward to and something to talk about after.

Don't forget—audiences are smart. Particularly in areas with robust theatrical offerings, your audience has other options. They want what's cool, what's new, and they want an experience to tell their friends about. Attending a Relaxed Performance would also appeal to anyone not interested in the traditional way of experiencing theatre. You could call it being part of an "extra-live" show. This doesn't mean texting during the performance, but it might mean not worrying if your laughter or responses to the show are going to be shushed by an uppity fellow audience member (see Dominique Morisseau's article in *American Theatre* magazine: "Why I Almost Slapped a Fellow Theatre Patron, and What That Says about Our Theatres," December 9, 2015). The minor adjustments made for R.P. make a world of difference to those for whom the theatre is an otherwise unfriendly place, and might be either welcome or not minded by the audience who chooses to attend that performance—not only providing novelty within the experience, but also creating understanding and inclusion among all attendees.

Going to the theatre is a practiced ritual; a group of strangers is made to sit together for a period of time, experience something together, and for a brief moment—and only if you're lucky—experience transformation, and then go back to their individual lives. If the theatre is our home, then we should treat our audience the way we would treat our families—with care and respect, because not only do we want them to come in, we want them to stay.

J.J. El-Far is the arts officer for the British Council USA, as well as the cofounder of the Harlem Arts Festival and a 2012 TCG Young Leader of Color.

WHERE ART IS EQUAL

Dipika Guha

Novelist Amitav Ghosh's entry into the world of literature began with his grandfather's bookshelf. In his Pushcart Prize–winning essay, "The Testimony of my Grandfather's Bookcase," Ghosh describes its contents as ranging from nineteenth-century masterpieces (Dostoevsky, Flaubert, Hugo, etc.) to Joyce and Faulkner, to the more obscure Knut Hamsun, Marie Corelli, and Grazia Deledda. "Their names," Ghosh writes, "have become a kind of secret incantation for me, a password that allows entry into the brotherhood of remembered bookcases."

In thinking about theatre and audiences, I immediately recalled this essay—one that I'd first read as an undergraduate. I remember a phrase I must have coined myself to describe my own wonder-filled relationship to the books that lined my own grandfather's bookcases (like Ghosh's grandfather, mine was also Bengali—a fact that we'll return to later). *The egalitarianism of the bookshelf,* I remember thinking. It's a place where all books are equal. They have equally assigned space, equal amounts of dust gather on their sleeves and (here's the leap) owing to their proximity to one another some grandfatherly type must have considered them equally worth reading. At the time, I was very pleased with this piece of literary analysis. Especially because it explained a condition I shared with Ghosh. Amidst the Russians, the American realists, the Victorians, and a smattering of bestselling Jeffrey Archer novels, as a child in pre-cable-television India, I found myself.

The summer of my twelfth year was the summer of Thackeray, Somerset Maugham, and Enid Blyton, a staple of many children of my generation in India. On the one hand, I'd like to think that the great and specific ways in which these books differ from each other allowed me the space to find myself in them. On the other hand, this is of course the legacy of colonization in action. I was raised in India with English as my first language. So the space most precious to me as a child, my *imaginary space*, was filled with the wonder of Cornish scones, magic faraway trees, and caravans. Ghosh did his precocious reading in the sixties, and I did mine in the nineties. And yet, the similarity of our experiences as readers and the contents of our bookshelves is striking. It has made me wonder....

What is it that makes us feel welcome in art and literature?

What makes us feel at home?

What allows us to imagine we might have a relationship to literature?

Who holds the key to this sense of permission or access?

And what is it that encourages us to return to art? To come back even if we have, for a moment or several years, left it?

Are the answers different for the novel than for theatre?

So what does make us feel welcome in art and literature?

I found myself thinking a great deal about proximity. I was at my own grandfather's bookshelf every summer for much of my childhood.

And boredom. Over the summer, the length of my grandmother's siestas added up to the length of a Victorian novel.

Leisure. Which, in childhood, means boredom, but it has a place here because unlike the teenage girls who slept deeply on the floor beside my grandmother during her siestas, I had not spent the day cooking and cleaning.

And about a tie to ownership. Ghosh tells us he discovered that the books on his grandfather's bookshelf belonged to a mild-mannered uncle. Mine belonged to my mother. When she married my father, she left her books at her mother's house along with her old life. This tie was soothing—her notes always in the margins.

And displacement. Who doesn't want to escape their own meager childhood life? I yearned for adulthood. And also, in some way, for England; her words were already planted deep in my consciousness.

Finally, location. I mean both where books are kept materially and also where they're set. I had a direct and tangible relationship to the physical books. I knew they'd always be there. I came to know the order of their spines against each other. Because I knew where they were, I could always find them and so I could always find myself through them. And novels are nearly always set somewhere. The process of 'going there' is one that's contingent on the imagination and little else. The books, once in my possession, asked little else of me.

Who holds the key to this sense of permission or access to theatre?

What makes us feel at home?

How much harder with theatre!

Proximity. You have to be near the physical space. Or near-ish. Or near enough that some willful grown-up might take you.

Leisure. That same grown-up someone has to have time not cleaning or cooking or working (not to mention the means) to scoop you up and take you.

Ownership/Inheritance. Unlike a book you can hold in your hand, your sense of ownership to the physical space is confined to your memory of your experience (playbills, I'd argue, do not conjure up the kind of sense memory that books do).

Displacement. Most theatre artists report a moment of falling in love in the theatre. It's often a physical moment, where the sense of recognition is corporal and not purely intellectual.

Location. This one's tricky too. It's much easier to fathom a relationship with a bookshelf than it is to a physical space where plays often happen without you.

The large difference between reading a novel and a play, of course, is that the experience of reading a play in no way equates to seeing it performed. Reading a play feels to me a bit like a promise deferred; the experience of finishing a novel like the fulfillment of a promise.

So, of course, as a child I was doing more than staring at the spines. I was absorbing their order of categorization; I was absorbing the mind of the person who arranged them (my mother); and I was absorbing the greater cultural consciousness that led to their yellowed presence on the bookshelf (the grandfather equals British Empire). So, of course, there's nothing remotely egalitarian about the bookshelf or its contents. The role of the English language in India, the immense influence of Western literary prizes, my mother's quiet love of literature all contributed to that moment when I pulled Ibsen's *Wild Duck* off the shelf and spent the afternoon weeping.

Theatre artists talk a lot about those formative experiences in the theatre, the moment that you fall in love. But what if the preparation for that moment has been a long time coming? And that it's invisibly and inevitably stitched to thousands of moments before it? Carefully tended and waiting for your presence? I'm reminded of Carl Jung's assertion about the strong influence of the unlived life of the parents on their children. When I think about my own yearning to write, I can't help now but think about the yearning of my mother, with her notes in the margins, and my grandmother, who didn't have enough English to read Tolstoy in translation but kept the entirety of the *Mahabharata* in her head.

So why were the bookshelves of Ghosh's family and mine alike? He concludes that the connection between the odd assortment of writers is the Nobel Prize for Literature. Bengalis have a particular fetish for the Nobel Prize. In Calcutta of the twenties

and thirties, "Not to be able to show at least one book by a Nobel Laureate," he writes, "meant you were almost illiterate." Although that obsession has dimmed, there's been a kind homogenization of bookcases around the world. All "serious bookshelves," Ghosh reports, are sure to have Nadine Gordimer, Salman Rushdie, and Michael Ondaatje on them. But this, he says, isn't a new phenomenon. For hundreds of years, stories have found their ways to far flung corners of the world. Writers have always sought one another from across oceans.

Just being around a bookshelf with novels creates a sensation that a conversation is happening. Sometimes just my proximity to books alone makes me feel a part of the conversation. But without immediate access to the physical space of theatre, I have the experience that people somewhere else are having a conversation without me.

When we talk about theatre we talk a great deal about exclusion. And about the barriers to access, institutional and cultural. And while I agree that this is true, I feel that the conversation is a broader and bigger one. Institutions can't make space for what they can't imagine. With increased access to literacy and education, women around the world are writing. Many are the first in their communities to write and forge new worlds on the page. If these worlds are violent, untidy, passionate, disobedient, and real, then it is because they rise from the truth of the conditions that are woven into the fabric of language made strange, new, and alien. How could it not? New and unfamiliar forms are necessary to give birth to experience consolidating itself in language for the first time.

The world is often an inhospitable place for those of us who have not historically had power to inherit. I know for sure I would not be writing plays today if Paula Vogel had not encouraged me to keep writing *and* underwritten the entirety of my MFA in Playwriting, first at Brown and then at the Yale School of Drama. Art is not accidental. Time, historical providence, the generosity of mentors, and opportunity enable its realization. But I am encouraged by the sensation that the conversation is ongoing; new webs are being spun around the world in the way that they have always been spun (except perhaps faster). Stories are alive and clamoring to be heard. If it is quieter in theatre it is because new forms are fighting their way to life outside it. It is our charge to build robust structures to support them—or watch the ghost light dim.

Born in Calcutta, **Dipika Guha** was raised in tea-drinking countries. Her work has been seen/developed by San Francisco Playhouse, Crowded Fire Theater, New Georges, Playwrights Horizons New Works Lab, the Lark Play Development Center, and Soho Rep Writer/Director Lab, among others. Dipika has an MFA in Playwriting from the Yale School of Drama, where she studied under Paula Vogel. She is currently a visiting artist at the Schell Center for Human Rights and is under commission from Oregon Shakespeare Festival and South Coast Repertory Theatre. Despite a long run in the United States she still drinks tea. See *www.dipikaguha.com.*

CHAPTER THREE
Place and Play

NARRATIVE OF PLACE

Thomas Riccio

The daily world we walk through, that in which we participate as players, is unprecedented, uncertain, fluid, questioned, under constant reevaluation, and full of challenges, distractions, choices, possibilities, threats, and change. We push, pull, and spin, constantly attending to our roles, becoming adept at reading and adapting to narrative terrains, improvisationally moving through the world as a new sort of psychic Paleolithic hunter-gatherers. There are more and more people and diminishing resources. Is it any wonder that games and competition—*Jeopardy, Big Brother, Top Chef, Survivor,* and *The Bachelorette* among them, along with video games and professional and extreme sports—have become such cultural reference, if not allegory, for our time? Out of need, anxiety, insecurity, or overcompensation we have become increasingly self-aware, self-conscious, and self-promoting. Apprehensive in this liminal and ambiguous time of global upheaval and transformation—a time that brings unimagined possibilities and devastation into close alignment—we find ourselves overwhelmed, confused, and distracted in a bifocal, bipolar, ADHD-emergent, and immersive sci-fi world, constellating myth, fantasy, and hyperreality. We survive, disoriented, overwhelmed by the Niagara of images, ads, words, voices, choices, upgrades, and possibilities upon possibilities, uneasy, fatigued, yet sanguine. The creep of increasing social, cultural, economic, and political mediation tightens and quickens in heretofore unimagined ways. We have been hacked, invaded, and we retreat, becoming willing Stockholm syndrome victims taking "selfies" to make sure we still exist. We accept lower, broader, bolder, louder common denominators to steady our faltering walk through jangled reality. Disorder craves order as its tonic, and so we have the rise of fundamentalism-conservatism, while others scramble for security and comfort in so many varied subculture forms.

Technology is no longer a mere extension of human capability, but rather has become semi-sacred—magical objects with wavelength spirits filling once quiet and empty space, enabling us to disembody and traverse the unfathomable everywhere ether. Technology is a facilitator and harbinger, like Shiva, the creator, protector, and destroyer, conjuring a new sort of life. Our humanity, hopes, and

dreams are progressively processed, programmed, and datafied; we find ourselves shaped by exponentially efficient, profit-driven, pre-chewed, freeze-dried pabulums of corporatized, franchised offerings of lifestyles, brands, and products. Like numb, drooling, and distracted addicts, we have become narrowly trained to the convenience and the comforts of the known and predicable. What better way, in an uncertain world, than succumb to the efficient fixity of the known, the quick way to momentarily assuage the feelings of anxiety, isolation, and inner emptiness? However, at risk is the flattening and licensing of the imagination and the diminishment, if not deadening, of the mind and the contaminating of the soul. It is a death by small cuts of consciousness, aliveness, and presence in the world, as we sink into a pleasant, warm bubble-bath suicide. The above are some of the swirling subterranean themes coursing, like crossing currents in a broad swelling river, through the narrative of our collective American now.

When performance increasingly shapes the actions and expressions of the everyday, and when the presentations onstage are surpassed by events of the world, the function and viability of theatre must be reconsidered. There are those that maintain the status quo—wittingly, unwittingly, reflexively, and stubbornly—recreating and reconfiguring with variations the conventions, vocabularies, and formulas carried from the past. There is comfort in the familiar, along with a whiff of nostalgia, in established institutions and in known patterns and experiences with variations. After all, theatre buildings and subscription series have been built and organizations, careers, and industries fostered and perpetuated, standing as monuments and testaments, asserting a long and storied history which bequeaths a rightfulness of place and being. Theatre—bigger, more efficient, more comfortable, more technological, more salacious and sensational, and more conformed to corporate ways of being—is symptomatic of a larger degenerative condition: acquiescence in the guise of response. Rather than an antidote, provocateur, and alternative voice speaking to the collective consciousness in time of need, theatre has been commoditized, serving as extensions and affirmations of larger ordering systems. Fossilized, impervious, or willingly ignorant to the foundational, tsunami-like changes washing over the world, theatre has become society's functionary rather than functional. A follower in a time requiring leaders. A place to gather and to reaffirm and reiterate, rather than transcend and reimagine, rebalance, and reorder the world. Rather than the narrative generator of this new place we find

ourselves in, theatre is content to be the equivalent of a cover band serving up warmed-over songs of the past. We are in a time demanding a revolution, a time to challenge all that preceded, a time when form, content, and function must be called into question. It is time to journey into the unknown with the willingness to leave all behind in the effort to recreate our social, cultural, political, and economic systems, the world and self anew.

In so many ways, the events of the world have advanced so far beyond the narrow, self-limiting, and ultimately conservative forms and expressions of theatre. The malaise of theatre is not in its doing—for the need and necessity of theatre is integral to human nature. At issue is the courage to embrace, evolve, and express that which is gestating within and without. Rather than self-marginalizing, becoming a compliant tool for a larger system, theatre can contribute, if not lead, becoming a gathering, the collective brain, and spirit of a community. This is a radical and daunting proposition requiring a fundamental reconsideration of every aspect of how theatre functions, serves, and is operated: its objectives, methods, and expressions. Theatre, with its long and storied lineage, from its shamanic and ritual origins to performance art, is first and foremost a functional and practical human technology able to have real consequences in the world. In order to do this it must reclaim, with confidence, its central place in the mediation of the world's affairs.

The need for performance is expressed everywhere; the world is increasingly performing—becoming "performative"—because theatre has abdicated its role, residing in hospice, and in this way controlled and marginalized from its rightful place at the center of a community. The rise of performance art, immersion and experience performance, dance-theatre, evangelicalism, radical politics far and near, and the preoccupation with gaming—video games, social media, reality TV, and LARP culture—are all expressions, in fits and starts, of a hunger for something else, for real life presence, participation, and community. There is a need to go beyond the artifice of acting and become being, a need to move beyond the human-centric conflict-resolution preoccupations of drama and the antiquated control-command structure of theatre. Descartes's dichotomy, of the mind of the stage controlling the body sitting controlled and inert in the darkened auditorium, is a relic from the seventeenth century. Our society, our culture, our world has moved beyond this form, which stays out of the lazy habit and tradition, not out of necessity.

Globalization is a given and with it has come a myriad of challenges and awakenings. The animated world and mind-body-spirit holism of other cultural worldviews and performance, once dismissed, denigrated, and marginalized, now offer not only exotic content to the novelty-crazed West, but alternatives to how and why performance exists—its forms, functions, and the worldviews that they embody. The rest of the world views the role of performance differently, yet the Western form and expression of theatre, along with its incumbent, economically ensconced production machinery and thinking, remains intransigent to a fundamental reevaluation to make it more vital to a greater cultural, community, and spiritual discourse.

The planet is evolving a new indigenous reality and we are immersed in, and performers of, a narrative of place: a holistic and inclusive planet. No longer is indigeneity simply a framed phenomenon of an isolated, geographically specific location, its societies, and its cultures. We are now all part of a complex coevolutionary process, aware of one another, seeing, communicating, traveling, trading, clashing, and mashing cultures of before, mining them for value and in so doing collectively intuiting a new, never-before-seen way of being. Humans have, since the dawn of civilization, remade the world, and now the world is remaking us.

We are becoming indigenous again, a never-before-seen alive and hyperaware indigenous: We are all becoming earthlings. Each day we become progressively aware of our presence and the fragility of our threatened environment. Each day we become more aware of our relationship with, responsibility to, and the intelligence of animals, insects, flora, the rivers, winds, sky, mountains, and oceans of which we humans are but a small part. The world's cultures interacting have promoted awareness, if not the evolution of a nonreligious way of spirituality. The cycles of seasonal, planetary, and biological evolution have always been in dialogue with human civilization. Yet, our theatre remains stubbornly human-centric, valorizing what is material-objectivist, fixed in a limited perspective, and in so doing hierarchically marginalizing, devaluing, or exoticizing all that is not. The legacy of the human-centric hegemony must be put to rest and understood for what is was, a step in an ongoing evolutionary process.

Our evolution as a species can be characterized by an expansion and consideration of sensitivities and perspectives—racial, gender, and sexual orientation among them—driven by the worthy and noble pursuit of freedom and individuality; but that was then. Our moment

requires a consideration of totality, a presence of being, and the creation of a comprehensive, vibrantly animated community of place. In this we rediscover a way to understand, balance, and give back. Theatre can be a facilitator of human evolution.

Humans, the most enabled and greatest beneficiary of earth's magnificent offering, are responsible for its maintenance and balance. Theatre has the ability to shape thoughts and feelings, to prod and provoke a new consciousness, explore and reveal a reconceptualizing of our relationship with, role in, and obligations to create a world of inclusion, gratitude, and healing. Theatre—its content, form, function, and expressions—can be a vital part of a coevolutionary process, enabling an emergent narrative of place where the voices of humans, animals, flora, spirits, all the elements of the environment, and ancestors "speak," each in their in their own way. Our survival as a species depends on it.

Thomas Riccio, performance and media artist, writer, and director, is professor of performance and aesthetics at the University of Texas, Dallas. He is artistic director of Dead White Zombies, a Dallas-based post-disciplinary performance group. He was artist-in-residence at the Watermill Center in 2016, and is collaborating with Sibyl Kempson on a series of performance rituals at the Whitney Museum.

A RUMINATION ON AUDIENCE DEVELOPMENT AND A SHORT SERIES OF UNWIELDY QUESTIONS

Kevin Lawler

A Rumination

I have an obsession with the enigmatic and illusory nature of time. One of the best descriptions that I have ever heard of for our birth, life, and death is that we are all as one river flowing, no separateness, until that river goes over a cliff (our birth) and the single unified body is divided into millions of individual droplets. Our lives here are the passage of these tiny droplets as they fall and our death is when they smash back into each other at the bottom of the waterfall and become one river again, unified and quietly flowing onward.

When we speak of audience development I feel like what we are really speaking of is the search for our connectedness. There is no greater unifying activity then to sit and share stories with each other. The current dominant performance/audience structure for the performing arts has been so deeply infiltrated with elements of capitalism and patriarchy that it is difficult for many to see where they adversely affect the original endeavor. I believe that we must continue to increase our consciousness of the economic, political, personal, cultural, and sociological forces that influence this activity, while at the same time devoting the bulk of our soulful energy to engaging in this endeavor in its purest form—and experiment with new ways—which is happening all over.

We have thousands of young artists emerging from in-depth training each year with a deep and wild desire to create new work that explores our lives and world. They are also hungry to create new ways of living in the world. This vast and growing army of the imagination is reason for joy and deserves as much energy as can be mustered to help facilitate their creative work both inside and outside the established practices and institutions. This is a huge, ever-expanding force that can potentially reshape not just the art form, but also the structure of society toward more vibrant and compassionate ways of living.

A Short Series of Unwieldy Questions

"The end of the world will be legal." —Thomas Merton

Are we riding on a red, white, and blue boat with millions of fear-gripped people who will essentially try (through myriad rationalized decisions) to disenfranchise, disable, silence, or kill anyone that is perceived as weaker or different? If yes, how deeply and where am I (are we) partaking in this process?

Are there really not enough resources for everyone globally to live a healthy, vibrant life, or is that a myth of fear propagated largely through nationalism and capitalism?

How do we help release the grip of our survival mind so that light can flood in?

If we are in the beginning stage of our extinction as a species, what stage of grieving are we in, and what of sort of death do we want to have? Is it destructive, compassionate, naïve, or all three, to ask this question?

Is compassion born through the process of dealing with and/or recovering from pain?

Are love and deep consciousness/presence one in the same?

Do fear and desire have to remain our masters, or can we sit and make friends with them as a species?

To what extent does art help shatter the illusions of time and separateness?

How can art help to reveal the threads of the infinite running through the fabric of everyday?

Is a significant sharing of stories essential to improving the health of our communal life?

How can we increase our capacity to make theatre that is so strong in its compassion and generosity (including the means of production and dissemination) that it fosters a micro-revolution of love inside everyone who takes part?

Ideally the means of production and dissemination are compassionate and communal. Among other things this means that performances should be free (or affordable) *and* accessible to the majority of the community, and that producers and directors understand themselves to be in a role of service to everyone involved with the production (and to the community) rather than working from the illusory idea of "I'm in charge."

Kevin Lawler is a poet, playwright, producer, director, designer, and actor. He is the producing artistic director of the Great Plains Theatre Conference, a cofounder of the award-winning Blue Barn Theatre, the founder and artistic director of the National Institute for the Lost, and the founder and host of the monthly storytelling gathering "The Stories of O."

PLAYING IN CITIES

Andy Field

"Play is free, is in fact freedom." —Johan Huizinga, *Homo Ludens*

1 – The City

Hyper-scrutinized and super-surveilled, fractured and fracturing, crowded with people, ideologies, contradictions, rhythms, retail opportunities, inequalities, inequities, good ideas, bad ideas, lost dogs, Wi-Fi hubs, and sites of contested historical value, it is in our major cities that the coding that organizes contemporary society is at its most visible and consequently its most reprogrammable. In our ever-growing metropolises we negotiate literally and figuratively the relationships that constitute the society we find ourselves a part of—relationships like that between ordinary citizens and bodies and instruments of conspicuous power, between private business and public good, and between you and me, the other people around us and the streets, buildings, parks, and squares that make up the physical spaces we inhabit.

Through this plurality of relationships we return again and again to the notion of freedom, the specter of control, and the ways in which both are manifested on our busy streets. Cities have long been places where this ideological conflict is played out with bodies and buildings through actions that are at once real and symbolic. In Paris in the nineteenth century the city's streets were famously redesigned in order to inhibit the kind of collective urban action that had fueled the transformation of the entire country in the previous century, creating wide boulevards that prevented the construction of barricades and enabled swift access to potential sites of subversion from the city's military barracks. At around the same time the city of Melbourne in Australia was being designed without any public squares at all, specifically in order to discourage the kind of democracy that such gathering places fostered.

This association of public space with freedom and democracy, and the consequent attempts to restrict freedom through the restriction of our access to such public space, is an equally significant component of the twenty-first-century city. Consider the number of political

movements that have emerged since 2011 which have been grounded in physical spaces, from Tahrir Square to Zuccotti Park, and how frequently the reaction to these movements has involved restricting access to those very same sites, often indefinitely. Alongside such blunt confrontations with the democratic potential of the public realm there are other more insidious threats. Architect Sam Jacobs, for example, has suggested that the dream of a digitally driven "smart city" of the future, seductively envisioned by tech giants like Google and Apple, has the potential to transform us into "voluntary prisoners of smart architecture." In the smart city our behavior is monitored and moderated by an elaborate array of networked devices that could include everything from the phones in our pockets, to the park benches we sit on, to the driverless cars we will soon be riding in. Convenience lures us into acquiescence.

Yet public space and the uses we are able to make of it remain crucial to our understanding of who we are, as individuals and as a community. And as traditional gathering places and familiar forms of protest are designed out of our urban environment and our personal and political agency is eroded by the utopian fantasies of unaccountable corporations, alternative methods of reimagining and renegotiating our relationship with public space become increasingly important.

2 – On Play

Seemingly lacking both explicit intentions and meaningful outcomes, play is ideally situated to evade the kind of restrictions placed on more direct political action. Play can appear trivial or unserious, and yet in its defiant unproductivity its superimposition of alternative rules or structures over the rules that normally govern our public behavior, and its encouragement to imagine something other than the ordinary, to imagine *ourselves* as something other than the ordinary, play can create a space of thrilling otherness to our current social and political conditions. Play invites us to imagine ourselves as free—free to impose our own reality upon the cities we inhabit, even if temporarily. In doing so it might fulfill a vital purpose in an environment in which more explicit acts of freedom-making can be so vigorously policed and constrained.

But if even if play has the potential to serve as just such an act of "freedom-making," what does that look like in practice? Is it the child crouched behind a park bench, waiting for just the right moment to

leap out and scare her passing parents? Is it the elaborate zombie chase game I attended a couple of years ago in an empty industrial estate in North London? Is it me, just earlier today, walking down the street secretly pretending to be a racing car? Is it all these things, or is it none of them? How might we begin to configure a politics of play as a means of understanding when playing on our city streets is a radical gesture and when it isn't?

One way to answer this question would be by identifying a possible history of such radical play. Such a history might lead from the purposeful aimlessness of the dérive, through the playful event scores and happenings of sixties artists such as Allan Kaprow and George Brecht, to more contemporary manifestations of urban play such as flash mobs, pervasive gaming, and certain kinds of contemporary site-specific theatre and performance art. Through recourse to such a history I can begin to map a kind of play that is placeless and appropriative, that disappears into the everyday activity of the city, that occupies time rather than space, that exists perhaps most fundamentally as a way of looking or a way of operating, ascribing new meanings to familiar actions and old architecture, and in so doing producing radical new experiences of the city. This is a definition of play I recognize as an act of oblique political resistance. It is the kind of definition around which my own practice has been constructed, informed by a critical and aesthetic vocabulary that has not only helped me to understand what I want to make, but also how to describe it.

3 – On Play and Privilege

Knowledge, however, is rarely only knowledge. In this instance the knowledge that has shaped the way I think about play has brought with it an artistic legitimacy and a cultural capital that has been just as crucial in affording me the freedom to play in the streets of my city. This freedom is manifested in a variety of ways: an ability to secure grants and commissions to devise and develop new projects; participation in festivals of play and performance that frequently enable special access to streets, parks, and other public places; and perhaps less tangibly a kind of confidence—a sense of what I am able to get away with and where. This confidence is born of experience, of my ability to justify or explain what I am doing, of my position as a professional artist, and perhaps most fundamentally from privileges of race, sex, and class that mean the streets are freer for me and people

like me than virtually anyone else in society.

The history of play that has informed my own work is by and large a history of people with a similarly privileged freedom to play in radical and unpredictable ways in the public realm—work emerging from, supported by, and remembered in galleries, museums, universities, and the pages of beautiful, expensive books. Celebrated yet circumscribed, well-intentioned but nonetheless legitimized by and legitimizing institutions of explicit authority and privilege, does such play risk becoming part of neoliberal machinery that reinforces rather than reimagines the power relations that govern our public spaces?

In 2009 on London's South Bank, I was involved in creating a street game for a summer festival. Promoted by the South Bank Centre, the piece encouraged players to dress in one of three colors and meet outside the Royal Festival Hall, freezing for two minutes and then moving in a series of stuttering, improvised patterns toward a nearby park where we had prepared as a finale a giant game of grandmother's footsteps led by a performer in a giant papier-mâché grandmother's head.

As the people playing the game started to move in fits and starts across grass, dozens of other people, many local teenagers hanging out and drinking in the sunshine, noticed them doing so and tried to join in. These new people did not know the rules; they had not received the pre-event briefing e-mailed to players the previous day; they were not visitors to the South Bank Centre. In delighted exhilaration they rushed at Grandma. We didn't know what to do. We hadn't anticipated this; we hadn't invited them to play.

Responding instinctively to the danger posed to the performer braced inside the oversized costume, we formed a cordon, a barrier, a strong line of defense; arms linked, we pressed into the crowd, forcing them backwards away from their immediate target. Behind me I could hear another supervisor using a loudhailer to encourage these new players to disperse. This was not the kind of play we had anticipated, and not the role we thought we would find ourselves playing.

4 – The London Riots

The complexity of my relationship to public space and the freedom to play was perhaps made most apparent to me a couple of years after this experience when, in the summer of 2011, a black man called Mark Duggan was shot dead by police in North London. Little explanation for his death was given and the police briefings about the circumstances

surrounding it inflamed the local community. Hundreds of people from the area marched on a nearby police station demanding an explanation. They waited for several hours whilst no satisfactory response was forthcoming—the crowd growing, the tension building.

Eventually there was a scuffle, then fights, and quickly things began to fall apart—or, perhaps more accurately, they started to be pulled apart. Violence spread like a meme—an idea, a pose, an action, a euphoric, irresistible carnival, carried on mobile phones and through the social networking sites. What followed was a flash mob of fierce chaos: an ecstatic, angry mirror to the corporatized incitements to dance in train stations or freeze in city parks that had infiltrated London in the previous couple of years—the same vocabulary of play and transformation shouted in furious voices by those who hadn't previously been invited to join in.

Following the riots a cleanup was organized on the internet by well-meaning, socially conscious people I thought of as much like me. Some of those organizers were people I'd actually met, at arts conferences and similar cultural events. They encouraged people to get a broom and go out into the streets to help with the clean up. People arrived on the streets ready to make a point, ready to take something back. By the time the crowds had assembled, the majority of cleaning up had already been done by local council workers. With little to do but gather, awaiting instructions, these unneeded players stood in the street, posing for journalists' photographs, holding their clean new brooms in the air like banners. They laughed, they cheered.

They swept away antagonism and reclaimed the streets for play of a kind I had become familiar: play that is *just radical enough*, participated in largely by people with the freedom to choose when and how they will be visible and when they will remain inconspicuous, people for whom the experience of running through the city has rarely been anything but thrilling.

5 – Walking Holding

More recently I have found myself drawn to a different kind of play—play that is not so reliant on adherence to a single set of rules or a secretive fictional scenario, both of which can often depend on the seductive idea of erasing the complexities of privilege, politics, and power that are always present in public space in the same problematic way Peter Brook erases them in his empty space.

Instead, the play I find myself drawn to is built around the more ambiguous, negotiated terrain of the encounter—an encounter that recognizes that different people will understand public space and their relationship to it in fundamentally different ways, that invites us to acknowledge that difference and explore it, that recognizes the production of meaning as a plural and collaborative act. This is play that, initially at least, does not appear so explicitly playful, and yet which to me is still a gentle act of reordering and reproducing: the fashioning of new freedoms out of extraordinary interactions.

Perhaps the best example I have so far seen of such an encounter is a performance called *Walking Holding*, created by the artist Rosana Cade. The piece invites you to walk hand in hand with a series of strangers on a journey through the city. The people you walk with are residents of the city who have agreed to take part in the piece, people of various ages, genders, sexualities. As you walk with each of these people in turn, you share a conversation with them about how this walking together, this visible intimacy, makes you both feel.

Through the playful and seemingly uncomplicated action of holding hands we are able to explore together some of the ways in which public spaces are performed and policed, the privileges of gender, sexuality, race, and class that so often determine our freedom to roam, and the contingent nature of our own visibility within the city. It is the simplicity of this gesture which is so powerful—the realization that just a held hand is enough to thrillingly and frighteningly transform our experience of the city and initiate new relationships of solidarity and resistance.

Andy Field is a theatre maker, curator, and codirector of the award-winning performance collective Forest Fringe. He has created and toured his own contemporary performance work across the U.K. and internationally. Andy also writes regularly on performance for a number of publications, and in 2012 completed a Ph.D. with the University of Exeter, exploring the relationship between contemporary performance practice and the New York avant-garde of the 1960s and 1970s. See *www.andytfield.co.uk.*

IMAGINING AUDIENCES

Kira Obolensky

I love that the call for entries for this book asked for us to consider "the *living* relationship between art and audiences." I've seen a lot of art that didn't need an audience, or didn't care if it had an audience—and work, also, that seemed to be in service to an audience. I've been in audiences that didn't need the work being presented or respond much more than to judge it. I've also been entirely transported as an audience member, brought to a place of joy and despair. The relationship we have to audiences as theatre artists covers such a spectrum! But I think it's great to think of the relationship as living, or alive. I thought I would speak to the *creative* relationship I have developed as a playwright with Ten Thousand Things Theater's audiences—and I use the word "creative" even as I recognize that the relationship also feels alive, living, mutable, and changeable.

For the past five years or so, I've been writing plays for Ten Thousand Things Theater, which was founded twenty-five years ago by Michelle Hensley. TTT brings its vibrant, high-quality productions of big plays that ask complicated questions (Shakespeare, the Greeks, some musicals, Brecht, etc.) to nontraditional audiences in Minnesota, many of whom have never seen theatre before. The theatre performs in sites where these audiences are or congregate, including community centers, prisons, chemical dependency centers, battered women shelters, immigrant training centers. And then the show will run for a month of performances for a theatre-savvy paying audience, who see the play in a big room in a Minneapolis literary center exactly as it's been performed for nontraditional audiences—seats arranged in a circle around the playing area with all the lights on.

Before you think you know what kind of theatre this is, let me assure you that there is not a whiff of condescension or preachiness in the work that the theatre does. The political agenda of the theatre is quite simply the idea that theatre is a wealth that everyone should have access to. (Michelle Hensley speaks beautifully to the theatre's history and premise and politics and power in her new book, called *All the Lights On*. Read it, it's great!)

As Hensley planned her seasons she found that she had difficulty finding contemporary plays that worked for audiences with such

a range of lived experiences because most contemporary plays are written for traditional audiences, which means they are often centered on middle- to upper-middle-class concerns. So about eight years ago, Hensley, collaborating with Polly Carl at the Playwrights' Center, offered a national commission opportunity which involved answering this question: "What play would you want to write if you knew everyone was going to be in the audience?"

The question is a simple one, but it's also pretty radical. For one, it puts "everyone" into the audience equation—instead of just traditional theatregoers, who tend to be middle- to upper-middle-class white people. The question also shifts the paradigm of the artist as visionary working from an inside spark; it forces the spark to be external and prods a question I think playwrights don't often enough ask themselves, which is the *why* question. Why this story? Why now? Why would everyone—this incredible range of people from every walk of life—want or need this story? Why this story for all these people?

I've now written five plays for the theatre, the last three as a Mellon Foundation playwright on staff. And that question about what story I want to tell, knowing it's going to be for "everyone," not only forces my imagination to creatively engage with the audiences that the play will perform for, it has made me a better writer. It puts my imagination in play with the audience from the conception of the play through the writing and revision and rehearsal process. And it's made my work bigger, more muscular, more complicated, even funnier; it's made my characters strive and take actions that have real consequences, and struggle with the big questions about the human condition.

This feels important to me—the idea that something happens to our stories if the equation of the audience shifts. If we know that our plays have to reach such a range of people from such different life experiences, it forces our work to have behavioral complexity, characters who are from different classes, and a playing field where no one can be an expert. It forces, in a sense, a blurred background—a sense that the play or the story has to happen not in a neighborhood or clinic in Chicago but in a suspended, more "fairy-tale" place and time. Adding this big audience to our creative process also begins to change the stylistic language of the piece. Characters don't sit on couches, if that makes any sense. They make mistakes, they plot revenge, they need hope, and they are part of the human family. They take big actions with big consequences. Most TTT plays have something epic about their scope and an ability to boil the story down to essentials

because the theatre produces without lights, no scene changes—the experience is an engaging, muscular ride based on a good story.

For me, the conjuring of these audiences has become an act of both remembering what has connected with audiences in other plays—what made that Brecht or Shakespeare play work?—and an act of imagining how these audiences with their rich and complicated life experiences might find their lives intersecting with my play.

For me, thinking about different audiences, considering how the questions the play asks can engage, surprise, and connect with various audiences is essentially a creative act, not an act of demographics. The summoning of these audiences is not unlike writing a character different from who we are. A playwright imagines a character and then leaves room for the actor to come in and occupy the role. It's an act of empathy, a summoning. An invitation. A place at the table.

Kira Obolensky is a Mellon Foundation–funded playwright on staff at Ten Thousand Things Theater in Minneapolis.

THE SPECTATOR:
COAUTHOR OF MY SHOWS

Ana Margineanu

In my first year of studying theatre, a teacher told us: "There are only two categories of theatre: boring and not boring. We try our best to be part of the first one, and we can only succeed in that if we always take into account our audiences. The only two elements we really need in order to do theatre are one actor and one audience member." Wow. Soooo...no director? No playwright? Gone were the big gods of theatre creation. The only ones left were the two "essentials of theatre making": the often-ignored spectator and the often-underpaid and overly exploited actor. This teacher changed my life: I could never let go of exploring her idea. This was the start of a secret and obsessive love story, as I fell madly in love with my spectators.

The truth is, when I look back over fourteen years of making theatre all over the world, the first things that I remember are not the shows or the rehearsals, but the spectators' reactions. I hope none of the actors I'm working with are reading this confession: When I am present at my show, I tend to watch the audiences, not the performance. From my row in the very back, my eyes search through the dark trying to decipher from the way they hold their heads whether they are absorbed or bored, or from the way they breathe if they are having fun or not. If an audience member checks his phone, I try to see if he is texting (about the show), taking a picture (of what's happening onstage), or just playing a game. So, this piece intends to be a little history of our love story or of my perpetual trials to seduce my audiences.

When I finished school and was working on my very first production, which happened to be staged in a bar, I started questioning this relationship, knowing that my spectators would most likely have a beer in their hand, and would not be exactly the type of audience my academic training had prepared me for. I decided the show should be interactive. Matei Vişniec's poetic *Theatre Decomposed* was not exactly the type of play one would stage in a bar, and I thought that if I involved the audiences in the performance I would make them feel that they are part of a game and let the poetry flow to them discreetly beneath the fun. In one scene, a questionable illusionist would do tricks, like

taking fake rabbits out of ladies' purses, before he would try his most impressive magic, making the whole world vanish, and thereby losing himself in an ocean of nothingness. The Human Trash Can would empty the spectators' ashtrays in his own pockets, while wondering what makes a human like any other become the target for everyone else's trash. For one of the most daring scenes, about the impossibility of communication, one audience member was taken from his seat, ushered onstage, handcuffed to a chair so he could not leave, and then asked by the three cop-like characters to say "string." No matter if the spectator was saying "string" or not, the characters would act as if he refused to say it, and would continue the game, by bribing him or trying to intimidate him, very much like in a police interrogation. The story of this scene always horrified any American that heard it, but in Romania we believed that theatre should not be comfortable.

The scene was quite a success. Spectators experienced both hysterical laughter and reflection about the nature of communication. People would come to the show again and again and try to bribe the producers beforehand, in order to get actors to pick a certain person for this scene—someone they undoubtedly wanted to play a trick on. We never took the bribe, and the actors always chose the (un)lucky spectator right on the spot, based on their intuition. I remember they once randomly selected a black spectator and he asked the actors at the end: "Did you chose me because I am black?" This thought gave a whole different level of depth to the scene, and the fact that it was unintentional did not take away its strength. I learned that by allowing the spectators to participate in the show I was in fact allowing the shows to become more than I initially had in mind—myself or the playwright.

Years later, I found myself in New York, working on my very first show produced there. (I'd previously had my work presented in New York City, but they were all shows created elsewhere.) I was very aware that I was facing a very tough market. I had no money, very little rehearsal space, no time, and nobody knew me. It was very likely that I would not get much of an audience. Everything that I had made or achieved in the past (multiple productions, some national and international awards) didn't seemed to matter much here; I was back at the starting point. I decided to create an intimate show for only one audience member at a time. The initial reason was the fear that I wouldn't be able to bring in many spectators anyway, but I was quickly fascinated by the amazing opportunities to create a unique experience

that came from this limitation. I wanted to create a "once in a lifetime" experience, so I indulged in the only luxury I could afford: actors. I hired (for free) twenty-five actors to perform for the one audience member, so she could feel totally immersed into a different world. I designed the show to function as a journey where the spectator was traveling in five different spaces of a building, each populated by a new story, performed by different actors. As a final touch, I decided to blindfold the spectator at the beginning of the journey. The spectator was told that she was free to remove the blindfold at any moment, in any place, but once the blindfold was removed she could not travel further. She would get to see the reality of that scene, and that would be the last.

Before talking about how people received this experience, I want to highlight the importance of three components:

1. The intimacy. Because the spectator was alone, the temptation to look around and "share impressions" with a fellow spectator was removed. In a world where the internet and its "sharing" experience forces everybody to be in a perpetual virtual state of socializing (oh, what a gorgeous sunset, let me Instagram it) and in a world where many are so busy sharing their experiences that they don't have time to actually enjoy them, *The Blind Trip* was forcing its only spectator to really live his experience, without the pressure of being watched or judged. The audience was forced to share a moment only with himself, in a world of fantasy.

2. Removing one sense. Again, we live in a world where everybody is used to receiving everything at once, in multiple windows open on a screen with ads at the bottom. With all this abundance of information, people tend to lose their focus. They need to learn to observe again. By taking out one's assumed right, I was hoping to open a door into their imagination, and make them more aware of the world they were stepping into.

3. The game component. You are free to chose: You can either see something but lose everything else, or have the whole experience but not see a thing. By this I was hoping to make the audience more responsible in crafting their own show

and their own experience. A man with a decision to make is a man with a mission, a man actively involved in the experience that he is living.

The result blew my mind. People lined up hours before the show in the theatre hallway, some of them waiting for hours to get in for a five-minute experience (yes, the show was only five minutes long). Nobody took his blindfold off. People stayed for hours after the show to discuss the experience among themselves. We received e-mails from spectators weeks after, some of them describing in detail the extravagant set they saw in their minds when experiencing the show. The show that they saw in their minds was far better and more spectacular than any show I could have created with my budget. The show that they witnessed was not my creation anymore; it was theirs. I was only a facilitator. Most of the fifty spectators that came to *The Blind Trip* remain to date my most loyal spectators, coming to see any production I make in the city.

I continue to draft experiences for spectators to have, rather than create shows for them to witness. I partnered with the amazing director Tamilla Woodard in creating our own little company, PopUP Theatrics, and we dedicate ourselves to exploring new ways of creating "one of a kind" experiences for our spectators. Over the years we developed many projects that started from the question "What if?": What if we have one actor performing live from the other part of the world via Skype for one audience member only (*Long Distance Affair*)? What if we have two audience members that think that they are watching the same show, but actually they each get a completely different perspective (*Inside*)? What if we use the streets of the city as a set for an intimate performance (*Broken City*)? We have performed our shows in many cities across the world—Edinburgh, Buenos Aires, Mexico City, Madrid, to name only a few—and we have discovered that while cultural background creates very different audiences, they all have in common the appetite for surprise, for uniqueness, and for the joy of being involved. Our relationship with those spectators went far beyond the moment of applause (which in many of our shows is completely skipped). *Long Distance Affair* gathered hundreds of postcards written by spectators to the characters they encountered on their *Long Distance Affair* "trip." *Hotel Project* and *Inside* filled up "guest books" with love letters, critiques, poems, and drawings. Some spectators become actively involved in bringing a show to their country, contacting us on our website and connecting with a site or

venue that could be our next performance location—a place, perhaps, that their aunt owns—or with an actor they wish was featured in our productions, or a link to a festival they think we should be a part of, or simply a note of the joy of being a part of the experience that we have facilitated, but really that they created themselves.

Ana Margineanu is a theatre director based in New York City, cofounder of PopUP Theatrics. Credits include: *Broken City* (New York), *Long Distance Affair* (Edinburgh, New York, Mexico, Buenos Aires, Bucharest), and *Inside* (Madrid, Bucharest). Her work has been presented in major cities in Europe and the United States and has received several awards. She is founding member of DramAcum (a directors' collective that supports young Romanian playwrights) and an alumnus of Lincoln Center Theater Directors Lab. See *www.anamargineanu.com* and *www.popuptheatrics.com*.

CRAFTING A PARTICIPATORY PERFORMANCE SPACE

Deborah Yarchun

I spent nearly every weekend in February 2014 on a frozen lake in Minnesota. It wasn't David Blaine–level endurance art or a masochistic performance art piece. I was a participating artist in the Art Shanty Project, a public art project that draws thousands of Minnesotans and travelers from their homes in the dead of winter, despite temperatures averaging ten degrees. The Art Shanty Project is part artist residency and part social experiment, lovingly and often inaccurately referred to as "Burning Man on ice."

Artists are selected from all walks of life through a competitive application process. The year I participated, musicians created a shanty shaped as a music box filled with inventive homemade instruments; art-car artists and cyclists turned a pedal pub into a polar bear that trekked around the ice; and a gifted group of technicians and artists created a simulated elevator experience. The main requirement: The work must be interactive. I gathered a team of collaborators and signed up as a playwright. As part of our application, we highlighted our interest in creating a participatory performance space that would directly involve the audience in the creation of an ongoing theatre piece.

My goal was to create an intimate experience amongst strangers on the ice. Ultimately 630 people became agents in shaping their own theatre experience by becoming performers and generating text.

Background/Our Structure

A month after moving to Minnesota for a Jerome Fellowship, I learned about the Art Shanty Project from a friend who posted about it on Facebook. As a new Twin Cities–based artist, I was drawn to the possibility of immediately connecting to the community. I've also been fascinated with interactive theatre pieces that break down the audience/performer barrier since seeing Punchdrunk's *Sleep No More*. The Art Shanty Project was also the perfect opportunity to create a piece not only informed by the space, but also a space informed by the piece. As a playwright, you can influence design decisions through

how you construct your play—but how often do you get to personally construct the building for your piece? I showed up at an Art Shanty info session where I had the good fortune of meeting Ben Pecholt, a talented engineer (and non-theatre practitioner) looking for a project. I later roped in Saga Blane, an environmental designer I met through a theatre connection.

Drawing on her Finnish upbringing, Saga suggested we build a lavvu, a structure used by the Sami people of northern Scandinavia. Lavvus can be assembled quickly, which was useful considering the harsh climate. They're similar to a teepee, but have a lower angle.

Serendipitously, it turned out there was a lavvu expert, Chris Pesklo, in St. Paul (possibly the only lavvu maker in North America). Although we didn't interpret or comment on Sami culture in our piece, Chris (who is a member of the Sami community) also served as our historical and cultural consultant, helping us bridge cultures and understand the history and context of the lavvu structure.

The Performance Piece

I titled our shanty Drama/Puppet Therapy Circus—Sami Shanty. Audience members, upon entering, were informed that they were also the performance.

Inside, participants were given an option to address their past, present, or future.

If they chose the past, they were instructed to write a confession from their past on a notecard.

If they picked the present, they wrote a list of five things they were grateful for in the present.

If they picked the future, they wrote a wish for themselves for the future.

The participants' wishes, confessions, and gratitude lists then plugged, Madlib style, into scripts I'd written. Participants were given props and costume pieces and paired with scene partners. Each script created a narrative structure for what the participant had written, making them a cocreator of the piece they performed.

The circular shape of our structure was ideal since everybody was automatically facing each other. Performers stayed seated in the same place they sat as an audience member, so there was no division between audience and performer.

An example of one of the shorter scripts:

The Zen of Balloons

Performer 1 reads their gratitude list.

After each gratitude is read, Performer 1 adds air to the balloon.

When they are finished, Performer 1 ties the balloon and hands it to Performer 2.

Performer 2 pops the balloon.

Performer 1 reacts with shock and horror.

1: You popped my balloon.

2: The Buddha says that "attachment leads to suffering; hence, we should practice detachment in our lives."

1: Yeah, but you popped my balloon.

2: Be grateful for the lesson.

The experience was structured as a three ring circus of the past, present, and future. We'd start with the first ring (the past), which used scripts that addressed the participants' pasts (the confessions) and then moved onto the rings of the present and the future.

All of the scripts involved puppets, balloons, or tarot card readings. The tarot cards, which I created with scripts on the back, ranged from serious future predictions and carefully researched bits of tarot wisdom to a Pikachu card ("an electric force is about to enter your life").

When I conceptualized the piece, I wasn't sure if anybody would participate. With participatory theatre, there's no "the show goes on" if nobody wants to help create the show. Fortunately, I would estimate that ninety-five percent of those who entered our shanty (age three and up) and stayed for our show ended up performing. On one hand, they were mostly hearty Minnesotans who had come with the expectation of having an unusual experience on the ice. But we had also specifically crafted the space to maximize participation. And it paid off.

How We Crafted Our Participatory Space/Reflecting on Nine Things That Worked:

1. There was no separation between audience and performer.

As mentioned above, the circular space ended up being essential. Had there been a division between the audience and the performers— if, for instance, they needed to step onto a stage or a separate space to perform—I suspect fewer would have participated.

2. We didn't ask permission; we handed them the scripts.

By the time participants realized what the performance entailed, very few said, "No thank you."

3. Initiation is key.

Creating a participatory space was a lot like creating a three-dimensional script.

I intentionally placed three chairs on the outside of our shanty with signs. One said "Self-Reflection Chair." Another chair facing outwards toward the center of the lake said "Outwards Reflection Chair." The third one said "Just a Chair." The chairs were not only a frequent photo-op, they implied that our shanty experience would involve a mix of humor and seriousness. We also frequently overheard, "Is that the self-reflection shanty?"

Our title, Drama/Puppet Therapy Circus—Sami Shanty, was also part of the initiation. Most shanty titles are simple: Meta Shanty, Dance Shanty, Wind Shanty. Drama/Puppet Therapy Circus—Sami Shanty elicited a laugh and clued audiences in to the fact that our shanty experience would be slightly more complicated.

A caveat: The few people who had a less positive or more neutral experience usually came in late and were not effectively initiated/ hadn't been introduced to the show's concept.

4. We created an inviting and comfortable environment.

To fully participate, people needed to stay in our shanty ten to twenty-five minutes. This was a challenge because with twenty possible shanties to visit, most attendees prefer to pop in and out. But a lot can be said for an inviting space. It was usually extremely cold, and we had a warm and beautiful antique wood-burning stove that could heat our space up to sixty degrees. This might not seem warm, but it was often fifty degrees warmer than outside. Once people came in, they usually

didn't want to leave. Our shanty was also carpeted with the interior perimeter covered in cushions selected to evoke the feeling of a rustic cabin. Even though our setup was fairly complicated, most people stuck around. On busy days, we often had a long line of people waiting to visit our shanty.

Once people were inside, it also helped that there was also a lot of evidence that others had enjoyed the experience. Upon entering audience members saw the hundreds of notecards posted on the wall with previous performers' confessions, wishes for the future, and gratitude lists.

Audiences were invited to post their confession, gratitude list, or wish for the future on the interior wall of the shanty. This also strategically kept our shanty always interactive. If one person was running our shanty and had to put the show on hold to visit the sanitation shanty, they left a sign on our door labeling our space a museum of past performances and inviting people to enter.

We also drew a lot of people, in part because the walls were thin (canvas) and people from the outside heard laughter.

5. Laughter goes a long way.

Participants appreciated the humor, particularly the striped hats that matched their puppet's hat.

When people laugh, they're more open to pushing their personal boundaries.

6. The experience was personal.

By participating in the experience, people had an opportunity to publicly share their wishes and their writing.

7. Participants had the opportunity to contribute something.

People appreciated the chance to leave their notecard behind, particularly kids who drew pictures. At the tail end of the day, those who had missed the chance to participate in our piece often asked to write something to leave on the wall.

8. Each experience was curated.

Audience sizes per session ranged from two to fourteen, and participants ranged from as young as three years old to over eighty.

I created a number of scripts and options ranging from shorter scripts to more complicated ones. The Master of Ceremonies (the

person running the shanty) was attuned to audience members' varying degrees of comfort and carefully selected scripts for the participants.

A caveat: When you're making snap judgments, it's easy to misfire. There were a few instances where we misjudged, but given the fact we had over six hundred people participate in our performance, this was inevitable.

9. We created options.

I created the opportunity for audience members to read scripted confessions I'd written and friends had contributed instead of their own confessions. For example: "I fell out of love with you over breakfast. I told myself at the time that it was the waffles." This created anonymity and a safe space for them to confess anything or not confess something personal at all.

Also, the experience was adaptable. If there were kids in the shanty too young to read a script, they were offered the chance to toss a balloon around while saying what they were grateful for. (They also got to keep the balloon.)

The majority of participants had limited-to-no performing experience, but fully committed once engaged. Overall, it was a great experience as a playwright. I not only had the chance to craft an audience's experience through the space, I got to interact with a large variety of people, see several short pieces I'd written performed dozens of times by a continuously alternating cast, and interact directly with my audience. With a wall that steadily filled with 630 Minnesotans' wishes, confessions, and dreams, it was also a lesson in Midwest humanity. But perhaps the biggest lesson I took away: Outside the traditional walls of a theatre, more people than you think are happy to step on a stage (as long as it doesn't look like one).

For pictures of our shanty project, visit *http://deborahyarchun. blogspot.com.*

Deborah Yarchun's honors include two Jerome Fellowships, the Kennedy Center's Jean Kennedy Smith Playwriting Award, an EST/ Sloan Commission, University of Iowa's Richard Maibaum Playwriting Award, and the Iowa Arts Fellowship. She has written essays for the Playwrights' Center and *HowlRound*. MFA: University of Iowa. Read more about her work at *DeborahYarchun.com.*

PILLSBURY HOUSE + THEATRE

Michael Hoyt

The TCG Audience (R)Evolution grant afforded us an opportunity to explore our complex and layered relationships to the diverse "audiences" that frequent our multiservice community center and live in our immediate neighborhood. We have always been a theatre with a strong community-engagement focus, but the level of porousness between the organization and our constituencies (including artists, audiences, partners, and funders) now is far greater than ever before. Our challenge was to identify the gaps between people in these groups who attend our mainstage plays and those who do not. The Audience (R)Evolution opportunity emboldened us to "put a stake in the ground" around a significant issue and to find a creative solution to bridge what we thought were disparate audiences.

Our gap-closing strategy commissioned visual and social-practice artists to design and implement creative interventions that engaged people in our common areas and immediate neighborhoods in the themes and content from three mainstage productions in order to deepen people's connection to the whole organization, to foster more layered participation in our program offerings, and to create new pathways to the mainstage plays. We identified this investment in art and artists as a way of engaging in a creative learning process about how to meet audience members where they are, reaching people traditionally disconnected from professional theatre. We hope to develop artistic pathways for our neighbors to access and connect to our work, while building recognition that the Pillsbury House + Theatre is really their neighborhood theatre.

Over the course of one season three artists, Allison Bolah, Natasha Pestich, and Sam Ero-Phillips, developed incredibly imaginative community-participatory projects—such as video installations about middle schoolers' ability to have voice, original screen-printed posters about clinic patients' relationship to the healthcare system, and a hand-rendered zine and way-finding tool distributed via a broad network of cross-sector community partners—that succeeded in engaging new groups of people differently.

The Audience (R)Evolution project allowed us to take action around some issues and questions that we have been working on

for many years: How do we remove barriers, real and perceived, to participation? How do we blur the boundaries between different groups of participants, spaces, and programs? How do we apply our artistic practice to all areas of our work, including audience development and even evaluation? And, as with any complex issue, attacking it one way opened up as many questions as it answered. In hindsight, the process of reflecting on an area of desired growth inspired us to attempt to address both program improvements and internal systems change. Suddenly, PH+T staff are identifying where we would plant stakes everywhere we look. So the insight we gained from the Audience (R)Evolution projects, along with a gnawing desire to have more impact, has empowered our staff to think more critically of our work and of the broader field. Two buckets of concepts/ideas/challenges have emerged as the focus for what we would most like to process/attack/ move the dial on internally and with others in our field.

- How do we define art and artists?
- How do we make equity (especially racial and economic equity) part of a new definition of artistic/organizational/ community excellence?

Art and Artists

How do we define art and artists? We have been a part of a lot of conversations about the notions of "quality" and "excellence" as they relate to works of art, artistic practice, and artist pedigree. Often it seems that definitions of "quality" and "excellence" are used not to set high expectations and then generate broad, inclusive dialogue about art, but rather as code to maintain power and control, and to justify exclusionary funding and curatorial practices. At the same time, many individual artists in our community are already working outside widely accepted notions of art making—helping to define new, emerging, and divergent creative fields. They are making the notion of engagement with people and places central to the art itself rather than something ancillary that comes after the act of creation.

So, our questions for our organization relative to this issue are:

- How do we (and others in our field) continue to expand the definition/perception of what Art(art) is and who is an Artist(artist)?

- How can we lead this conversation and be a part of reimagining the roles of art and artists in everything?
- How can we help open up space for artists working outside traditional field-and-discipline-defined boundaries to be recognized as a valued, critical part of the overall arts (and neighborhood) ecology?

Equity

How do we make equity (especially racial and economic equity) part of a new definition of artistic/organizational/community excellence? This is a meta-question that brings up a tangle of additional questions that call for exploration. Some of these questions require deep self-reflection, like:

- How are our values leading and embedded in the work?
- What are we fighting to change? What are we fighting to protect or preserve? Do the two lists jive?
- How complicit are we in maintaining a system that is founded on/relies on/perpetuates inequities?
- What do the ways we use our resources say about us from an equity perspective?
- What do individual artists gain in working with our organization?

Other questions require courageous conversation among peers and the kind of truth-telling that we are often loath to do publicly, lest it jeopardize our ability to attract resources, such as:

- What gaps can we identify in our field(s)? Are we addressing them?
- What are our desired impacts? At our current capacity (individually as organizations and collectively as an arts sector), is it possible to make the impact we desire/ promote/envision?
- How is equity embedded in the work/organizational structure/systems? How can we shift power and help redistribute resources to benefit all people? Let's be real: How much is enough (especially on the organizational side in terms of salaries, income, and admin)?

- When we say "revolution" or "social change," what does it look like, sound like, smell like, taste like? Is it sweeping change, micro adjustments, or even gimmicks to attract financial support?
- How do we create intersecting accountabilities that allow us to share knowledge, ideas, connections, and other resources while at the same time opening space for us to call each other out on our missteps and untruths respectfully?

The answers to these questions lead us to another meta-question: Based on how we approach and begin to answer these questions, how willing are we (our organization, our peers, funders, the broader community) to change?

At PH+T, we talk internally about "holding" tough questions open, staring them in the face, wrestling them to the ground, and then propping them back up to look at in new light. The TCG Audience (R)Evolution projects have enhanced and extended this commitment. We are committed to doing this within our community of artist and non-artist stakeholders as the process to find workable solutions to an ever-evolving set of complex issues.

Michael Hoyt is the creative community liaison for Pillsbury House + Theatre, a center for creativity and community in Minneapolis. For over twenty years Hoyt has produced and directed arts-based community-development projects and youth-development programs, while making art with his community. Hoyt is honored to have the opportunity to engage local artists and community members in creative practice toward the development of a vibrant and healthy community for all.

STORIES 'ROUND THE CAMPFIRE

Amparo Garcia-Crow

Having served previously as both an artistic director and resident company member as an actor/director in different companies, my personal evolution went from being the only nonwhite company member in an ensemble to serving in the leadership capacity as a Latina in order to engage Latino/a audiences in particular. Once there, we focused on the developing and producing of Latino/a works. The focus came from a necessity to increase the awareness of Latino/a work and, more importantly, to develop and support plays about Latino/a culture.

In both cases, new work has had the most audience involvement because it begins with a dialogue, talk back, and sharing of process. A sense of ownership and community helps the audience to return and revisit in order to see how the work evolves.

There was one original show in particular (*In the West*) that became a "cult" favorite in Austin. People would brag about how many times they had seen it! It ran for six years and the *Austin Chronicle*, when it commemorated its twenty-year anniversary, described it as "the little monologue show that changed Austin theatre"! When we first developed it, we thought at the time that we were just doing a one-weekend showing of a workshop process! When a national music writer came to town to review a well-known artist and he happened to see our show, he wrote a glowing review of it for *Variety*. Soon after, more than one Broadway producer flew in to watch it. Because sixteen company members "owned" the piece, it was an unruly negotiation that ultimately proved impractical. However, this show still holds the record for being the second-longest running theatre show in Austin's theatre history. And it taught me a lot about the power of word of mouth regarding "homegrown" work that authentically reflects its region. In this case, it was our company's response to a powerful photographic exhibit (Richard Avedon's "In the American West") which became the zeitgeist of simplicity-meets-authenticity, as Avedon's work, which inspired it, also became an instant classic in museums.

For the last six years, I have created and focused on a monthly storytelling series entitled: "The Living Room: Storytime for Grown-ups."

In the six years that it has existed, we average anywhere from fifty regular audience members attending to 280 per show.

This project has become a renaissance in my own artistic development because of the deep exploration I do about the power of story at its most stripped-down and most human-interactive possibility. Six storytellers, often three men, three women (I always tell the last story of the night) present their tales, and regularly one of the storytellers per series is a musician storyteller.

The storytellers come together through a theme that ties the tales together, the looser and broader the better. At its heart, "The Living Room" is about brave living and the hero's journey for meaning. The stories are often mystical, profane, and usually reckoning with God, Sex, and Death in the tireless search for Love at the root of it all. Because there is no "acting" involved in the traditional sense of the word, the "show" is bare bones: raw and basic with an expressive, soulful telling of transformation against all odds and the truthful willingness on the part of the storyteller to come undone—anew. In some ways, it's the real life version of what *In the West* was attempting to create in "play" form. In a digital age where honesty and vulnerability are less witnessed via text, for example, I observe the audience discovering that to live, love, and breathe story in every form possible begins with the well-lived life—and the solitary voice willing to share it. By "well-lived" I mean always at the root of the story is an individual willing to make meaning of what shows up in their lives.

Storytelling, I am finding, is big medicine for both the storyteller and the listener. (And the research shows that it's physically healthy for our hearts and brains.) Narrative is now known to support bilateral integration of left and right hemispheres, neurological integration of upper and lower brain, nervous system/emotional regulation, cohesiveness, resilience, and healthy relational attainment (*The Developing Mind* by Dan Siegel). I am the privileged one witnessing the seed from where the next story begins—which originates with the impulse of a perfect stranger to sign up or say—"I have a story about..." and then enters into process with me through dialogue.

As the curator/dramaturg of the story, we witness quickly how time and the time limit per slot becomes the "artful" crafting of the tale. It isn't different from workshopping a play—in this case, a one-person "short" play. It is this interaction, I have noticed, from which lasting community and faithful attendance of the event begins.

In the six years I have hosted this event, I have seen firsthand that

nothing is more "holistic" or contributes more to "community wellness" than one solitary storyteller at a time, telling their true experience unabashedly to the audience. The diversity in age, occupation, and race, which on any given night can range from the girl next door to one of our Texas state elected representatives, telling their individual, very personal, true tales right next to the other, *does* capture our "gather around the campfire" attention. And—it keeps it.

If a group of theatres were to collaborate within the same city or across cities and states to share resources and ideas focused on audience evolution, maybe that would involve one "little" show a season, one storytelling series at a time, traveling to a different venue in the same city or across cities and states, and "re-place" one offering in their host theatre's season. We could Airbnb shows! We step into each other's lives, apartments, and lifestyles like the Greeks used to do during Dionysus festivals, where you were given permission to leave your "identity" for a short time to take on a new "life" or person for a time, knowing full well you will return home again renewed for having done so. And—we'd have a great story to tell the community about it— renewing our coffers for the next offering!

Amparo García-Crow is a multidisciplinary artist who acts, sings, directs, and writes plays, screenplays, and songs. Recently, as an artist-in-residence with Mabou Mines, she began developing *Strip*, a new musical, and her *Unknown Soldier: The New American Musical of Mexican Descent* is featured in Hector Galen's PBS documentary *Visiones (Visions): Latino Art and Culture*. She is founder and host of "The Living Room: Storytime for Grown-ups" and is currently a teaching artist at Austin Community College, after serving as the inaugural program manager for the City of Austin's new $16-million Mexican American Cultural Center. A collection of her plays, *Between Misery and the Sun: The South Texas Plays*, is published by NoPassport Press, with an introduction by Octavio Solis. She is based in Austin, Texas. Visit her at *www.amparogarciacrow.com*.

MILTON: A PERFORMANCE AND COMMUNITY-ENGAGEMENT EXPERIMENT

Katie Pearl, Lisa D'Amour, and Ashley Sparks

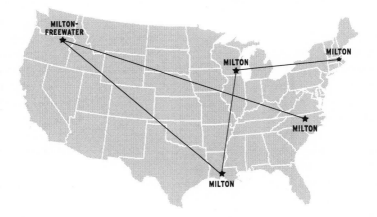

PearlDamour has built our body of work in cities—Austin, Minneapolis, New Orleans, and New York—primarily in edgy, experimental theatres under one hundred seats. Conversation about our work has circulated within a relatively small, urban network of artists, educators, and theatre enthusiasts who are interested in a conversation about aesthetics and form—how can theatre continue to break away from linear narrative? How can interdisciplinarity help us reinvent/reinvigorate/reimagine the theatrical event? These rigorous conversations helped us grow our work and build a tight community of audience and collaborators. Recently, almost accidentally, we got curious about moving outside of our "urban bubble" and developing a piece for and with rural communities. For the past two years, we've been working on *MILTON*, a theatre piece and community-engagement experiment. We've been visiting five towns named Milton—in Massachusetts, North Carolina, Louisiana, Wisconsin, and Oregon—interviewing people about their lives, towns, and worldviews. In each interview we ask: *How did you get to Milton? What is your advice for future generations? If you could change one thing about the world, what would it be? Why do you think we are here on this earth?* Slowly, we created a theatre work inspired

by these interviews: a three-person, spoken-and-sung performance that incorporates sound collages taken from the interviews and video of the sky over each Milton.

We recently premiered the show in Milton, North Carolina, a town of 250 people on the North Carolina/Virginia border. The journey to get the show to Milton, North Carolina, taught us incredible life lessons about the time and effort it takes to cultivate an audience and about art as a catalyst for conversation and action. And now the process continues as we work toward performances in the other four Miltons. Throughout all phases of the project, we—Katie Pearl (project cocreator and director for the performance), Ashley Sparks (project cocreator and community-engagement strategist/dramaturg), and Lisa D'Amour (project cocreator and playwright for the performance)—work closely and fluidly. In this article, we jointly consider our own ethics and strategies of engagement.

Meeting the Miltons: Engagement As Intimate Creative Encounter

As outsiders, we embark on a twofold process for engagement with each Milton. First, we do our homework as artists. As a team we articulate why we are doing the work and identify our dreams about the potential impact, engaging each other in ongoing conversations to get clarity on the intentions, motivations, and values that are critical to our process. And second, we do our homework about and with the residents of Milton. From community asset mapping (identifying the local talent in town, which might include artists, cooks, organizers, electricians, preachers, poets, and so on) to attending church on Sundays, from afternoon hangouts at local businesses to attending community meetings, this type of homework values the development of personal relationships. It is grounded in curiosity, and takes as its practice deep, active listening. As an outsider, it requires time to build trust with the people you'd like to invite into a creative encounter. The *MILTON* process is intimate and personal, and we are transparent that we are approaching each Milton as a long-term long-distance relationship. We also are transparent about our own lives, which feels like an important risk to take as, together with these towns, we actively seek an honest common ground.

SNAPSHOT:
Katie is sitting with her eighty-nine-year-old host, Ms. Jean Scott,
in the kitchen one morning. Over coffee, Katie tells Ms. Scott

that she has a "female partner" who will be coming to Milton to see the show. Ms. Scott nods, nonplussed. "That's just fine," she says in her slow, rich voice. "What you do is your business. You are both welcome to stay here."

Creating the Show: Engagement As Content Building

Our engagement always begins with conversation about life in Milton. We might start with the mayor, the head of the garden club, a church official, business owner, speaking with them in places where we are clearly the guest (someone's living room or office or maybe the basement of a Baptist church). We begin with the four questions shared at the top of this article; the conversations inevitably wind their way toward the challenges and opportunities in that particular Milton. These meetings provide material and content for our show, but they also plant the seeds of an exchange that continues to grow. Individual conversations lead to organizational, municipal, and institutional partnerships, where the discussions expand to include reflections and perspectives representing different aspects of the community, including their hopes and dreams for that particular Milton.

SNAPSHOT:
Lisa and Katie finish a tour of the Thomas Day House, a museum dedicated to the life and work of the free black cabinetmaker Thomas Day, an important Miltonian from the early 1800s. Their tour guide, Joe Graves, stares them down through his big glasses. "Now, what you girls are wanting to do here in Milton," he says, "could have a significant effect on this town. I really believe that. We have good, energetic people here. This could really be something."

Catalyzing Change: Engagement As Community Development

As we listen to these reflections, we start to dream, ask more questions, offer ideas, try to suss out the information and resource gaps. The process is reciprocal: The interviews feed the artistic content for the performance, while the answers to community-based questions feed the generation of engagement ideas amongst the residents themselves about challenges they face. As an artistic team we talk about what tools we have that might be used to address those challenges and/or instigate community imagination. We'll host informal gatherings and ask people

what they want to see happen in their community. We create catalytic space for people to come up with their own solutions and then integrate our own artistic impulses. It's an organic collaboration that arises both because we've taken the time to build trust, and also because we have a real interest in having the community play *with* us (rather than us playing *for* them).

We find ourselves instigating ideas about which our local partners then make concrete decisions. How or will these ideas be brought to life? This combination of our open idea factory couples with strong local leadership. We are not working in a model that is solely about the community coming up with solutions; rather, we recognize that as outsiders and artists there is value to us bringing different impulses, ideas, and methodologies. It is a collaborative dance where we and the community are leading at different times. We wouldn't be able to do this without a foundation of trust and openness of our community partners to try new ideas. The artistic success of this project relies on a range of voices and audience being in the room—we'll do the work to ensure that happens in both the show and our in our engagement activities. Along the way we share our tools and provide trainings, which will leave the community with tangible skills after we are gone.

SNAPSHOT:
Lisa and Katie sitting in the Thomas Day House in January 2013.
We've asked community members to gather to learn more about our show, and to explore a collaboration that could happen months before the show, to build interest, create context, and help us meet more people. We were going to propose something like a potluck. We pose the question to a room full of about twenty people. Shirley Cadmus, who runs the Milton Studio Art Gallery raises her hand. "I'd like to propose a Guild Day, where artists can do demonstrations and sell their artwork." Within the hour this idea grows into the First Annual Milton Street Fair, an event that would bring the whole town together to plan and make it happen.

The First Annual Milton Street Fair: Engagement As Community Collaboration

At the end of that first meeting, the street fair held the potential to be a dynamic community event that showcased the town's assets and brought vendors, craftspeople, musicians, tourists, and dispersed

residents together to celebrate and experience Milton. It felt like a risk—the town hadn't done anything like this before—but an exciting one. PearlDamour joined the planning committee, participating across distance through e-mail and phone calls. We arrived several days before the fair to help with the final prep—errands, sign- and mapmaking and so on.

The street fair was an enormous success, not only in building awareness about Milton in the region, but giving residents a strong sense of confidence in their abilities and pride in place. It brought hundreds of people into their usually sleepy downtown area to eat, play games, watch art demonstrations, and learn about the history of Milton and significant residents. PearlDamour used this as a time to introduce our aesthetics to the community. We hosted two events that tied directly into our project: a "cloud-making" workshop to introduce people to an element of our performance (in which we build a cloud in the space), and a "Milton memory sharing" conversation for local elders (which we videotaped and then sent back to the town for a civic archive). We wanted to do something that added to the spectacle and joy of the event, so—hearkening back to our New Orleans roots—we made a set of bright yellow "Street Fair Umbrellas," covered in sequins and ribbons, and passed them out in the morning to be used throughout the day. They added a great visual splash to the festivities and worked as a kind of celebratory glue, circulating throughout the fair. We also manned a table with photos and artifacts from our past performances, and chatted with people about the upcoming *MILTON* show—capturing names and phone numbers as we went.

SNAPSHOT:
Two p.m., Saturday of the street fair. Walking down the steep incline which is the main road through Milton. On the left, in the parking lot of the shut-down gas station, people are in line for fish sandwiches and sno-cones from the High Street Baptist Fish Fry, and for fresh vegetables from Donald Lea's vegetable stand. On the right is Milton Presbyterian Church, where local actor Fred Motley is performing his piece on Thomas Day. You walk over to the covered sidewalk outside the main businesses, stepping over whimsical artworks created this morning in the sidewalk art contest. Outside the art gallery, Shirley Cadmus has a crowd gathered as she demonstrates how to make a "face vase" on her potter's wheel. Across the street, the cornhole tournament is in full swing. Further down on the sidewalk,

*owners of one of the antique shops are passing out cold slices of free
watermelon, and Herman Joubert, a local resident, plays James
Taylor on his guitar. And if you keep walking, you wind up at
PearlDamour's info table, with a display about the other Miltons,
and their past work. Later that night, you hear Cleota Jeffries, a
ninety year-old Milton native, say: "Milton is in bloom."*

Through our participation in the street fair, our project became
embedded in an ecosystem of arts and community togetherness that
emerged from the needs of this particular community. It was a mutually
beneficial event for PearlDamour and the town and, as a result, residents
began to feel more ownership over and familiarity with our *MILTON*
project—they became our best marketers and advocates as the piece
moved toward its premiere. Our audience developed through making
something with the people who would eventually come see our show—
traditional marketing tools like print, radio, or TV ads felt flat and
uninspired in this context. As we built the Street Fair with the town,
the town built trust in us—which made it easier and more exciting to
move forward together, and get the word out about the show.

Preparing for Performance: Engagement As Marketing

In North Carolina, as we prepared for the play itself, there were two
things that motivated us: First, we wanted to make a performance
that reflected the host community back to themselves, creatively
and respectfully, without letting go of our experimental aesthetic or
simplifying the complexity of our experiences (or theirs). And, second,
we wanted to help the audience get to know *us* so they would feel
curious and interested enough in what we were doing to want to come
to the show; once there, we wanted them to feel welcomed and safe
within what was sure to be an unfamiliar experience (one strategy was
simply to keep saying, "Well, it's not going to be like any play you've seen
before!"). Producing and bringing people to our work meant a deep and
mutual getting-to-know you process. It meant that our marketing *was*
our engagement.

We also did all the usual marketing—we made posters and published
to online media outlets. We did a radio interview on the local NPR
affiliate that brought nonresidents to the show. And we used grassroots
systems that included a reservation signup sheet at the local post office,
stuffing the city water bill with a show flyer, making announcements

at churches and signing up audiences after services, and setting up a 1-888 reservation line that personally confirmed reservations. These final marketing strategies were effective only because of the deep collaboration that had been built between PearlDamour and the town of Milton over the past year.

SNAPSHOT:

Ashley is perched on a porch in Milton, returning reservation calls on her cell phone. With limited phone reception, sometimes returning phone calls is tricky. Other times people were happy to stay on the phone for a long chat. She heard one story from someone who accidently called a different 1-888 number and ended up on a sex-time hotline.

Bringing the Show: Engagement As Performance

We knew we wanted the piece to reflect our experience of *all* the Miltons, with a special focus on Milton, North Carolina—a tall order for a piece that we wanted to keep in the realm of seventy minutes! How to pack that wealth of experience—all the surprise, specificity, and idiosyncrasy—into one piece? To begin, we turned to one of our documentation tools that we call a "sometimes list." We kept this list while on research trips—they were strings of details and images that we wanted to remember about each day. They included things like: "Sometimes you are taken out to the garage to see the pecan-shelling machine," or "Sometimes you eat Chinese food with a cowboy balladeer." We loved these lists. They felt vital, immediate, and alive to us. As we started the scripting process, we wondered if our list could *become* our script. In the end, it became a frame for the script, with recordings and longer monologues about specific Miltons mixed in. It is a pointillist approach, using bits of images and experiences to move toward an ultimately ungraspable whole. This structure also speaks to our "Milton Constellation"—an image that has guided us from the beginning and that has become the brand for the project (you can see it at the top of this chapter). An earthbound constellation with "our" five Miltons as its points, we look toward the Milton constellation to help orient us within the vast concept of "being American."

As we developed the piece, we also considered carefully how to cast it. We considered making the show for untrained actors, and hiring locals to perform. However, our work often involves a complex vocal

and physical score, and since so much about this project was new to us, we decided to work in ways we were most comfortable, which in this case meant in New York City, with NYC-based actors. This also gave us the opportunity to bring more people from New York to this town that had captured our hearts.

SNAPSHOT:
Over and over again, residents said to us: "We can't believe you all came to little old Milton." There was a sense the town did not know what a special place it was. As outside artists and devoted visitors, we could notice and celebrate things this town could not notice, or did not have time to celebrate.

Performing the Show: Engagement As Audience Interaction

One of our favorite experiences while performing in Milton, North Carolina, was watching a Miltonian recognize themselves or a friend referenced in the piece. We arranged the seventy-person audience in a loose circle: five groups, several rows deep, Quaker meeting style. The actors sometimes sat with the audience, sometimes stood in the center of the space, sometimes crisscrossed to different audience banks. Details about all the Miltons flew rapid fire, with North Carolina images peppered throughout. It was inspiring to see a certain bank of seats light up because the person we mentioned in the script was sitting right there! By the end of our run, the actors knew a lot of people in town, and they would know when someone from our script was in the room. An example: When the script mentioned the man in the Carhartt overalls who made earrings out of fishing lures, the actor improvised: "Taco, can you please stand up and take a bow?" And the artist stood up and took a bow. So while the aesthetic of our show may have been unfamiliar, the text was layered with details about the town that became points of connection and entry for Miltonians. It was deeply fulfilling to have found a way to be true to our experimental roots while also providing a platform for these residents to be welcomed and seen. You can see a five-minute trailer of the show here: *www.skyovermilton. com/what-is-this.*

In Conclusion: Engagement As Big Picture

Making the performance of *MILTON* and activating all the concurrent

creative activities in Milton, North Carolina, as we did, were inherently collaborative acts. We often think about the gift of reflection: The town residents shared their lives with us, and then we reflected back their stories, memories, and history back to them. As outside witnesses, we saw the poetry of people's lives and then brought the wonder of that into creating a theatrical, meditative, and conversational space for those same residents to experience. In this way the show is both *of* and *for* the residents of Milton. The creative programming that went along with the project was sparked by us but shaped by residents. Now, with support from a local foundation, we've been back several times since the performance occurred. We are providing professional-development training to support the planning and design for the Second Annual Street Fair and also for a new, ongoing Summer Performance Festival, inspired by the presentation of our show. We are so gratified that our work can continue in this way—and also are just happy to go back and hang out with our new friends and catch up on the town news.

Working on this project in general and in tiny Milton, North Carolina, has made us understand how engagement and marketing can be the same thing. In fact, in this project, the relationship between engagement and marketing was not only possible, it was necessary—and, to a certain extent, it was unavoidable. We still have questions—and we still have four more Miltons to present the show to. We recognize that as a small team operating outside of large theatre institutions, we can be more flexibly responsive and nimble than large organizations often can be. But as we think about sharing what we've learned with the larger theatre community, or taking PearlDamour's knowledge into our next project, there are things we will all need to consider: When the work isn't built from the voices of the community, what motivates artists toward this kind of deep relationship building with their audience? What motivates the potential audience toward interest and curiosity in the artists? What are the constructs that bring these two entities—artists and audiences—together? Answers will vary, of course...but we will tell you this: If you find yourself in a small town named Milton in North Carolina, you might find the answers while sitting at the breakfast counter of the Milton Tire and Grill, chatting with the mayor, or the leader of the High Street Baptist Choir, or any number of other Miltonians who have decided to drop by that morning to find out what's new.

Katie Pearl and **Lisa D'Amour** are Obie Award–winning interdisciplinary performance makers. Engagement strategist **Ashley Sparks** is a core collaborator for *MILTON*, guiding the dramaturgy and relationship-building in each community. Visit *skyovermilton.com*, *pearldamour.com,* and *ashleyasparks.com.*

NEW OPPORTUNITIES FOR SURPRISE

Steve Moore

Within the last year and a half, we've been able to double the attendance at our live theatre events—as an unintended consequence of an absurd experiment with technology....

In an effort to push the limits of the kinds of stories we can tell and the ways that we can tell them, we've been creating plays to be delivered exclusively via text messages. No set, no lights, no venue to go to. Just the individual audience member and his or her phone.

The first of these was *Computer Simulation of the Ocean*[1]—a romantic, supernatural, psychological thriller told over the course of six months, from April to October 2014. We sent messages about four or five times each week from three different characters. If we'd known in advance what was going to be involved in terms of technology, infrastructure, and even writing, I'm not sure we would have attempted it, but the idea kept seeming fun and we kept trying, despite many setbacks and blind alleys. In the end, we made it work—artistically, technologically, and even financially....

Because we had hours of volunteer help from a very bright computer programmer and because each text message we sent cost us just a cent, we were able to make the "show" available for free—and not just to those in Austin but to people across the country. After a small marketing campaign over social media and e-mail, over 1,100 people subscribed. Most of them were in Texas, but in the end we had subscribers in forty-five states, Washington, D.C., Canada, and Puerto Rico.

The story took six months to tell, in part because its events happened in real time and in part because we wanted it to feel like a set of real text message conversations, which for most of us play out over long stretches of time. To foster that feeling of immersion, the messages themselves arrived at random times throughout the day, and they were addressed directly to the receiver. On the face, they were indistinguishable from any other text the person might receive.

What could easily have seemed cheesy, tedious, or robotic, instead felt personal. Yet, because the show was free, because we made it easy to unsubscribe, and because we sent only a handful of texts each week,

[1] *https://physicalplant.org/computer-simulation-of-the-ocean*

the commitment we asked from the audience was gentle and slight. We wanted the story and the storytelling to feel intimate and surprising, but never invasive or demanding. It wasn't everybody's cup of tea (and some people simply unsubscribed), but for the rest, it built a genuine connection.

I mention all of that background in the context of encouraging audience attendance at live events because the connections we made to our text-story audience have allowed us to send follow-up texts (judiciously and infrequently) to those same people to let them know about our live events. The first time we did so, we didn't know what to expect. We thought we might lose big swaths of the audience if we used their numbers to send a notice for something else—and I think we would have if we hadn't earned their trust over the course of those six months. Instead, they've given us the benefit of the doubt and shown up in large numbers to the live shows. I think as long as we continue to earn that trust by delivering good and intimate work and demanding little in return, they'll stay with us and will look forward to more—whether on their phones or onstage.

Obviously creating free text message stories isn't right for every theatre company, but for us exploring this new territory has inspired some helpful questions:

- How can we make a connection to a potential audience member using the art itself, rather than talk or advertising about the art?
- How can we lower costs in order to be more generous?
- How can we make something that's easy to enter and easy to exit, which nevertheless strives for intimacy?
- How can what we make spend at least part of its life in the real world rather than in the theatre? And related questions: What are the new opportunities for duration? What are the new opportunities for surprise? What are the new opportunities for a light touch?

Steve Moore is a theatre maker based in Austin, Texas, and is cofounder of Physical Plant Theater.

THEATRE AND THE NET:
PROJECTS AND POSSIBILITIES

Brian Bell

Theatre is an analog art form. It lives from the moment-to-moment exchange between audience and performers. Nowhere is this more true than in Germany, where the infrastructure for creating theatre has not changed significantly in a few hundred years. At the German National Theatre in Weimar, where I have been working since 2013, they still do not have Wi-Fi in the building. So it should come as no surprise that in a place where the internet has not yet reached the rehearsal hall, the idea of "digital theatre" is still treated with a fair amount of skepticism.

I was therefore very curious to attend the "Theatre and Internet" conference at the Heinrich Böll Foundation in Berlin a few summers ago. The conference was coproduced by Nachtkritik.de, an online portal for theatre reviews and cultural journalism about theatre in German-speaking Europe. The purpose of the conference was to question how internet culture influences the theatre and to search for a new definition of artistic practice in the digital age. I attended lectures and panel discussions about the role of the internet in theatre, the importance of online reviews to the broader critical conversation, and the implications of the internet generation on the future of theatre audiences.

At the same time my cousin Renick Bell, an experimental electronic musician who lives in Tokyo, was in town. He was in Berlin for a conference, presenting a paper on a computer program he had written that translates live computer coding into a visual element, in an effort to make laptop music more accessible to a broader audience. Renick was telling me about the difficulties he faces finding venues and audiences for his work. Whether he is working with club managers in Tokyo or academic presentations in Europe or Australia, finding the right configuration of projection screens, DJ setup, and audience orientation is always a struggle. Although the content that he and I produce could not be more distant from one another, we often find ourselves facing very similar logistical concerns. And every time we sit down and talk about what we do, I am keenly aware of the technology gap that

exists in the theatre.

So there I was, head full of new input about the possibilities of using the internet as a tool in the theatre, when Renick asked me:

"Have you ever made a play with Skype? Like where the audience is in another room or another city or country, and they witness the event projected live via Skype? Or considered teaching a theatre workshop digitally to students on another continent? Ever thought about making theatre in a club with the soundtrack improvised live by an electronic musician? Or what impact that would have on the storytelling?"

(Honestly, I had not thought of any of those things.)

What was so interesting to me about Renick's questions was that they were so different from those that were being asked by the theatre professionals at the "Theatre and Internet" conference. Up until then my main point of reference for current innovative theatre models that were challenging the status quo had been Punchdrunk and their huge immersive projects like *Sleep No More*. But despite its innovative approach, *Sleep No More* is in many ways a traditional piece of theatre: One buys a ticket and interfaces with a piece of literature (in one form or another) as an audience member. The existing theatre conventions are in place.

Similarly, most of the events I had been attending at the conference were dealing with ways the theatre institutions were observing internet trends (mostly in marketing) and attempting to incorporate them into the normal day-to-day operation of their theatres. Renick's questions were provocative to me because they were calling those day-to-day operations into question.

The impulse I received from him sparked a lot of new questions in me: How can we use the internet as a theatrical tool? What does live storytelling look like in the digital age? How can we use the connectivity of the internet to reach new audiences and connect with artists around the world? What are the impediments to incorporating digital technology into our practice? Are theatre artists in other countries grappling with the same issues? And if so, how are they solving them?

That same week I had the pleasure of meeting Amitesh Grover, a theatre artist from Delhi, India. He was in town for the International Forum of the Theatertreffen festival and he gave a presentation about his theatre work in India. It was as if the questions Renick had asked were being answered by Amitesh. He told us about a piece he had created together with Michael Weber (Switzerland) called

Gnomonicity, where the backdrop for the show was a live-feed from an actual CCTV camera somewhere else in the world. The backdrops would change throughout the performance, so that at certain points the scenery would be a street corner in London or a café in Bern, Switzerland. Amitesh told us about the (il-)legality of the project, how he had spent hours hacking the CCTV cameras all around the world, and the singular weirdness of spending so much time observing people in other countries while he created the piece. There was one man who evidently drank his coffee every day in the café in Bern at exactly the same time, same table, and had no idea he was being projected onto a stage as a backdrop for a play in India.

Another of Amitesh's projects, called "Social Gaming," involved setting up laptops in public squares in multiple countries and organizing a sort of intercontinental scavenger hunt. One group of participants would be asked to buy some street food with the change in their pocket and then describe the way it tastes (without giving away what it is) via text message to the participants in another city. They were then required to buy something that tasted similar in their city and then pass it on to the next group. After an hour of these simple exercises, all of the groups came together for a mutual Skype conference and chatted about the experience.

For Amitesh, internet theatre "questions traditional hierarchies of theatre and opens itself up to collaboration and co-making, across disciplines and continents." His presentation really got my gears working as far as what was possible with the internet and performance. It also raised some even more complex issues: questions about privacy and access, in the case of the CCTV set, but also aesthetic questions, like: What does theatre look like in the twenty-first century? Does a Skype-facilitated intercity, intercontinental scavenger hunt qualify as theatre? Why or why not?

To add yet another layer of complexity, that week I received an e-mail from my colleague Tom Arvetis in Chicago with two very important links: one to the Future of Storytelling website (a group of folks who are all engaging deeply with these same questions) and one to the Conspiracy for Good website, which seems like the next logical step in putting the audience at the center of the storytelling. Conspiracy for Good is part social network, part fundraising platform for third-world causes, part staged happening, part networking hub. The founder (*Heroes* creator Tim Kring) refers to it as "social benefit storytelling" or an "augmented reality drama." The production value resembles

that of a Hollywood film; it's backed by Nokia and has every type of digital integration imaginable (cell phones, tablets, apps, etc.). It's a hybrid model that takes the best aspects of live performance, online connectivity, and epic storytelling and integrates them into a thrilling user experience.

So the question I keep asking myself one year later is: What do all of these diverse new storytelling forms have to do with my own practice? Conspiracy for Good is an enormous undertaking—as are the Punchdrunk productions, for that matter. I'm not suggesting that theatres should necessarily try to compete at that level, but both productions, as well as Amitesh's digital experiments in India, have one thing in common that should be a clear sign to all of us dramatic storytellers: They treat their ticket-buyers as *users* rather than as *audience members*. This is a fundamental shift in the way one thinks about creating dramatic content. The next generation is interested in being a part of the story; they want a direct-user experience instead of a passive-audience experience.

Don't get me wrong, I'm a huge believer in classical theatre. Of play-plays. Of well-crafted evenings of theatre, ripe with the technique and virtuosity that is singular to our art form. I live for that, and it is what I spend the majority of my time doing. And at the same time I cannot help but think that these hybrid forms—where the internet, digital technology, and social networking fuse together to create an immersive user experience—will play a big role in the future of our art form.

Which takes me back to my conversation with Renick and the questions that have been following me since then. I am starting to unpack some of those big ideas to try and see what implications they might have for our current theatre practice.

Perhaps we should start to think of season planning in terms of user-oriented experiences as well as audience-oriented experiences. Perhaps we should be more proactive about using technology to connect artists and productions not just nationally, but globally.

- How can we use the internet as a theatrical tool?
- What does live storytelling look like in the digital age?
- How can we use the connectivity of the internet to reach new audiences and collaborate with artists around the world?
- What are the impediments to incorporating digital technology into our practice?

- The sooner we start experimenting with digital technology as a connective and performative tool, the sooner we can start answering some of these questions.

Brian Bell is a stage director and performer based in Berlin. Originally from Texas, Brian's work ranges from contemporary American plays, including those of Tracy Letts, Naomi Wallace, and Neil LaBute, to world premieres of new plays and devised works. In 2014 he made his directorial debut at the German National Theatre in Weimar with Tracy Letts's *Killer Joe*. The production was taken into the GNT's repertoire for the 2015–16 season.

SPACE FOR THEATRE

Jake Witlen

Inside a cavernous and frigid abandoned *kino* (movie theatre), deep in Berlin's former East, something magical is taking place. As the orchestra tunes their instruments, the audience is warming themselves with slow-dripping absinthe and champagne and the artists are crouched underneath the stage in a dungeon-like dressing room. The candles flicker on the tabletops as the first notes of our surrealist opera take flight. During the show—an operatic adaptation of a text from Apollinaire, who coined the world "surrealist"—the space becomes our muse, our guide, and our executioner. The bat that flies across the space during the show is unplanned, but an omen that says we have pleased the ghosts of this *ehemaliges Stummfilmkino*.

In 2012, those six weeks inside that icy theatre changed my perceptions on the what, where, and why of making theatre. Almost a year after moving from New York to Berlin, space became the foundation of new perception on creating theatre.

Art requires a vessel to carry its message. Whether that vessel is a hypermodern theatre, an ancient amphitheatre, or an alternative venue, theatrical arts cannot exist without space. Never has this been clearer than in our current times, when funding and venues are drying up like the Sahara, and artists are forced to evolve to find new and unique ways to present their work. While venues will always come and go in dynamic cities, losing the opportunity for artists to dream big in grand spaces is a blunting force against enlightenment. Space carries with it history, and audience and actor must breathe the same air during their hours there together. This is what separates us from film, from TV, from fine art—the nature of shared space. History gives us a common palate from whence to work, whether at Brecht's Berliner Ensemble, Shakespeare's Globe, or walking the boards in old Soho lofts where Andy Warhol or the Wooster Group might have once staged an experiment. The space itself influences the work that will be born.

History is made in the present, but our collective history is what influences the future. This generated history lives in the air of a particular space. Theatre, of course, does not need an ancient vessel to inspire us. It does, however, need space—any space!—to let our

imaginations fill. In today's real-estate-centric reality however, our creations are sadly stifled by the spaces available. As an anecdote, I offer a recent teaching experience.

A group of students from New York visited me in Berlin for a workshop, and the first thing they remarked upon entering the rehearsal studio was, "Wow, look! No columns!" Inherent in their understanding of creating was the simple truth that one must learn to avoid physical obstacles before being able to delve deeper into the work. Finding clever solutions to physical problems is naturally the work of any director, but a column in the middle of your stage is an external influence that inherently dictates the type of work one creates, simply based on the creativity and ability of a director to avoid said obstacle. The space itself becomes a guide to create provocative and intellectually engaged art.

But who has access to those spaces?

Inside of that abandoned theatre, just north of Prenzlauer Berg, I was forced to reimagine my own relationship to space as an artist. During the 1920s, the Delphi had once hosted decadent and glamorous screenings and parties, where stars from Fritz Lang to Marlene Dietrich might be showing their latest film. Miraculously surviving World War II, it sat derelict as a storage space in the GDR—an affront to its intended grandeur in a reach toward communal equality. When my collaborators chanced upon it one New Year's Eve, its very existence became the impetus for the work we would create. The show would not have worked in a traditional theatre, nor would it have worked in a completely alternative space—it was only made for this one, dilapidated former glory. It was electric.

Along with the physical location, we were also given space to create through financial support from state and local funds. However, more important than the euros we were given, were the intangibles offered to us from the community around. There is a spirit of sharing in Berlin that permeates almost all aspects of life and rewards both artist and citizen with top-notch education, health, and cultural opportunity. On the production side, projectors that would cost hundreds, if not thousands, of dollars a day to rent in New York were given to us for free. Set materials and electronics were shared or lent for little or no cost. The costumes were built by a local designer and rivaled the greatest pieces one could find on Broadway. It was not the artists who weren't paid, as is often the case in New York, but rather the technology and inanimate objects (sets, costumes, etc.) that were the ones without

compensation. It was the complete reverse from the method of theatre making I was used to, and the freedom was intoxicating.

Models of art making vary naturally from land to land, and culture to culture. What is apparent, however, is the divergence of what's being created between the capitalized theatre world (New York and London) and the more socialized experience of art making (Germany, the Netherlands, Denmark, etc.). The irony is: The scarcer money has become in the States and in England, the more our conversations exponentially revolve around it.

Whether one works as part of a collective, at a not-for-profit, or in an old-dog producing house, art has somehow slipped through the cracks, and the rat race of finding the money has become tantamount to delving deeper into work. It is not to say there is no good art in America or England—far from it—but it seems our model for creating theatre has become so centered around this one tangible fact that it becomes increasingly difficult to dream big or outside the box. For those brave souls who are exploring alternatives—from new venues to smaller and more flexible models of development—the emotional rewards and accolades can be huge, but supporting a family or paying rent remains a challenge to most.

To nurture anything is to give time to solutions and to luxuriate in the unknown. Financial security helps us to realize these dreams, but it is the audience who must always remain in the center of the equation. In New York, aside from the money generated from tickets, the audience is almost totally ignored or infantilized; we worry about offending or receiving bad reviews, but never about how the work will change their perspective. We aren't rewarded the *space* to have deeper conversations, simply because we need to fill every seat and charge as much money as possible. Having a trusting audience ready to jump into the abyss of the unknown and take a risk on the art they are willing to experience is what inspires the artist to push the boundaries of theatre and not be afraid of alienation and bad reviews. The vessel became not only the space itself, but the entire society to which it belongs.

In New York and London, we are losing spaces to make room for banks and pharmacies. While there is a growing movement to explore alternative spaces and the very nature of how theatre is presented to an audience—be it on the internet or in a taxi cab—many of the changes are a result of our temples being destroyed for the sake of profit. Our ingenuity is breathtaking, and technology and unique

experiences can indeed create new and previously undreamed of spaces. But we must give ourselves space for rehearsals, for production, and get away from the current dead-end path of permanent "development" as ersatz productions. We need audiences who are intellectually curious and emotionally adventurous. And we need to not be afraid of upsetting them.

As an American living in Germany, my understanding of healthy working models has changed dramatically. The two basic models of theatre making in Berlin are as follows: One is to work at one of the many state-supported theatres, operas, or ballets (Berlin has eleven state-funded theatres, out of 150 total in Germany). Many are staffed with ensembles of actors, directors, and designers who present a dizzying rotation of work, both new and old, in repertoire. The second method is to find space on your own and, in turn, receive funding from both foundations and state/city organizations to develop your work.

Space in Berlin, while ever diminishing, is never too hard to find. Even as more and more of the abandoned spaces are taken over and turned into functioning (and legal) art spaces, work spaces, and coffee shops, you're never more than a stone's throw away from an abandoned factory or house where you can create something. What neither of these models relies on is Kickstarter or board donations, allowing the artist to invest fully in the work, and less so on the day-to-day grind of finding cash. The space is enlivened by the intellect, not by the wallet.

After leaving New York, one of the most striking things I experienced as a director was the response of an audience to my work—there were no more false accolades or pats on the back. Instead I received from audience members long and intense discussions, describing in detail what they found worked or didn't work in my creations. Sometimes it was borderline aggressive, but it was always precise (as only Germans can be), and productively helpful in moving my own artistic vision forward. Without the burden of needing to pay for space, and having an abundance of resources available at my fingertips, I began to notice a fundamental shift in the work that I was making. I was inspired to move deeper into the work I was willing to investigate, and had the time to do so. The actors and designers with whom I was working understood this too, and being educated by a society comfortable with artists pushing back against the norms, we were able to stand on the shoulders of the past and look toward the future. I was working in a society influenced by artists from Goethe, Brecht, and Tucholsky in the past, to Ostermeier, Castorf, and Shermin Langhoff (finally a woman!) in the present, all

of whom had systematically conditioned the society to view art as a conduit for questions and not one for answers and entertainment. The societal influences of the past were now permeating my own personal styles and directorial choices.

This evolving understanding of theatre making had little to do with money, and everything to do with a society and its educated audience. The theatre I saw in the state system was almost comically accessible to the farthest reaches of society: €3–7 for a ticket for those on welfare, €7–12 if you were a student or artist, and a whopping €12–30 if you were just a normal *mensch*. I work today at an anomaly—a private theatre functioning in a state system (the Schaubühne)—and our audiences range from fifteen to ninety years old. Last year we presented at ninety-four-percent capacity, showing nearly 450 days of performances (we have four venues), plus 165 days out of town, from Beijing to Zagreb.

When we showed Ibsen's *An Enemy of the People* at the Brooklyn Academy of Music several seasons ago, one *New York Times* critic derided the production because it was too long (two hours without an intermission) and because of a real debate between audience and actors in the middle of the show, which the critic found insincere. The debate is offered between Dr. Stockmann in contrast to the corporate interests of Aslaksen, but is a freeform discussion that audience members are free to lead along with the actors. Our *Volksfeind* has played all over the world—from South America to Korea—and in each and every city the debate is polarizing and engaged, and often lasts quite some time. In St. Petersburg half of the audience rushed the stage, as chaos erupted between two factions of dissidents, and the actors had to offer a vote as to whether to continue the fifth act, or simply let the debate continue into the night. This space for theatre is offered not by Ibsen's words alone, but by a director's vision to engage with the work in the space that is given to us by the writer, and actors and audience willing to take the journey. In Brooklyn, the audience engaged quite astutely and intensely, but apparently the critics didn't think theatre was a space for debate (or two hours without a potty break) and lambasted it as intellectual exploitation.

Theatre allows us to hold the mirror to nature, to create a *Verfremdungseffekt* that can lead us to revelations that in turn change our society from the inside out. The damage of critics and audience not feeling theatre is a space for challenge or debate does a great disservice to the American theatre, because if we cannot debate or push ourselves intellectually in a theatrical space, how can

we imagine doing it in our social space?

Artists are a resilient bunch and overcome crisis in unique and malleable ways. No doubt this generation of new artists will also have the wherewithal to find space where there once was none in order to create unique and affecting theatre. Space exists wherever we create it, but we need to dream big and dream outside of the box. When I asked that group of students visiting me in Berlin what was necessary to create theatre, it was the *fifth* response that mentioned "an idea, or material." The four answers before that revolved around money, time, producers, and *space*. It is clear that Berlin offers something that may only last for a little while longer—a city whose history has left behind huge abandoned factories and hidden treasures just waiting to be filled with art—but it is in fact the society as a whole which creates the space for the artist to fill. In order for us to create healthy working models of creation in the U.S. and Britain, we need to start with the most fundamental asset—our spaces and our audiences. The rest will follow.

Jake Witlen is a video and theatre artist based in Berlin. He is the head of the video department at the Schaubuhne am Lehniner Platz, working side by side on new works with Katie Mitchell, Simon McBurney, Falk Richter, Romeo Castellucci, and Thomas Ostermeier. In the United States, his work as a director and designer has been seen in New York at 3LD, P.S. 122, HERE, and the old Ohio, and at Williamstown Theatre Festival in Massachusetts and Actors Theatre of Louisville's Humana Festival. Internationally, he has made and presented work in Ecuador, India, Romania, Germany, France, Russia, England, and Greece. See *www.jakewitlen.com*.

CHAPTER FOUR
Being

THE ACT OF RECOGNITION

Barney Norris

What I would like you to hold in your minds for a while is the idea of a theatre which is both a focus for and, crucially, an expression of the audience it serves. This is not a new, or radical, or particularly remarkable idea—it seems to me, in fact, to be a pretty basic component of the theatrical act. But it is an idea which I think merits some orbiting, because I don't believe it's spoken about or thought about as much as it might be, and I think its implications, and the possibilities toward which it gestures, are remarkable. I'm talking about a theatre which actually matters—an art form people actually need, rather than one sustained by arts graduates sticking with the theatre for want of transferable skills. That's what I want to think about today.

In my book *To Bodies Gone: The Theatre of Peter Gill*, I explored the way one writer made his work by collecting and refracting his experience of life into successive statements, so that the work of his life became a kind of intellectual biography—a shadow biography, if you will. I was interested to encounter Brian Friel ascribing the same creative process of collection and refraction to himself in an old interview recently (one of a selection collected in an excellent book edited by Christopher Murray for Faber and Faber, if you want to look it up). Of course, like so many writers dabbling in critical prose, I had been interested to explore this particular approach to creativity in Gill's work because it is my own. *To Bodies Gone* is in large part a shadow manifesto for my own work, as Auden noted the criticism of most writers usually turns out to be. To encounter another writer I admire claiming that creative process for himself was thrilling to me, suggesting as it did a link between us. I never met Friel, but to all intents and purposes he and I appeared to have committed ourselves to the same project.

Now, it is possible that this idea of writing makes Friel and Gill and myself distinctive. But I don't quite buy this. It's my contention that the process of gathering and refraction is at the root of the lives of most writers. This simple repetitive act is what a writer does, what a writer is. The infinite variation of outcome doesn't imply a variation in the basic process—it's the inevitable and fascinating result of infinite modulations in the experience gathered, and the way the mind refracts it.

The overwhelming majority of critical attention trained on the theatre is directed toward the second half of this writing process, the refraction of life into new statements—or perhaps not even to that, perhaps only to the consequences of that second half, the play itself as it appears on the stage, not the play's making. This makes a deal of sense: Criticism is primarily used by audiences on these islands to work out what they should go and see, so the thing they'll be seeing is a good thing on which to focus attention. Product is also more easily analyzed than process, of course. But I don't think it allows us into the whole of the conversation around any given play. Criticism of the finished product can show us something arguably, possibly anyway, about the process of refraction undertaken by the writer (or the company, or whatever, forgive me, I'm being unreconstructedly writer-centric here in the name of brevity). But it pays scant meaningful attention to the first half of the equation of creativity I have outlined here, the gathering of material, unless the play being explored is a dreadful sledgehammer that insists on showing its working.

This may be of limited importance to a professional literary critic, of course. I understand it is still possible to focus solely on analyses of completed works and function meaningfully in academia. But academics have responsibilities to fields other than the one they themselves graze in. Their work cannot help but inform discourse and prioritize attentions elsewhere. So I would like to imagine theatrical activity, for a moment, as a kind of social catalytic converter, absorbing material from the real world and transforming it by complex processes into something new. And I would like to ask: What value to a chemist is a process of conversion, if the materials that went in aren't known? How do we really learn anything from that? Shouldn't we begin our analyses of the work on our stages earlier in their development than we presently, habitually do?

I am interested in the creative potential of being conscious of every component of a theatrical act—input, control, and output. (Here, I think we land on the best metaphor for playmaking, better than "collection and refraction," because, of course, it's ludicrous to divorce the output, the play itself, from the process, but the finished product is not at all the same as the making of the finished product, just as the making of the play is nothing like the collection of material for the play, so I like this metaphor in three stages. I'm grateful to my chemistry teachers for making me listen long enough for this to go in.) If the collection of experience to make work is already the business of every writer, day

to day, job to job, as with Friel and Gill and me, then I wonder what possibilities might lie in store if we deliberately cultivated discourse around that collecting, encouraged specific attentiveness toward specific elements and events, explored what might happen if we fed different elements into the equation?

As I've said, this isn't a radical idea—it's basic to the process of commissioning: the application of a particular stimulus to a particular mind. But no one seems to talk about it very much, and the blunt truth is that a great deal of commissioning on these islands is hopelessly blunt-edged, serving many more priorities than it could possibly satisfy, and I feel convinced the potential exists for a more sophisticated relationship in our theatre culture with the way that work is made. And I think that's an important thing to encourage. I believe it is among the potentialities of this relationship that the possibility of a genuinely necessary theatre lies dormant. I think if we gave this idea of creativity some thought, we might find ways to plug theatrical work into the real lives of people more meaningfully than is ever achieved at present, except in fits and starts, and by accident. I think for those of us working in the theatre, who are doing so because we've been in the auditorium on one of those lightning-rare nights when the theatre does actually reveal itself as having something to say that nothing else on earth can say, it's our duty to make those nights happen for more people, more often. We know, after all, what they can do to you, how they can change you, how they can make things better. So I return now to the idea I want you to orbit a little while longer—a theatre which is both a focus for and an expression of the audience it serves.

Many people are perfectly comfortable with using the theatre as a means of escape, if they use it at all in their lives. I don't see that as the most valuable possible function of the art form. I think theatre can be a way of plunging more deeply, deliberately, thoughtfully into your life, of examining your experience of life through the kaleidoscope of another person's refracted experience (by seeing life deconstructed we afford ourselves the opportunity to put it back together in different patterns— to imagine new potentialities). Theatre can be a way of paying close attention to ourselves, our problems, our qualities; by doing this, it can be a way of inculcating greater empathetic understanding, a greater emotional intelligence in a community, of operating an empathy engine to combat the predisposition one struggles not to read into many societies to perform sociopathically. It can be a place where irresolvable problems are fruitfully analyzed and questioned, an impossible

process in analytic arenas built on binary models. (It's always struck me as interesting that in Athens, the home of democracy, the founding principle of so many of our subsequent societies, the theatre was built even quicker than the temple at the top of the hill. A space is required in a democratic society where the nebulous can be treated, ideas of mortality and need it's impossible to vote on. And, at least since the Greeks, that hasn't just implied the need for a religion; it's implied the need for a theatre as well.)

Theatre, by painting impressionistically, can tell truths about who we are that get closer to the heart of the question than any rigid naturalism the anthropologist will ever allow. (Have you ever read past the introductory chapter of one of Ronald Frankenberg's books? If you have, you'll know what I mean. All writers should read the first and last chapters of anthropologists but, in the end, nothing tells us less about people than brilliantly researched analyses of what they're like. In this, I'm in the modernist camp—fucking with the method of depiction can undoubtedly depict a thing far more accurately.) Theatre can inculcate a quietness in us, by asking us to look long and lovingly and hard at what we do, that creates space for thought where thought is often absent. (Don't we all get lost and distracted among the details of the everyday, the washing up, the bills? How often do we really think about the actual fabric of our lives, the detail of experience, rather than just plough through it trying to get to that bit of the day where we can be really happy, or really get on with whatever it is we really want to do? And yet what else is there but paperwork and housework and physical acts, ultimately? Surely we're missing a trick if we don't nurture a forum in which to pay attention to the physical living of life?)

The attentiveness I'm alluding to could be consciously cultivated in the work on our stages if we gave greater attention to the way life feeds into theatre. By focusing more thinking on the creative process, not just its end products, we could become more intelligent about the way theatre connects with life in the process of its germination. It seems to me that it is only from this position, from developing a nuanced understanding of the way we feed the world into our work, that we could ever evolve a process for feeding that work back into the world that made it genuinely necessary to society—a voice articulating us, a standard to rally round. It would be by directing our attention toward what is gathered up in order to be worked on and converted into story that we might make the theatrical act something more than an act of

abandon, sublimation, or ventriloquism and find a way to perform an act of articulation, exploration, affirmation, recognition.

Barney Norris is a critically acclaimed playwright, poet, and author. For his debut full-length play, *Visitors*, which ran at London's Arcola Theatre before transferring to the Bush Theatre in November 2014, he won the Critics Circle Award for Most Promising Playwright. His first nonfiction book, *To Bodies Gone: The Theatre of Peter Gill*, was published by Seren in February 2014, and his first book of poetry, *Falling*, was published by Playdead Press. He is the co–artistic director of the theatre company Up in Arms, and is the Martin Esslin Playwright in Residence at Keble College, Oxford. Barney's debut novel, *Five Rivers Met on a Wooded Plain*, is published by Transworld/Doubleday, 2016. This essay originally appeared in *Exeunt Magazine*, and is reprinted with the author's permission.

WE ARE NOT ALONE

Adrianne Krstansky

Today I came upon the funeral procession for Boston firefighter Lt. Edward Walsh. I stopped and watched as his family was led out of the funeral home and his casket carried to the fire truck to bring his body to the church. I watched his widow, children, parents, friends, and hundreds of firefighters mourn the loss of this man who so heroically gave his life to save others. I stood with hundreds of onlookers on the sidewalk. People had tears streaming down their faces. It was impossible to not be deeply moved by the sacrifice of this man and the loss his family—especially his wife and children—will now endure. It was impossible to not be moved by the magnitude of the respect and gratitude people displayed. Lt. Walsh's sacrifice is proof that we live in a culture where people devote themselves to the selfless care and welfare of their community.

The procession was carried out with ritual precision. I would not call it theatre. The participants were not there to be seen and some seemed to resent the intrusion. And those of us looking on intended a show of support, an offer of condolences. We were not there to be "served." We needed to take part in a communal ritual of grieving and assure ourselves that we are not alone.

There are many ways of making theatre that can "include" the audience—site-specific work, interactive theatre, installation, audience participation. The manner of doing this kind of theatre is one thing. The intention behind it is the other. Perhaps a useful question to ask is: Who is the audience? And what stakes do they or must they have in the theatrical event? Whether folks are onstage with the actors or twenty feet away, what are we all doing in that room together? Mourning? Discovering? Exploring? Imagining? Are we there to be surprised? And what role can we imagine the audience playing?

In April 2014, I had the great joy of seeing *Not by Bread Alone* by the Nalaga'at Theater at ArtsEmerson. The company is comprised of a group of blind and deaf actors from Tel Aviv. At the end, we were invited onstage to eat the bread the actors baked during the show. We were asked to touch the actors as we came onstage. For that is how they can best, as one actor put it, "know that you are there." A young woman ran onstage and embraced an actress who sat quietly waiting to

be approached. She needed contact from the audience—she needed to know, in her body, that we were there.

I have no answers, but I do know that this question of how we can "touch" each other, so we know we are not alone, is more resonant in our culture today than ever. And whether we break the boundaries down via space or time, I do know that the spirit of invitation—to touch, embrace, and share a meal, a ritual with the actors—may go a long way toward convincing us, in our bodies, that we are not alone.

Adrianne Krstansky is a Boston-based actor and currently associate professor of theatre arts at Brandeis University. In the New England area she has performed at Huntington Theatre Company, the American Repertory Theater, SpeakEasy Stage Company, Boston Playwrights' Theatre, New Repertory Theatre, and Commonwealth Shakespeare Company, among others. In New York City and regionally she has appeared at the Public Theater, Atlantic Theater Company, Steppenwolf Theatre Company, and La Jolla Playhouse. Film credits include featured roles in *The Company Men* and the HBO miniseries *Olive Kitteridge*. She holds an MFA from the professional actor training program at the University of California, San Diego.

ART IS PEOPLE

Roberto G. Varea

Since the time when I first set foot in a theatre as an audience member, I was simultaneously aware of that permeable border between performer and spectator and, also, of my desire to cross it. I remember vividly when, as a young Argentinean wrestling with the brutality of life under dictatorship, I attended a "clandestine" performance of *The Curve* by Tankred Dorst in my home city of Córdoba, and finally found the resolve to sneak over to the other side of that tenuous, but significant, divide. Albeit intuitively, it seemed to me that the value of theatre was not merely about what was happening onstage. As crucial as an aesthetic vision, a developed craft, or an engaging topic are to the practice, what matters most, I thought, hinges on the quality of the multiplicity of relationships present, particularly on the one between those onstage and those in the seats. What really allows for the experience to have depth and richness depends on this bond, this kind of ephemeral complicity, a blurry space between art and people, often defined, to varying degrees, by the nature of the risks taken by both artists and audiences to venture together into a place where surprises and insights can happen—where discoveries can be made. The risks back then also involved being caught in the act of acting, attending a banned practice, and unlawfully assembling with others in large numbers.

I decided to try out for the company. I was twenty-two, and had been in a play only once before as a child. The military had closed all university training programs. Like an undocumented immigrant in a foreign land, I didn't have much in terms of papers or recommendations. I could only offer a burning need as my safe conduct. I was granted an interview and communicated my desire to become an actor with such passion and clarity that I have rarely experienced anything like it since. Toward the end of the meeting, Cheté, the company's director, called Mario, the lead actor and company rep, into the office. He asked me a couple more questions. They looked at each other for a beat, smiled, and without conferring in private, she said: "Show up tomorrow at 8 p.m. with comfortable clothes. We are beginning to workshop our next piece, so you are just in time." "Don't be late," Mario said. "We lock the front metal door at

ten minutes past eight and no one gets in after that." There was more of a need for safety than respect for the craft behind that decision, I later found out.

Years passed before Cheté told me what she and Mario had really seen that day during the interview. It was not a convincing young man with promising talent and a deep desire to act, as I had long believed. She and Mario were astounded that both in semblance and personality that evening they saw before them the spitting image of a young Kelo, a founding member of the company who was abducted by the military a few years back, and no one had ever seen since. It was as if Kelo had come back, she said, and for a moment, was there again in the office with us. They were actually not taking anybody into the company, but the circumstances had convinced them to make an exception. That felt to me like a double affirmation. Wanting to become an actor meant something to me that had little to do with self-expression. I did not want to call attention to myself by stepping on a stage but, rather, to *ourselves*, to that larger and collective dimension of being that, through curfew laws, murder, torture, or disappearance, the regime was working hard to tear up. Also, I thought that perhaps Cheté was right, that on that fateful evening I was indeed possessed not only by my own desire, but by the spirit of Kelo himself. The spirit of reconnection, of mending relationships, had marked the process for all involved, in unexpected ways.

Reflecting on the painful legacy of the so-called "dirty war" in his country, Salomon Lerner-Febres, president of the Peruvian Truth and Reconciliation Commission, once told me: "Violence has a thousand faces, and all of them relate to the breaking of the bonds that give us both humanity and meaning." Dr. Lerner-Febres later articulated this brilliantly in "The Rebellion of the Masks," his foreword to volume two of the *Acting Together: Performance and the Creative Transformation of Conflict* anthology (edited by Cindy Cohen, Polly Walker, and myself). Before I knew anything about Brecht's breaking of the fourth wall or Boal's notion of "spect-actors" (both authors banned by the Argentine regime as "subversive"), crossing that borderland between front row seats and playing space meant venturing into a place where I could contribute to restoring at least part of our sense of belonging to something larger, some aspect of my own denied citizenship, of my own humanity.

Looking back more than thirty years, I feel that working toward developing creative spaces to be in meaningful relationship, particularly

inclusive of those most marginalized from civic engagement, has been the single most important building block and guiding thread of my work.

My first acting lesson upon joining the company (the TGC, or Teatro Goethe Córdoba) was to be taken to an inner patio, accessible through the backstage, and shown how to climb up on the roof and jump into a back alley to make a run for my life if troops, *paras*, or the police were to storm the theatre. The second lesson, implicit in the first one, and relating to the fact that the TGC had two other actors *desaparecidos* by the government in addition to Kelo (Alicia and Mirmi, thrown into the back of death squad cars after a rehearsal of *Señora Carrar's Rifles*) was this: Theatre mattered. In fact, it mattered so much that the regime censored it, shutting down theatres and theatre schools throughout the country and violently persecuted those who practiced it. If detained for any reason, which happened, the last thing that you would ever answer when asked, "Occupation?" was, "Actor." You might as well tell them that you have a bomb in your backpack.

I believe that this creative power that threatened some and inspired others has lots more to do with theatre's capacity to build that liminal space, where art brings people into a meaningful connection, than with the artistic craft alone.

Why take the risk of doing theatre at such a dangerous time? What Lerner-Febres formulated with such lucidity in reflecting on the role of performance in violent social contexts illuminated what had been the main reason for me to join a company and what makes performance artists so subversive to a totalitarian mentality. I needed to make sense of a life torn apart by violence and the resultant distrust of one another. Without engaging these unknown "others"— sisters and brothers who, like me, felt lobotomized from a communal consciousness—I could not fully understand my circumstances and value my very own sense of humanity.

It has taken me years to articulate what I only then knew viscerally: that theatre/performance/art was a most profound, immediate, and effective way to engage in the kind of relationship of mutuality that would restore "the bonds that give us both humanity and meaning."

Theatre/art is meaningful and impactful not necessarily when artists put their lives on the line to deal with socially or politically taboo subject matter. Rather, I believe and experience in my own practice that this is so when we become truly mindful of our part in sustaining that

paradoxical space, that borderland realm between personal artistic expression and social imagination. Engaging a collective poetics on a feedback loop with audiences gives birth to language, images, to a symbolic world where the burning questions of the real one can be examined in ways that rarely happen in creative isolation, in the model of "artist as provider."

This relationship is always deeply political. And yet, what I was doing in Argentina, what I do with my collaborators creating work with undocumented immigrants in the hyper-gentrified Mission District of San Francisco, is just "theatre" not "political-theatre" or any other hyphenated variety. That it takes on a more overtly political dimension is not a result of a political agenda, but rather what emerges from the relationships that we find more meaningful and engaging during these difficult times. Dorst's *The Curve* and a brilliantly staged version of Lope de Vega's *Fuenteovejuna* that I saw in Córdoba under state terror were also that—*just* theatre, often referred to as "absurd" and "classic" works, respectively. In that context, however, aesthetically, socially, personally, and politically, they were the most transformative, representing the kind of artistic high that we keep on chasing for the rest of our lives.

How many times has "the theatre" been diagnosed with a terminal disease, agonized, and died, and how many times has it resurrected even within our lifetime? I believe that it "dies" when, like any of us does periodically, it loses its ability to make meaningful connections, to build meaningful relationships that matter to a larger community. When it ceases, like James Baldwin beautifully put it, to "uncover the questions that have been hidden by the answers." When it—and by that I mean we, who do it and attend it—almost magically, collectively, and not in personal or sectorial isolation, becomes able to reformulate the questions that matter, it does its phoenix act and becomes a living theatre once again. It is never in crisis because we have lost our ability to be "innovative." Mexican director Luis de Tavira reminded us during a panel not long ago that Lope de Vega himself once wrote: *"Vienen a ser novedades las cosas que se olvidaron"* ("We take for novelties all things we have forgotten"). Seen this way, the "new and riveting" is pretty much the rediscovered, made relevant to a significant group of people, through genuine and difficult dialogues.

It is important to ask, "How are relationships changing between theatres and communities?" since change they will, as any organism does to stay alive. Its function will evolve too, and now I will pose to this

open circle: There is a real need for a wider field where risk-taking and artistic nourishment more explicitly relating to "social issues"—taken on quite disproportionately by artists and organizations considered marginal in the performance world—can take place. It comes as no surprise that the mainstream of American theatre and professional training programs have felt too uncomfortable to bring them to the heart of their practice, but its time is certainly due. At one point, the development/recruitment department alone cared about community, and that was largely to fill seats (not a minor issue by all means). Now the matter is far more existential in nature.

Has American exceptionalism (and its corresponding insularity) exempted us from our sense of reality? Our social contexts are marked by extreme polarization: a growing class of poor, income gaps not seen in decades, and an ultra-rich elite with an equally disproportionate concentration of power; entrenched, structural gender and racial discrimination, resulting in de facto segregated educational and health systems; renewed obstacles to exercise the right to vote for those historically marginalized; the exploitation of immigrant labor and the criminalization of undocumented people, within a racist prison industrial complex with no parallels in size anywhere in the world; a systematic erosion of our civil rights since 9/11; and an enormous corporate-intelligence-industrial-complex with unlimited reach, which may be the most dangerous threat to our democracy yet, to name a few.... When we ask ourselves: "How are these issues affecting me? How are they affecting my neighbor?" do we also follow up with, "How do we land these issues in the realm of the personally relevant and specific in our practice?" There are thousands of creative disruptions to be made, amazing stories to tell, not only about suffering and injustice, but also about survival, empowerment, and triumphs of the spirit against all odds.

Lerner-Febres reflected on the way by which the best of Peruvian theatre played a critical role in addressing the country's needs to articulate a language to "speak the unspeakable," restore the social fabric, and engage the imagination to effect transformative change. I have lived in the U.S. for half of my life, and I cannot remember a time when the conversation about what has become of the social project called "America," who are we and, also, who we want to be, has been more necessary. This is a time when much attention is placed on the great divisions that plague us and not yet enough on the great potential for intersectional approaches to help us define and address the central

issues that afflict us, in inclusive terms. I see familiar patterns between the Argentina of the seventies and the U.S. of today, with an emphasis on what divides us, perhaps in the reengineering of what divides us, coming from places high and low, from our very own Congress to the corporate-owned news media. That can be a scary thought...but amazing strategies of resistance were born there out of deep suffering.

We, theatre/performance artists, have an amazing, culture-shaping role to play in creating spaces to collectively make meaning from so many questions: Is torturing people in the name of freedom ever acceptable, even if lawful? How about continuing to do it even after the detainee has been proven innocent of all charges, as in Gitmo? Can a man shoot and kill an unarmed teenager that he found suspicious and followed on his own, and that act be considered self-defense? Have we arrived at a place of racial equality for there not to be a need for affirmative action programs anymore? Should we deport people who came to our country when they were little children and know no other national identity, culture, or language? How can spending money be equated with the valued exercise of freedom of speech...? These are some of the questions that Mr. Baldwin would want our art to engage with today and, indeed, many artists and companies have taken them on and with great merit. In my experience, at least, we still have to make them much more central to the conversation, the dialogues among ourselves, and with the people in our communities, particularly beyond those immediately affected by a given scenario.

Most will not debate that in times of crisis the need for spaces of connectivity and reflection is crucial. Yet many of us are understandably overwhelmed and suffer from the very same isolation that feeling part of a larger social whole through our very own art making would help remediate. Imagine the thousands upon thousands of Kelos and Chetés all over the world that we do not know about. The former was killed because he aligned his profession with community needs and dreams, like the best ones anywhere do. The latter is still at it, now dealing with low budgets, mediocrity, lack of vision, and a new host of social ills. We have plenty like her here, too. While we will likely agree that the traditional institutional places created for social dialogues in our democratic society are in a crisis as deep as we have ever seen, not enough of us, however, particularly those working on advocacy, policy making, even activism, seem to have fully realized what totalitarian regimes, or anyone benefiting from the status quo, know very well: that these spaces are often only possible through the mechanisms and

dynamics inherent to creative work, particularly to embodied practices of the art/people kind. We have to do more ourselves to paint that picture more clearly.

Live performance is definitely much more aptly equipped to support necessary dialogues on inclusive and engaging terms than disembodied social media or activist forums that only see what matters if it lands squarely on their agenda territory. While we all must address an ever-complex and interconnected world from whatever time-space locality we find ourselves in, creative work has taught us that it is in the borderland spaces where the larger ecologies that we are all part of become more visible, and where alternative insights and strategies can be offered by unexpected partners. Via mechanisms grounded on solidarity, inclusive strategies, or the construction of relationships where histories and experiences can be mutually acknowledged, art can channel the potency of the collective imagination to give wings to understandings and possibilities before thought of as unthinkable.

As poet Audre Lorde put it, "...the master's tools will never dismantle the master's house."

Roberto G. Varea's research and creative work focuses on performance as means of resistance and peacebuilding in social conflict contexts. His work in the United States includes directing and developing plays and performances, writing, and co-founding the Performing Arts and Social Justice major at the University of San Francisco.

THE VOLT (OF RESISTANCE)

Jay Ruby

The word "ministry" awakens a sense of revolt in me. There is a cellular reaction of disgust to the general hypocrisy and failures of the "church." Such a reaction seems far away from the intention of audience engagement and community development for the Audience (R)Evolution blog salon, but the sensation of revolt requires an inquiry. Beyond ideology, what is the action of ministry? When religious connotation is removed from its given definitions, one is left with being a servant of place and caring for its residents. A Latin synonym is the word "curate," from which "curator" derives, and at the root of which is the word "to cure." To cure and to care. These words transform the revolting flavor of ministry that my personal bias associates with imposed dogmas and rigid belief systems. When you are curing and caring collectively for an audience you are providing a rejuvenation and/or a catharsis. Just because we are living in the digital age does not mean we have lost our need for care or to be cured by catharsis.

The start of encouraging audience to attend live events may be located in recognizing the barriers to collective rejuvenation, rebuilding the accessibility of the commons, and deconstructing the commodification of catharsis. Unconscious identification with the hero narrative drives much of our present-day rituals of catharsis through media to sports and entertainment. Can live theatre match the win-or-go-home drama of March Madness or *American Idol*? How can a center of artistic expression, be it a body, community, building, or movement, extend a quality of care and cure to reframe our focus and address the wounds and issues intimately living inside of us? How can a web of relationships overcome resistances to minister to needs that are not easily recognized?

What if we started by checking our assumptions of importance against the quality of our interactions? Let's pretend theatre has no right to exist. NO building to exist in. NO subvention to guarantee existence. NO conference to affirm the condition of one's existence. What is left to start with if NO body cares? What is possible when starting at ground zero?

Street theatre is the most honest contract in the business...no waiting to see if the show gets better, no guilt about leaving the sermon

or the box seats early, no remorse about having paid, no jockeying for position on center stage to promote an agenda. If you like it, you stay and enjoy the show. If you don't like it, you leave...no social protocol is broken and no false pretense of appreciation is enacted. The contract is upheld by the traction of the attraction.

When Peter Brook was touring Africa in the 1970s with his theatre company, presenting *The Conference of the Birds*, they found that driving into the villages in their vehicles insulated them from the encounter with the culture of the village they were visiting; whereas, walking into the villages and carrying their theatrical wares with them allowed the village to develop a response and to welcome their entrance. They chose to park their cars outside the villages and approach as the village was accustomed to people approaching.

Perhaps the size of the audience is secondary to what the context is and what the intention is. What if capacity is not seen as volume to fill—a quantitative relationship—but seen as activity—a qualitative relationship.

Context, Intention, and Quality open the theatrical experience up to encountering intimacy, cultivating inclusion, and integrating the unknown. These are the strengths of theatre. They expand the periphery of the commons. They are the result of successful catharses. They subvert the winner-take-all drama of entertainment sports media.

Perceive shifts in context to encounter intimacy.

For a few years when I was young I gainfully self-employed myself as a subway busker, sing-acting songs for donations. It was outside the law, it was clandestine, and if done right provided joy and refuge from the anonymous and disconnected moments of mass transit travel within a city. In one session I would sing the same song thirty to forty times in different subway cars. My audience was enclosed with me. It was a gamble. Each time I walked into a subway car to share the truth of my song, effectively I had to build alliances, determine needs, and maintain vigilance. The subway police were possibly nearby and the passengers could "rat" me out. The quality of the song changed each time it was sung to enchant who was there. Catching the glance of a mother with a sleeping child in the late morning turned it into a lullaby; seeing a pack of rowdy young men on a Friday night prowl turned it into a howler. Context carried the clues to connection. If I lost sight of the context I lost my audience...and my payoff. The insight of this practice was to continually perceive shifts in context akin to Peter

Brook and his actors understanding the difference in approaching a village by vehicle or by foot.

Cultivate inclusion with intention.

Prescott is a small, mostly conservative and very Republican town in Northern Arizona. In 1999 I founded an all-ages contemporary performance art festival, entitled Tsunami on the Square, to present free performances for the public and pay the performers. We used the public steps of the county courthouse as a natural amphitheater. When the festival started we did not have the money to print a quality program, and I was not interested in a piece of paper that everyone would throw away. At the time I was listening to a mixed tape that had Flatt and Scruggs singing a short song called "Martha White's One All-Purpose Flour." It was a jingle for a sponsor. I realized the early tours of bluegrass musicians were supported by businesses to sell products. Advertising could be live performance. To raise money for the festival I walked door to door to the downtown businesses promoting our festival and offered to do a short skit about their business between larger acts. The "skitmercial" was born. For two weeks before the festival my colleagues and I brainstormed funny, poetic, outrageous, and clever two-minute acts to highlight the local businesses through our performance work.

The skitmercials became a defining feature of the event, eventually requiring a pre-festival dress-up, ticketed event where sponsors could see the premieres of the skitmercials. Sponsors became involved in crafting and even starring in their own skitmercials. As performers our process and creativity served the immediate business community of the square around the county courthouse plaza. The skitmercials directed festivalgoers to the restaurants and stores that supported the festival. The skitmercials built face-to-face alliances with the downtown business community that advocated and supported the festival's existence. Real support grew out of those face-to-face encounters, which included lobbying the city council to finance the festival, showing up at county meetings to prevent the festival from being moved, and countering rightwing radio attacks against the festival with narratives about the festival's positive financial impact. The transformation of an economic relationship with a sponsor into advocate and partner enabled us to be both a cutting-edge arts festival, whose curation challenged and expanded the town's perception of art, and a family-friendly, all-day, inclusive event.

The skitmercials of Tsunami on the Square amplified the presence of beneficial relationships in our context by sharing our capacity to place local businesses front and center in our event and, more importantly, in our creative process. We were not just asking for money and a program ad; we were asking business owners how our creative process could represent them in front of living, breathing people. The intention to share our process with the activity the businesses defined themselves by cultivated a deep inclusion in which we cared for each other's existence and mutual survival as part of the fabric of the town's culture.

Quality integrates the unknown.

For the last decade I have toured globally with my company, the Carpetbag Brigade. Our performance work transcends the barriers of language by utilizing acrobatic stilt walking to create dynamic open-air spectacle-based drama performances. Our developed and refined artistic vocabulary approaches cultural divides and crosses them to encounter and integrate. We have found that clear perception and good intentions, while crucial, are not enough. The pursuit of quality and its ability to integrate the unknown requires training and technique—not as an end in itself, but as a means of creating fresh ground. When we pedagogically share our acrobatic stilt vocabulary it is to allow a new space of engagement to occur. The technique becomes the bridge because it grounds us in a common activity that allows the encounter to be one of mutual growth.

The pursuit of quality in our theatrical craft allows our work to find actions that transcend local differences and affirm the universal. A strong quality-driven technique births an aesthetic with appeal beyond the demographics of language, culture, age, and class. Audiences respond to expressions that reflect their personal experience of the universal. For me, a successful show is one in which the members of the audience feel empathy with one another. The quality of the performance integrates its spectators into a temporal community where people begin to know each other.

Nurturing quality in your community is not just importing quality through curation; it is an act of creating the context for your community to develop quality. If you have a space, how are you assisting in the development of training? If you are a programmer paying to bring in a company from abroad...are you having that company share their skills? Are you nurturing a process at the margins of your community

to develop and present professionally within the center?

The practice of addressing context, intention, and quality creates a true center. If a true geometric center is defined by equal distance to its margins—a true cultural center should parallel this dynamic by allowing equal access to the narratives that emerge from the center's margins. The migration from the margin to the center is the birthplace of frictional truth—a truth both subjective and objective, where the encounter between different narratives becomes the function of the center. Concentrating on context, intention, and quality prepares us to receive essential encounters and develop a charge in our web of relations.

The charge inside evolution and revolution is the volt, defined electrically as the difference of potential that drives current against resistance. Putting that in the context of "to care" and "to cure" lets the cultural voltage that builds audience and develops community be defined as the difference of potential that drives the capacity to care against the resistance not to.

Jay Ruby choreographs action to animate social space and invigorate collective reflection. He cultivates spectacle-based drama using principles of precarity practice. Engaging in festal culture as an aspect of contemporary ritual, he applies modalities of theatre, circus, and dance to address the inequities and wounds of our times. As founder and executive director of the Carpetbag Brigade, Jay stewarded the company's innovative use of acrobatic stilting. With his colleagues he has pioneered its application in site-responsive, site-flexible, and site-specific works to function as a means of developing ensemble craft, propagate community empowerment, and activate cross-cultural exchange.

WHAT REMAINS?

Tanuja Amarasuriya

When we were little, my mum used to try and get me and my brother to garden: to plant seeds and tend the plants as they grew. IT WAS SO BORING.

But now that I'm nearly forty, I get it. I'm older. I understand time better. I understand the action and effect of time better. Suddenly (or, more likely, gradually) I want to train myself into the patience and dedication and practice of gardening.

Theatre is time, in a space, with other people. You can fill it with anything.

There's a lot of focus on the immediacy of the live moment. Too right. It's the sensitivity of that liveness which gives the form of theatre such potential. There's much more talk now of audience as participants in the experience, rather than viewers or receivers of the work. Many more of us think of our practice as making theatre with, rather than for, audiences. There's so much theatre now that asks its audience to interact physically as well as engage emotionally and intellectually. There's so much more attention drawn to the here-and-now presence of all of us—performers and audience—together in this moment. The intensity of the live moment is that we're in it together...and then...and then....

And then, it makes me wonder if the real power of that intensity doesn't more often make itself clear only much further down the line—days, months, and years after the event?

I hate the word "participation." It's so utterly banal. I know why we use it—the sheer blankness of the word makes it a usefully grey heading that's never gonna color the authentic amazingness of actually feeling connected with or part of something beyond yourself. But if we think about participation as the interaction of personal response with event, then I wonder whether we shouldn't talk more about what happens later? The aftermath of the immediate experience. What has changed that stays changed? What remains?

The speed of modern information exchange, the now-ness of social media, the pressure to make your presence known through iteration and reiteration is immense. The ephemerality of theatre, the impossibility of its mass production—the very thing that gives it such potential power—is also what makes it hard to access. (There's an argument to

be had over whether we tend to confuse the notion of rarity—because it can't be mass produced—with elitism, but that's a tangent....) Our reliance on comment and critique as the way in which we memorialize theatre means that we're reliant on increasingly immediate reflections on the event.

But sometimes you just don't get the thing that's in front of you until much later. When I first heard P.J. Harvey's "Sheela-Na-Gig," I hated it. I didn't know what to do with it. I didn't know how to process it. It freaked me out. I hated it. Maybe a year later, I heard "Legs" on the radio, and I couldn't tear my ears from it. It fascinated me like nothing else I'd ever heard. And now I have to make a leap of imagination to recall my initial aversion to that first P.J. Harvey tune I encountered. I could say the same about Mukesh and Lata Mangeshkar. I could say the same about my first glimpse of Forced Entertainment.

Recently, a performance company invited me to write a reflection on a show of theirs from a few years back. The words that recurred, the sensations that remained were not at all what I thought most important at the time (I know this because it prompted me to look back at the notes I'd made around the show at the time it toured).

This made me think of how, during our long process of making *The Bullet and the Bass Trombone*, one of the things that most informed our artistic decisions about what mattered most in the piece came from conversations we had with people who had seen work-in-progress months before. Very often people would misremember the facts of the story, but there was real depth about what people found resonant over the long term. Some of those things were about voice, sometimes about duration, sometimes about how it played alongside the real world. Sometimes these were effects that we'd never recognized ourselves. We took note of what people found meaningful to help us anchor the production—like the base notes of a fragrance, or the key in which the story played.

I like the idea that the live event is not necessarily the end, but the beginning or the middle of a process that the audience can take away as their own. We do this more often with pop music, I think— take it and own it on our terms in relation to our own particular life experience. It's easier, of course, when you can cheaply own and replay the thing itself, but that's not to say that, even if you can't stick it on your iPod, you can't make the invitation to an audience to feel their honest response and own their experience (even if they get a few facts wrong in the remembering).

In Bob Dylan's 2015 MusiCares award speech, he talked about his songs as the inevitable fruits of seeds in the shape of songs he's loved by singers like Big Bill Broonzy and Robert Johnson—planted in his soul and grown into songs like "Highway 61 Revisited" and "A Hard Rain's A-Gonna Fall." Is that influence an act of participation too?

I couldn't have predicted it on first encounter, but now, many years on, I can talk about the influence of Franko B's *I Miss You* or Ridley Scott's DVD commentaries on my work as a theatre director. As artists, we're attuned to our creative processes, and the accessibility of digital publishing makes it much easier for us to share those stories. What I'd love to find are more places where audiences, critics, and others reflect on and review theatre from some time ago. If the liveness of theatre is its big deal, then what remains of the experience inside me is more than just an echo—it's part of the thing itself. It's under my skin. It's planted in me. What remains? What grows?

Tanuja Amarasuriya is a director and producer based in Bristol, U.K. She is co-director of Theatre Bristol. She collaborates regularly with writer and composer Timothy X Atack under the name Sleepdogs to make theatre, film, audio, and whatever else it takes to share the story right. Their work has been developed and presented nationally and internationally, including at the National Theatre (London), Bristol Old Vic, Seattle International Film Festival, Brighton Festival, NexT International Film Festival (Bucharest), the Royal Exchange Theatre (Manchester), and Bios (Athens). Visit *www.sleepdogs.org*.

PLEASE PLEASE PLEASE LET ME GET WHAT I WANT (EVEN IF) YOU CAN'T ALWAYS GET WHAT YOU WANT (OR, HOW THE SMITHS AND THE ROLLING STONES CAN TEACH US A THING OR TWO ABOUT THEATRE)

Caridad Svich

Tell me what you want.
Please
Please
Please
Tell me what you want so that I can get what I want

I will make something
Precisely
For *your* want
And you will want
For nothing

You see, I am a text-builder and theatre maker
I am a citizen and sometimes I am a citizen-spectator
And I have been trained to ask myself what characters want all the time
And as such, am told, that I am also trained to ask you
What you want
So that, in effect, I can give it to you

———

It is nine o'clock on a Saturday. I am staring out the window of a hotel room in Kansas City, Missouri. I have a non-view, as it were, of another building, one that is under construction. A sign hangs from the side of the building announcing "Luxury Condominiums Soon." I wonder who will buy these condos, and who will live there in this, the Power and Light District, which is hauntingly sleepy and desolate during the day

and comes to fervent yet brief life late at night on Fridays and Saturdays.

There is heavy construction down Main Street. It has been going on for a year, so I am told by the locals. A street trolley is being put in. It will be amazing, once it is in place, but for now, there is the incessant battering noise of hammers and drilling, and trucks sweeping debris snail-like down the street.

Bars upon bars line the short thoroughfare that leads to the Alamo Drafthouse Cinema, and further east there are blocks and blocks of empty storefronts and equally empty streets where the occasional homeless person is spotted lugging their belongings.

I am in the Midwest. The heartland. There is money here, I am told. There are spanking new buildings and investments igniting the life of this city. But there is this other side too. The one that speaks of poverty and neglect and working-class folk running to take the bus at the end of their work shift, and of those barely making ends meet eyeing the dollar-store rack at the local drugstore for some "cheap eats." Like many American cities, especially ones that have gone through bust-and-boom spurts over the years, it is one of stark contrasts, magnified by stretches of highway that cut across neighborhoods, divide communities, and segregate economies. This is a city of cars and BBQ, blues and baseball, and where more than 35,000 tickets have been sold for an international soccer match between Mexico and Paraguay at Arrowhead Stadium.

It is also a city where some of us in the field, in this struggling and beautiful field of theatre making and producing, have been talking for a few days about how we can engage with audiences and revitalize our theatres and artwork. Nothing new here, I suppose, other than the fact that an inevitable dichotomy is eternally at play in such discussions, one that demands, in a culture that is already "infinitely demanding" (to quote Simon Critchley), that practitioners and administrators ask their audiences what they want and, in turn, be able to give it to them.

But what do audiences want?

Who do we think is our audience?

And is there such a thing as a monolithic body called the audience in the first place?

So, I make a little art sometimes. I never know who is going to be in the audience. I do hope that my friends and colleagues will show up. But honestly, I don't know who will walk in.

Well, actually, I do a little. That is to say, depending on where I am doing my work, the ticket prices will vary. At some venues it is in the $20 and under range. At others, it is more, though hardly ever above $65—in my experience, anyway (both inside and outside the USA).

If the ticket price is more, then likely those that can afford or have saved up to afford to buy a ticket, will come. If it is less, then the chances are that the audience will be comprised of folks who either wandered in out of curiosity, came with friends, are students, or are in the starving class—or what we often refer to as the "artist class" in this country. No news here. But it bears repeating, I suppose, that there is such a thing as an "artist class" in these United States and that often this is the economic class that represents either the highest of the high incomes (think actor celebrities, CEOs of major theatres and entertainment companies, and the like) and the lowest of low incomes (think artists living paycheck to no check, and on meager grants, occasional commissions, day jobs, and twelve part-time jobs to make one job).

I start with the economic divide first, because I do think that ticket prices are an issue. We know already that movie theatres are closing around the country precisely for the same reason. If you can download or stream a film made by first-class filmmakers and performers for less than the cost of one movie ticket, why bother seeing the movie on the big screen?

Although theatre is one of the live arts, and therefore not eminently reproducible (although in the U.K., National Theatre Live cinema broadcasts and Digital Theatre downloads and rentals offer the pleasures of high-quality recordings of live events), the price of admission—note the weighty undertow of the phrase—does matter. We can talk about theatre and democracy all we like but the fact is that if a ticket for a show costs $80 to $150, then, you know, it's not quite a democratic enterprise.

So, who is it for? And what does it mean?

If you, say, make a play about the poor, but charge $100 for a ticket at a commercial venue, then who is coming to see the work? I would hazard that poor folk are not going to come on a day-to-day basis. After all, $100 plus $100 adds up pretty quickly—and are not easily come by when you have bills, rent, mortgage, insurance, and other of the Western world's basic life amenities to pay for. Therefore, as an artist you run the risk of putting the poor "on display" for the upper classes.

Okay, we all know about empathy. And, yes, theatre is an abstract form. It is not inherently mimetic. All kinds of stories should and can

engage an audience. And do. We can imagine ourselves kings, queens, laundry workers, salesmen, office temps, barflies, punk rockers, and more. Theatre asks us to see ourselves in all of our flaws and frailties. For rich and poor and those in between. In its imagined commonwealth, theatre teaches us about commonwealth—we are ALL in this together.

But the price of admission in our capitalist theatre system—one that will likely not change anytime soon, given that we are, after all, in a late capitalist society—does play a factor in who shows up, who gets to wander in, and who even gets to see the work being made under the glare of the bright lights. You can ask an audience to be with you, to engage with you, but if they can't afford to get through the door or no-door (depending on the kind of theatre you are making) then your request may go unanswered, however hard you may try.

———

I am a Smiths fan. Still. Yes, I know they broke up a long time ago. But I still love those songs and Morrissey's mad-yearning croon of a voice. As a practitioner, I am not going to lie. "Please Please Please Let Me Get What I Want" is a mantra of sorts. I mean, let's face it, making art is in part about putting your vision out there. It takes a certain amount of healthy arrogance to even think anyone might wish to engage with your vision in the first place. And, yes, part of that vision has to do with intoning a bit of mad yearning desire into the act of making and, later, production, if it even gets that far. I face the page and ask it to tell me what it wants, which usually means that characters will show up and do their telling. In other words, I may face the page demanding vision, but the only way to realize vision is to be open to what it may be. You can dictate all you want, but if the page says, "Write this!" and it's burning hot and true, and if you believe in truth-telling in your theatre, then, you know, you step out of the way, and let the work make "itself." In reality, of course, you're the text-builder or playwright and you likely know a thing or two about the form called a play, just as a shipwright may know a thing or two about ships, and while the work may be telling you what it wants, you are in there somewhere making it happen. Another part of you is calling through the act of the demand, through the pleading "Please Please Please…" to get to this thing called art that you wish to share in some way with your fellow citizens.

When I am making art, I am not necessarily thinking about the audience all the time. I am my first audience. Usually a trusted circle

of colleagues are my second audience of readers, and then actors, and so on. The imaginary audience—the public of whom Federico García Lorca wrote about in his last "unfinished" play—is waiting in the stalls, diving under their seats, clamoring against the madness onstage, imagining themselves Romeo and Juliet, tragedy's apprentices, and heaven knows what else.

I am interested in pleasure—in an audience enjoying the work. I think pleasure and sensuality sometimes get short shrift in our discussions of theatre making. But it is a deep-seated thing: to be in the presence of something that gives pleasure, and that makes you feel sensual and electric. Or simply: makes you feel alive. What did Sondheim say in *Company*? "Being Alive"?

It is what live art does. At its core, it is live. It is about being alive. It is about the human condition. It is an experience that can do many things—offend, provoke, alienate, invite, teach, make you think, amuse, entertain, illuminate, reflect—but ultimately remind you of the bristling sensation of being awake and alive on the planet. The best theatre does this. We know this. We have known this for a long, long time.

And yet, we ask ourselves, what do our audiences want?

Do all the market research you wish, but what they want is to be reminded that they are human in the most electric, visceral, witty, intelligent, unexpected manner possible. Sometimes with words and stage pictures. Sometimes with no words. Sometimes with music or dance or puppets. The WHAT isn't the thing. The play's the thing. And with it, the responsibility to speak truth to power. Because what does theatre do? It says people have power—the power to tell stories, move through the world, and perhaps, yes, do some good. Not all plays shows us at our best. But that is the point too: to make us see when we behave less well with others, when we speak hatred, violence, and rage. If all characters in theatre were decent and behaved well, there would be no theatre. If we were are well-behaved at theatres, in their shiny clean enterprises of culture, there would be no theatre.

Listen, theatre is dirty. It is messy. Give me filth, it says. It stirs up the weird shit, the uncomfortable stuff within us, and the stuff we would rather not face. It asks us to embrace tenderness and violence as one and the same. It is cruel and beautiful and not merely a forum for whatever is the latest issue on the daily broadsheet. It cuts deeper than that because it has to do with desire. And desire, the stuff we traffic in, court, wrestle with in theatre, is bloody difficult. You can't data-manage it. You cannot compartmentalize it. You can't checklist on a

survey and say to yourself, "Ah yes, well done! Now I know what WANT is. Now I know what to do with this wanting person called theatre and how it need answer to the predicated want we have identified in the audience." It doesn't work that way because working imaginatively with desire goes beyond commodified structures and requires something else from the art maker and, in turn, the audience. You want cultural urgency? You want art to go deep? Then you have to let it go deep. Sometimes maybe even to the point of near disappearance, in order that it may find itself and understand how it—the art (unnamed in the act of creation)—wants desire in the first place.

If you do not know what it is to want desire, then you have to go back and look out into the darkness. Really look.

And wait for a long time.

And then let it course through you, and speak to you in tongues that may be unfamiliar, altogether strange. It may be the tongue of fire, rain, absence, loss, grief, pain, trauma, pride, madness, quiet, beauty, ecstasy, or something else. Like stone, or rock or flower or animal. Yes, desire may be all these things. And that's what being present and alive to the wanting want of art, the please please please of it, yearning in that mad croon of Morrissey back in the day, feels like sometimes.

And yet....

Listen, you can't always get what you want. The Rolling Stones said it. And who knows who before them. You get what you need. Right? Art is a necessary thing. Or simply put, art is necessary.

It is not dutiful. It is not a service. It may not even be useful (as in a utilitarian tool of society—although many bodies wish to make it so, for reasons that perhaps have less to do with art itself than the lack, especially in market-driven societies, of a deep understanding of the nature of the true ethics of engagement, the role of the citizen-spectator historically and in the present, and with art's defiantly unstable position in regard to its perceived or expected "value").

But it is necessary. Usefulness and necessity are not the same thing! Art is not going to go down easy all the time. In fact, most of the time it won't. Because it is alive and roaring and not a pacifier of culture but a stirrer-up of culture. Yet, one that knows how to hold society in its hands and say:

Hey, look, see, this is us. Now.
This was us, then.
This is who we may be.

What are going to do about it?
What are we going to do?
What can we do?

Art making (and all its senses and tenses, including its production) is caretaking. We are doing cultural work, after all. We are taking care of our society. Somehow. With this telling stories thing. We are putting another ripple in the stream of history. We are working for the better good. And we are working for the future.

When we ask audiences what they want? They may say what they saw yesterday is what they want. But our job is to make for the future as well as the now. Even if we are talking about yesterday. The audience, smart and alive, may not recognize the future call when they see it. It may take an audience fifty years to discover the thing made years before that was for them. That's the nature of the art. There's no guarantee. There's no magic formula. There's no real surefire anything. Do all the market tests you want. Audiences are fickle, difficult to please, unpredictable, hearty, strange beasts. We love them. Sometimes we are them.

But as makers, we tend to look at our fellow citizens with a bit of unease, because when we make things, we are stepping for a moment outside the path trod by our fellows, even if we are walking in their shoes.

Art making demands we step out and look and see before we make. We become spectators of the spectators in order to be artists, and then we rejoin the society with our art and ask the spectators, emancipated, glorious, alive, and kicking, be they one or a hundred or more, to recognize what we have seen. It becomes a kind of collective dreaming—at its best. A dream of the future born of a recent past. A model kit born out of no model, save the one of an event in space and some/one to witness it.

Caridad Svich is a text-builder and theatre maker. She received the 2012 Obie Award for Lifetime Achievement. She has written over forty plays and thirty translations, including *12 Ophelias, Iphigenia Crash Land Falls...*, *JARMAN (all this maddening beauty)*, and *The House of the Spirits* (based on Isabel Allende's novel). Her works are published by Intellect U.K., EyeCorner Press, Seagull Books, Manchester University Press, Backstage Books, Smith and Kraus, Playscripts, Inc., Arte Publico Press, and more. Visit her at *www.caridadsvich.com*.

THE REMINDER

Itamar Moses

I'll start with an anecdote which is actually true.

Last November (2008), a play that I wrote opened Off Broadway, and, as is sometimes the case when a new play opens by a writer, the *New York Times* came and bravely panned it, and, because the *New York Times* is, and has been for many decades, the only critical outlet that has any effect whatsoever on a play's commercial viability, I knew that this meant the play wasn't going to extend or have a commercial transfer, even if every single one of another dozen reviews ranged from good to excellent—which, by the way, I feel obliged to point out that, in this case, pretty much all of them did.

I also knew, though I don't really read reviews, or at least not the ones I hear are bad, that the gist of the criticism was that my play was content to skim the surface of its subject, because when you get a bad review people send you e-mails refuting it, with the possibly unintended effect of telling you what it says. I furthermore also knew, whatever we always say about not reading or caring about reviews, that because the theatrical community has internalized this tyranny to such a degree that everyone I talked to for the next few weeks would say things like, "I was surprised that play wasn't more well received." As though the rest of the critical, not to mention the audience, reception, was irrelevant. So at the very least it's fair to say that I was in a philosophical mood that morning.

I live in Park Slope, Brooklyn, right in the gentrified heart of the neighborhood, which means that I am often accosted by various people in bright blue t-shirts trying to get me to stop and give some money or time to various causes. These days it's gay rights, "Do you have a minute for gay rights?" The question is always phrased this way. During the campaign it was, "Do you have a minute for Obama?" Sometimes it's, "Do you have a minute for the environment?" The question is carefully framed to acknowledge that, more than my money or my signature, the real demand they're making is on my time and attention. In addition to those people, you'll also sometimes run into Hassidic Jews, all in black, trying to get you to wrap *tefillin*, or, if it's autumn, shake a *lulav*, or just generally to foist onto you whatever ritual act is appropriate for that time of year or day, and, as many of you may know, the question these people

always ask when you walk by them is, "Excuse me, sir, are you Jewish?" And, whereas, "Do you have a minute for the endangered manatee?" is a question constructed to allow you to say, "Not right now but good luck, I love the manatee," without any awkwardness, "Excuse me, sir, are you Jewish?" is a question designed to trap you. Because your options are to say, "No," which doesn't feel quite right if you, like me, *are* Jewish, or to say, "Yes," and then weirdly just keep walking, or to say something like, "Yes but no," meaning, "Yes I'm Jewish, but no I don't have time for you right now, not that you asked." One time I said, "Not right now." And the guy just laughed and said, "It doesn't depend on the time."

So that morning, the morning my play had been slammed in the *Times*, I was walking through my neighborhood. I was carrying a book. It was a book I'd received as an opening night gift from the theatre, one vaguely inspired by the play. The play was about athletes, and the theatre had given me a beautiful coffee table book of photographs of athletes, published by *Sports Illustrated*. These really gorgeous photos of basketball players in flight or boxers glaring wearily into the lens, that kind of thing, really intense stuff, quite beautiful. And as I carried this book under my arm, one of those Brooklyn Hasids approached me and said, "Excuse me, sir, are you Jewish?" And I thought, on this morning, which is different from all other mornings, perhaps I am in need of at least some kind of spiritual exchange. It might be nice to engage with something larger and older than nonprofit Off-Broadway theatre, something ancient that might even restore my perspective on the origin and purpose of art itself. So I said, "Yes."

And the guy says, "You have the look." Then he hesitated like he was worried he'd insulted me, or Jews, or something, and clarified, "I mean, not that you can always tell from the way a person looks but certain people there's this sense that...." So then he says, "Tell me. Where did you get that book?" And I said, "I'm a playwright. And I had a play open last night, and it's a play about sports, and so the theatre gave me this as a gift." And he said, "Oh. It's better than I feared. It's not something you purchased for yourself but rather something you received as a gift." I said, "What?" And he said, "This is a very base and terrible publication and in particular they produce one issue of their magazine each year that is especially disgusting and what I advise you regarding this book is that you get rid of it and divorce yourself from it...oh, don't open it!" Because, when I started to attempt to show him that this was essentially a collection of artsy photos of people achieving the absolute limit of what is physically possible for human beings, and not a compilation of

swimsuit photos, he shielded his eyes and averted his gaze like he was Indiana Jones at the end of *Raiders of the Lost Ark*. So instead I just walked away. And as I was leaving I heard him say, from behind me, I am not making this up, he said, "Also, you may want to consider a change of career. It's...not ideal."

I am not now nor have I ever been a particularly religious Jew. I was born in Berkeley, California, in the late seventies—that's not the entire explanation—I was born in Berkeley, and, while there is a large and thriving Jewish community in Berkeley, some of it Orthodox, there's also a large Israeli immigrant community, which included both of my parents, and Israeli Jews often locate their Judaism in the simple fact of their being Israeli, even if they don't live there anymore, with the religion kind of like parsley decorating a steak—you can have it if you want to, but it's not really what you ordered. Nevertheless, the fact and importance of our Jewishness was a constant: My parents gave my sister and me Israeli names, ensuring, among other things, that I'd have to introduce myself at least twice to everyone I met for the rest of my life. Until fifth grade I went to a Jewish day school where Hebrew and Judaic Studies were on the curriculum. At first we didn't go to synagogue much, because my parents weren't comfortable with either of the nearby options, one Orthodox and one Reform, but as soon as a Conservative synagogue appeared in Berkeley, we started going a lot. And throughout it all at home we lit candles and observed all of the holidays and there was a fair amount of Hebrew spoken, usually when people were yelling. I was Jewish.

It's not that I would, as a kid, have resented the implication that I wasn't Jewish enough. The suggestion would have baffled me. I would have had no idea that it was possible to be *more* Jewish than I was, or, rather, I didn't consider the Orthodox Jews that I knew to be more Jewish, just kind of differently Jewish. More inconveniently Jewish. Like, okay, you can't play video games on your Atari on Saturday, which is one of the only days on which you have sufficient time to play video games, and so that just seems perverse. Really, what unjust God would require this kind of sacrifice? Orthodox Jews were, to me, Jewish in a way that was less focused exclusively on the fun parts, like food and singing harmony on evocative minor-key melodies, and more concerned with the notion of obedience to a specific idea of God in a way that, even then, seemed to me to kind of miss the point.

So what was the point?

When I was in the ninth grade, I started going on weekend retreats

with a Bay Area Jewish youth group called Midrasha, which mainly practiced the Northern California acoustic-guitar-based variety of Judaism. On one of the early retreats, there was a designated time for "lights out" that was unacceptable to any self-respecting fourteen-year-old who was away from his parents. The standard rebellion against this for most of the kids was to "sneak out" of the cabins at night through the windows, which led to a lot sprinting across fields in the darkness, getting chased by the counselors and by eleventh grade junior counselors, and ultimately to "getting busted," as we called it, and being sent home early. What wasn't clear was what these kids—from the Valley, I hasten to add, not from Berkeley—were even sneaking out in order to *do*. See girls? Get high? They didn't ever seem to actually get away with doing anything. They just got in trouble and then did it again until there had to be a hushed conversation with someone's parents and you never saw that kid again.

My friends and I, the Berkeley kids, Gabe, Jesse, Dan—guys I'd known my whole life, since my days at that Jewish day school, guys I'm still friends with—Gabe is getting married next month, in the Santa Cruz mountains, and I just bought my ticket—we had a different approach. An hour after lights out, maybe, we'd walk casually out the front door of our cabin, go to the common room where the counselors were having a meeting, sit down among them, and participate: "I think we don't have time tomorrow for *both* the hike *and* the sing-along. We're going to have to cut one of those, much as it breaks my heart." And the counselors would laugh, and we'd get to stay up later. In a way, we were just doing what we thought was funny. But we also seem implicitly to have recognized that punishment had nothing to do with disobeying the rules, per se, but with *treating* the counselors like mean authority figures, because then that's what they became. And of course it made them angry. No one wants to be told that they've grown up to be everything they used to hate. And in any event they hadn't, not really. Mainly, they were goofy slackers just like us, but ten years on.

Meanwhile, during those years, whenever I talked about or wrote about what my favorite thing was about being Jewish or what was important to me about being Jewish or what defined Jewishness for me—which happened more often than you might think when you factor in application essays and personal essays and what-I-did-last-summer essays and oral presentations and closing speeches at festivals of arts and ideas—I had a stock answer, and my stock answer was that I loved Judaism's emphasis on questioning. Which is, if you think about it,

hilarious. But I always praised the Jewish tendency to embrace rather than to suppress interpretation and debate. I mean, I also loved the friends I made and building memories together through rituals that I could later be nostalgic about, but everyone does that, that's a part of growing up, and not essentially or exclusively Jewish. So I'd write about or talk about how even, say, at the most Orthodox Yeshiva, everyone is literally assigned someone to argue with over everything they're studying, a chevruta partner. And how the pages of the Talmud surround the original text with commentary, and then, increasingly small, commentary on the commentary, and so on, until it looks almost vandalized, like a culture-wide bathroom stall, and how I thought that this was great. The fact that I had never actually read most of this original text, let alone the commentary, was an unimportant nuance. The awareness that the commentary existed, and was permitted, even encouraged, gave me, I felt, tacit permission to look at Judaism in a certain way.

I didn't see a connection then between our youth group shenanigans, which were taking place in a Jewish context, and what I kept saying was central to my Judaism until, well, okay, basically until I started working on this part of this piece. Now the connection seems obvious. (Writing is just as often about telling the truth to yourself as it is about telling it to other people. Or, first you have to do one before you can do the other. Or something.) So, for instance, when the kids from the Valley eventually complained about the strictness of the rules, trying, as always, to fight authority only through the most obvious official channels, and the only concession they could secure was that it was okay to be outside the cabins after lights out if you were demonstrably on your way to the bathroom, whereas *they* were frustrated, because though this was a defeat, we began walking around at all hours of the night holding toothbrushes, insisting, no matter where we were or what we were doing, that we were on our way to brush our teeth. "Why are you guys playing tetherball at two in the morning?" "We're on our way to the bathroom. Look: my toothbrush." It was like postmodern insubordination, disobedience that contained within it commentary on itself, and on the arbitrariness of roles and rules. It was, in other words, kind of Talmudic. The Valley kids accepted the premise that, because the lights out rule *existed*, then to break it must be bad. *We* posed the question: What if breaking this rule can be hilarious and awesome and make everybody's experience here better, even that of the people who are supposed to be enforcing the rules?

We did this kind of thing everywhere, for years. In eleventh grade, when we were junior counselors for that year's ninth graders ourselves, we begged until they let us handle the night watch duties after lights out, not because we wanted to preserve order, but because we wanted to put on camouflage and face paint and carry giant police-grade flashlights and pretend we were commandos, which is what we did. We had a running joke where, whenever we met a new authority figure, one of us would pull him aside for a serious discussion in which we placed him in charge of whatever he was already in charge of. After the first sports practice, you'd pull the coach aside and say: "Listen, I really like the leadership qualities you showed today and, if you think you handle it, I'd like to actually let you 'coach' this team." Senior year of high school, on the first day of physics, when the teacher asked if there were any questions, Gabe pointed at the word "Physics" written on the board and said, "Now, are we actually going to learn in this class to *be* psychic?" You're thinking, "Oh, so you guys were smartass pricks?" Yes. But I also think it was more complicated than that. On the first day of college, when I met my dean, I had written his name and title on my name tag, and asked him how he was settling in and if there were any questions he might have. He said, "Hm. Role reversal. Very amusing." But he didn't actually laugh. This may have been a sign that I was finally too old to this kind of thing, but it may also simply have been because my college dean was not a Jew.

Now, of course, this attitude toward the world is kind of how I make my living. There is very little overtly Jewish content in my work, very few specifically Jewish characters or themes, at least so far, I'm kind of still just getting started, but the way I approach playwriting and theatre, the spirit of inquiry or questioning, is completely bound up with a worldview that is, to me, fundamentally Jewish. It's not just that my characters are themselves sort of questing and ambivalent, or that the process of writing a play necessarily involves divvying up your own psyche a little so that you can give equally passionate and plausible points of view, or parts of you, to different characters who disagree with each other. I'm also very interested in playwriting as a form, how the form tells stories, and how questioning the form itself, exploring the limits of what's possible with the form, can itself be a part of the storytelling. Which is also kind of Talmudic, if you consider that biblical narrative, whether you believe it's the literal word of God or not, is a story in which mankind tries to make sense of itself and its place in the universe, and the Talmud to be kind of exposing the building blocks

of that story and making that a part of the story. Plays—and novels and TV shows and paintings, all art, really—are, at their best, shards of this same story. Not of the Bible, but of the pre-biblical flowering of human consciousness that made us self-aware enough to write the Bible. Or, that made us worthy to receive it. Depending on your point of view.

What's maybe interesting, though, is that despite, or even because of, the fact that I can make the argument that theatre, and the way that I do theatre, is one of the more Jewish parts of my life, at least culturally speaking, a total stranger also felt compelled to tell me that playwriting is not an appropriate pursuit for a Jew. And, sure, in addition to, or maybe even partly because of, theatre's reputation for consisting basically of debaucherous narcissists competing for attention in small rooms, theatre, and art in general, is, in a sense, direct competition for religion. One thing this means, of course, is that religion has nothing to worry about. But it's the same reason Scientologists are threatened by psychotherapy: Because psychotherapists charge less money to do the same thing. Though, given how expensive theatre tickets have become, again…. But, so the point is maybe a religious animosity toward artists emerges from the observation that art is essentially religion without God. That it is, in other words, ritual for its own sake rather than as a form of worship, beginning, oh who knows, with reenactments of the hunt, which then became theatre when Thespis stood on a hill and recited *The Iliad,* which in turn was rendered pointless when Beckett got depressed after the Second World War. (That's the short version. I just saved you all $80,000 in graduate school loans.)

And there is something analogous, maybe a little loosely or tendentiously analogous, but nevertheless analogous, about the experience of an audience at a play and a congregation at a synagogue. The analogy already lines up imperfectly between the audience and the congregation, for one thing because there is generally more participation from religious audiences, although that depends on the religion, and on the audience, and on what you mean by participation, but gets even murkier elsewhere, so rather than get bogged down in, "So wait, is the rabbi the director, and people who read Torah portions are the actors, or, no, wait, maybe the rabbi is an actor, too…," rather, in other words, than trying to fill in the blanks in some kind of equation, and rather than ask a really vague question like, "Can't the arts and religion just get along?" which is like, "Can't science and religion just get along?" the kind of question to which the answer is either obviously yes or obviously no depending on what you mean by

"get along," and which in any case would be a pretty loaded, not to mention compromised, question coming from me, anyway, since I've already revealed that I'm not religious, I'll just say that I think there is something very, very interesting lurking in this analogy that I think is worth talking about and thinking about some more.

The best religious experiences I've ever had—and I don't mean religious experience like "religious experience," like, "I had dim sum last weekend and it was a religious experience," I mean just literally experiences involving religion—have basically consisted of people coming together, around some story, to talk about what it means. For Passover every year, a group of families that were all friends would get together for a Seder, and everyone would get an assignment, to read up on the ten plagues, or the four questions, and to give a little presentation to the group when we got to that part of the Haggadah. There was someone leading the Seder, sure, but the role was more gentle facilitator than tyrannical doctrinaire. This has been true of all my favorite rabbis. And I mean "rabbi" both literally and figuratively— my best classroom experiences have involved teachers who were not an end in themselves but rather a conduit to something larger, something that student and teacher together invited into the room, a third party, a story we're trying to interpret together. I'm using "story" pretty broadly here to mean, I guess, any closed system with its own rules of cause and effect. History is a story, sure, and literature has stories, there are stories in literature and there's the story *of* literature, but I mean science, too, science is a story, and math is a story, a story a good math teacher can invite into the room with you, to live it with you until you understand it. And it's the same thing that great art invites into the room, into the space between or around the art and the viewer, and all the artist has done is to craft a window of a particular shape and size that looks onto that story. And it's the same thing that visits the artist during the creative act, only then the third party appears between or around the artist and the art.

Or, take a personal essayistic piece of writing like this.... To the extent that I even have a point, the evidence for it is my experience: the anecdotes I've told, about the Hassidic man on the street, or the stories from my ninth grade youth group retreats. And these carry weight because I told you that they were true. Which they are, by the way, I'm not preparing to pull some kind of sneaky trick where I suddenly reveal that I made those things up, and I didn't. But if I *were* to tell you that I made them up you'd probably feel betrayed, or at least confused, and

in any event you'd find whatever points I'm trying to make to be less persuasive because the foundation on which those points were resting would suddenly have vanished. But if I were writing a play or a novel or making a movie about my camp experiences, and presented all those scenes as the adventures of my young protagonist, and bookended it with a scene of the protagonist as an adult having an encounter with a Hassidic Jew on Seventh Avenue in Brooklyn, I'd actually be making exactly the same points, and if you were touched or moved by this movie, and someone said to you, "Yes, well, it's only a movie," you'd wonder what this person even meant. "So what?" you'd say. "I got it. I got what he was saying." In fact, in that case, if someone then told you that the movie was autobiographical, it might then carry for you *less* weight, it might feel earthbound in a way that it didn't when you thought that it was fiction, less readable as metaphor.

In either instance, the stories in question don't change. What changes is *your* initial belief about the story's origin. Why is this change so painful? Why does it sap things of their meaning? I'm actually asking. I don't know. But it's especially weird because, as a writer, I know that things are almost never just one or the other, anyway. People are always asking writers whether their work is autobiographical as though the answer could possibly be "yes" or "no," whereas in my experience the answer it always some variation on "kind of." Every piece of writing needs some kernel of truth to keep it tethered to meaning and every piece of writing also needs the freedom of imagination to let it soar. Art as a kite, is I guess the image here. The real conscious experiences of the artist bind it to the earth, while the unconscious is the wind. (The *ruach*, as it were, to spin this for my current audience.) And this is true of fiction and nonfiction, both, I'm telling you.

Which is why when I suggested earlier of the Bible that the difference between our having written it and our having received it is one of point of view, I was only being halfway glib. To write something *is* to receive it. "From where?" is a question that no one has ever been able to satisfactorily answer and personally I don't think it's a very interesting one. The question that interests me is, "How can I remain in contact, as often as possible, and throughout my life, with that place, whatever and wherever it is?" The Jewish story is, yes, in itself, a powerful one, and Jewish religious texts are, yes, in themselves, rich and fascinating, but the real power of Judaism, to me, is in the *approach* to that story and those texts, a way of thinking and feeling that applies to all of life.

Now, the guy on Seventh Avenue might quite reasonably object, at

this point, and tell me that I'm wandering into some dangerously new age-y territory here. He'd say that, actually, Judaism has specific laws and that that's what makes it Judaism, and that the point is to obey those laws, not to seek out some vaguely defined spiritual satisfaction for myself and treat my own feeling of connection to something larger than myself as the only evidence I need that I'm doing it right. He'd say it's great that I had some nice camp experiences, but "Jewish" can't simply mean whatever I say it means because if that's the case then "Jewish" ceases to mean anything at all. In response to which I'd say, "Good point. But. The question 'What is the meaning and purpose of my life?' and the question 'How should I spend all of my time?' are actually two different questions. And isn't one potential pitfall of total adherence to millennia-old tenets the danger that you might simply be finding comfort in having a permanent answer to the second question, because you have this book that *tells* you what to do with all of your time, *without ever having to genuinely engage* with the much more difficult and elusive first question? In other words, if religion actually *rescues* you from *ever having to ask*, 'What is the meaning and purpose of my life?' then what's the point? I mean you probably think that secular people like me live lives that are more cushy and lazy than yours, and in a way that's true. But it's also worth asking: Who really has it tougher? Psychologically, I mean. Who's hoeing a tougher row, internally? You, who already knows everything? Or people who allow themselves to admit, at every turn, the possibility that they might be wrong? Or would you say that that's the point, to make my internal life easier, by no longer asking any questions? In other words, do you think I am simultaneously lazy *and* making things too difficult for myself? Because frankly I don't see how I can possibly be guilty of both at the same time." That's what I'd ask him. And I'd be interested to hear his answer. But of course we didn't have that conversation. He didn't invite a conversation. He just walked up to me and told me what to do and that was the end of our exchange.

Another anecdote.

A couple of years ago I was having dinner with Jonathan Lethem, not to drop names—if that even counts, some of you are like "Who is Jonathan Lethem?"—but I'm just trying to give credit where it's due, since I'm about to quote something he said that night. A couple of other theatre artists and myself were about to begin adapting his novel *Fortress of Solitude* for the stage, and so we were taking him out for a steak to celebrate him having given us permission to ruin his great

book. One thing professional writers sometimes talk about when we get together, apart from writing, is reviews, because non-writers seem to think that complaining about your reviews means you're not sufficiently grateful that the press is paying any attention to your work at all. Which is fair enough. So we were talking about reviews.

Brief sidebar: by reviews, of course, I mean Reviews, not Criticism. The problems with theatre reviewing-slash-criticism in this country are a subject for an entirely different speech, but, just very briefly, the purpose of theatre reviews, which is to say things that come out in daily or weekly papers, or in magazines, is to let the readership of that publication know whether a particular play is something they might enjoy enough to spend their money on. This isn't a dig. Ask a reviewer what they are for and that is what they will tell you. "People have limited money to spend on things to see," a theatre reviewer once told me, "and there's lots to see in New York and I can help narrow it down for them." And while this is an important function it obviously has very, very little to do with Criticism with a capital C in the sense of an attempt to understand an aesthetic object in depth. Again, this isn't a dig. Given how much these people have to see and write about, they can't be expected to do real criticism. There just isn't time. But what this means is that reviews, however useful they might be to potential ticket buyers, are almost always useless *to the artist* because they simply aren't, by definition, engaging with the work in enough depth to be a serious contribution to the artistic conversation. Okay. But so then why do they upset us so much when we read them, or hear about them, or get sympathetic e-mails from our friends quoting them? It would be easy to dismiss that sting as a bruised ego, as oversensitivity. But if that were the whole explanation, our feelings would boil down to: Writers like good reviews and hate bad reviews. And that's true, we do like good reviews and hate bad reviews. But that's not the whole truth and it's not really an important or interesting part of the truth. The important and interesting part, I think, is that we *really* like thoughtful and engaged reviews, positive or negative, and we *really* hate shallow and unengaged ones. In a way, an inane positive review is as upsetting as a dismissive negative review because your real concern as an artist in that moment isn't, "Will this guy I'd never heard of until yesterday like my work?" because, really, honestly, who cares, it's, "Am I having this conversation alone?"

That night, at dinner, we were also talking about politics and the recurring fantasy, which I think a lot of people on the left have had,

that, sometime after his presidency was over—this was while it was still going on—George W. Bush would, some late night in his Crawford, Texas, ranch, start Googling, or whatever, and reading about his own legacy, and stay up all night, reading more and more of the information that had been denied him by his inner circle for eight years, and have a kind of Greek High Tragic moment of recognition and reversal in which he suddenly sees himself as some of us see him, as someone who badly damaged the idea of America. A fantasy destined to remain a fantasy because what is most frustrating about people like him, or people like how I imagine him to be, since obviously I don't really know, is that they will never give you the satisfaction of seeing themselves, even for a moment, as you do. It occurred to me as we talked about this that this is precisely the same fantasy that artists often have about people who write reviews and I said something about how maybe that's why bad critics make us so angry.

And Lethem said, here's the quote, he said: "Right. Because it reminds us of something that matters."

That morning, the morning after my opening in November 2008, I was upset. Partly, sure, because something I had worked very hard on had been very publicly chastised. That doesn't feel good. But I was also upset about my encounter with the Hassidic man, which had not been in any way public. Or, you know, until now, when I just told it to all of you. On top of which a lot more of my ego is bound up with the question of whether or not I'm considered a good writer than whether or not I'm considered a good Jew. So why was I angry at this man at all? I was angry about his certainty that a book I was carrying, which he knew nothing about, was dangerous. I was angry about his certainty that the work I do, which he hadn't truly investigated, was, I don't know, depraved and base. These attitudes reminded me of something that matters and that something is these same attitudes applied from positions of genuine power.

There's a couple of different things that this might mean. Staying for the moment inside the narrow purview of all of art and all of religion it means this: It wasn't that this man in that moment could really harm my sense of myself as a Jew. Or that one review could really harm my sense of myself as an artist. It's not the fragility of an artist anyone needs to be worried about. It's the fragility of art. And if this man on Seventh Avenue is worried about the future of Judaism, which is what I assume he's worried about, then I wonder if he's ever considered that what danger there is might be coming as much from

his insistence on as narrow as possible a definition of what qualifies as a Jew or is appropriate for Jews to do as from the potential expansion of those definitions to include too many things. Granted, his definition of Judaism is older. "Orthodox Judaism" is a retronym. We didn't need a word to modify "Judaism" until the existence of Reform Judaism made it necessary. But, in a way, so what? "Realism" is a retronym, too, made necessary by "Absurdism." And if the comparison is offensive because, well, religious rules are considered holy and unassailable by those who watch over them, well, then, I suggest you go back and read Beckett's early reviews. Or Chekhov's. Or Pinter's. Or Brecht's. Or Tony Kushner's. The list is endless.

When a critic walks into a play with certain biases and then walks out with those biases intact because to allow them to be truly challenged might cause a long dark night of the soul that calls into question his whole life's work and as a result he sees in a play only what's on the surface and so then accuses the play of being all surface, in effect projecting his own shortcomings onto the artist, and, here's the part that's really infuriating, thus saving himself from precisely the kind of struggle the artist went through in order to create the work he's just panned, which is to say staring straight into that kind of long dark night of the soul for weeks and sometimes months on end...I mean, come on, say what you want about me or my work, but do I *sound* like the kind of person who is content to skim the surface of a subject? Or, if my play, like any play, necessarily skims the surface of certain things, might that not be because it's actually delving deeply into certain *other* things? Maybe what's actually going on is that we disagree about what the "subject" of the play is, and, since I'm the person who selected the subject, maybe a more accurate way of saying this is that maybe the critic is incapable of correctly identifying a play's subject, which, if you ask me, ought to be pretty basic requirement for the job. But actually, really, maybe the most important thing is that both of these concerns, the health of the arts and of religion in themselves, are secondary, because both art and religion are themselves just reminding us of something else that matters, and that something is a pretty basic set of humanistic principles on which the survival of the species and of the planet seems ultimately to rest. It reminds us, in other words, that certainty is a slippery slope and our humanity often seems to be hanging by a thread.

Or, in a slightly different context, "Excuse me, sir, are you Jewish? You have the look," becomes relatively creepy.

But okay. Yes. There is a very insidious trap lurking here for me and maybe you see it. It goes like this. Like the kids in my youth group, who treated the counselors like tyrants, getting themselves, in turn, treated like children—and, of course, there's no difference, all tyrants are children, and all children are tyrants—it's possible to grow up to be everything you used to hate, as it were, by becoming, out of a desire to protect your work, for instance, or whatever it is you are most invested in protecting, so defended against and so angry at the adherents to the doctrine of unquestioning certainty that you become yourself unquestioningly certain that you're completely right and they're completely wrong. Or, faced with certainty we are tempted to mirror certainty back and that's a terrible mistake, as big a mistake as total surrender. So, I mean, who am I even calling an adherent to the doctrine of unquestioning certainty anyway? For all I know, this Hassidic guy is some kind of huge radical where he comes from. Maybe his sect believes that people like me aren't even worth talking to and he's going to go back to them and mention our encounter and his buddies are going to say, "Oh, Shlomo, there you go again, reaching out to the infidels. Just ignore them like we told you to." Maybe, from where he's standing, he's in the exact center of his own spectrum of certainty and doubt.

And isn't it kind of amazing, by the way, given the institutional limitations on what critics do, which are if anything more stultifying than those on playwrights, that there are so many thoughtful and engaged theatre reviews out there? That there are *any at all*? Some of the people who write reviews are obviously doing their best to strike this balance, too. Not all of them, maybe. But some. And, look, isn't Shlomo's suggestion that I put down the *Sports Illustrated* book and stop writing plays emerging from a genuine belief on his part that all of the decadence and suffering *he* sees in the world can be partly mitigated by altering the path of someone like me? Which is a fallacy, I know, just because an action emerges from a "genuine belief" doesn't mean that it's above reproach, but the point is, shouldn't I examine my own beliefs with at least as much scrutiny? Who am I to say what the true subject of my play is, or ought to have been? Maybe what I delved deeply into was what I ought to have skimmed the surface of and maybe what I skimmed the surface of was the interesting and important part. Instead of asking, "Excuse me, sir, are you a critic?" should I just ask, "Do you have a minute for my play?" and leave it at that. Shouldn't I even, for that matter, examine my belief that there's something fruitful

in constantly examining my beliefs in this way? I mean, it can't all be accounted for by neurosis, I must in a way believe in it or I wouldn't do it. And isn't it possibly also just a great way never to commit to anything, like when someone asks you which character in the play is you and you dodge the question by saying, "Well, they *all* are," only I'm living my actual *life* that way?

When I was a kid, I was really into science fiction and fantasy and one of my pet peeves was genre snobbery, people who would be like, "Oh, I don't read science fiction," and I'd be like, well, then you're an idiot, because some of it is amazing, and even if most of it is bad, well, most of *everything* is bad. You know why? Because it's really hard to make something good. Most of literary fiction is bad, most movies are bad, god knows most theatre is bad, but there is a layer of greatness at the upper edge of every single platform for storytelling that there is. This kind of thing still bugs the shit out of me, actually. Every time I read some news article the peg of which is how surprising it is that someone has made a video game with substance I want to scream. Because it reminds me of something that matters. Video games are probably the most flexible and complete and potentially powerful storytelling platform ever invented, because they can contain every single other type of storytelling, *and* are interactive, and this is self-evident if you think about for it ten seconds, but people are genre snobs, and they don't want to admit this information into their worldview, and that drives me crazy.

But so by now have I become a genre snob? About *answers*? Do I worship at an altar of *un*certainty? Is there a perspective from which, "What is the meaning and purpose of my life?" is a much *less* important question than "How should I spend all of my time?" Like, the perspective from which actually *doing* things matters? Not to mention the fact that, if I think science fiction and video games are so great, then why don't I write video games and science fiction? I might actually just be a genre snob in general, my own self. And also if I'm willing to openly admit, like I just did, that most theatre is bad, then why blame this guy, or anybody, for entering the conversation with the assumption that my play, too, is probably bad?

And, while it's obvious what this might mean from the perspective of the critic, from the perspective of the Hasid it might mean something like: Your work doesn't elevate us. It, at best, distracts us. The reason your Orthodox friends are not allowed to play video games on Saturday, no matter how artfully constructed those games might be, is that it's

important to spend some time, in stillness and quiet, contemplating God without the constant electronic interruptions of the modern world replacing thought every other minute, okay? And doesn't he have a point? And, as this list of questions shows no sign of ending, ever, it occurs to me that what we're talking about here is probably not a spectrum at all, but a circle, the way the political spectrum meets itself, with fascism on the right and communism on the left both devolving into totalitarianism off the edges of the map. The earth is round, not flat. Drift too far in any direction and you're back where you started. The polar opposite of the religious fundamentalist would presumably be a kind of emotional and intellectual paralytic who is at every moment so aware of all of his or her choices that he or she makes no choices at all, ever, but it kind of seems like the guys at each extreme, the guy who is rigid with certainty on the one hand and the guy who is paralyzed by doubt on the other hand, are actually indistinguishable from one another. No one's choosing anything. And that's the trap.

And this trap is waiting not just, for instance, there on the street for me, that morning, in the wake of an unfortunate encounter with a bizarre zealot whose opinion no one even asked for, and also with the thing that happened with the Hassidic guy—it's there all the time. And avoiding it demands a more or less constant process of moving back and forth across that membrane, between certainty and doubt, an alternation between softening and hardening, or somehow getting those two things to embrace each other, double-helix-like, inside yourself, even though they repel each other, or even though, together, they're radioactive, though maybe it's that radioactivity, throwing off protons and neutrons like sparks, that is the source of creativity in the first place. And in those moments, when I feel most fulfilled and useful and connected and like I matter, maybe it's because I've, however briefly, struck a balance.

But wait, hold on. Because isn't this trap even waiting there, too, inside that balance? Because the moment you think to yourself, ah, yes, I have now struck the perfect balance in my life between doubt and certainty, I am so proud, let me share this great discovery, oops, there it is again, it's got you. Here it is, right now, happening now, on this stage, this trap, in a speech about how to avoid it, and you're the congregation and I'm the Rabbi and my fear is that I'm just standing here telling you something, something I'm obviously barely able to articulate myself, but *something*, and but my *hope* is, what I hope is, is that what I've managed to do, rather, is simply to invite into the room

some third party to be here among us. Some story about who we are that we can now discuss.

Do you feel it?

Is it here?

I'm almost done.

One thing that distinguishes theatre from nearly every other art form is that theatre is happening now. And this is true in the sense, of course, that the actors are physically in the room with you, enacting the story as you watch it unfold, but it's also true in a slightly subtler way, maybe with the emphasis on *happening* rather than on *now*. Theatre is happening *now* but the audience is not engaged unless it is also *happening* now. Unless something is happening. One word for this is "stakes." We ask our students when a scene they've written sort of lies there on the page, "Well, what is at *stake* here?" And as a playwright you know you've really done your job when an entire audience is riveted by a silence. Sure, landing a big laugh is very satisfying, but it's not nearly as exciting as that feeling of a full silence because the full silence means that there are truly stakes. And how to achieve that, well, that's the craft, and it's always a little different, each situation has its own demands, maybe you even start by, for instance, saying something like, "I have never done this before." But, whatever it is, you have to do something to make the audience feel that this is happening now, it has never happened before, and it will never happen again, and I am invested in the outcome. Those moments onstage feel like they're balanced on a razor. Radioactive, and therefore unstable, temporary. The characters, the situations, these things have left the prison of certainty and the swamp of doubt, which, remember, might actually be the same thing, and have risen up, at least for a little while, above them, still tethered to both, buffeted by the wind, and free. And what is at stake is not just what the outcome of this moment might mean for the fictional characters in the play, not least because we must know in some way it's not real. No, the real stakes rest on the fact that, in the theatre, in the ritual space of a theatre, the small stands in for the large. It just does this, it doesn't have to try, it doesn't require a character in the play to gives a speech about how what's happening is a microcosm of something more universal, it's just the case that the stakes of a silence onstage are also about what is at stake for us, in the audience. In other words, what's happening onstage isn't real. But it is reminding us of something that matters. And, of course, something that reminds us of something that matters is, itself, something that matters.

So let me close with an anecdote that did not really happen. I get on the subway and go back to Park Slope. And on Seventh Avenue I pass the same man, the same Hassidic man I saw in November, his Bible tucked under his arm, hurrying off to somewhere. And I stop him. And I say, "Excuse me, sir, are you Jewish?" And he says, "Yes." And I say, "You have the look." And I say, "Tell me, where did you get that book?" And he says, "It was given to me at my synagogue." And what I'd like to say, given what happened the last time is, "Oh, it's better than I feared, it was given to you, but let me say, this book has many problems, chronology that doesn't make sense, and internal contradictions, and doesn't really jibe in a lot of places with the scientific evidence, and what I suggest is you put it down and divorce yourself from it, and you also might wish to consider a new line of work...it's not ideal." But maybe instead what happens is I say:

"Listen. My friend Gabe, who I've known my whole life, is getting married next month. His fiancé isn't Jewish. And they're getting married on a campsite in the Santa Cruz mountains, and so everybody, other friends I've known my whole life, everyone is going to camp there for the weekend, and one morning everyone is supposed to meet in the big tent to do yoga together, and, why don't you come?" And he does. And as we stand there in woodlands of Northern California, which, if I may say, might just be the most beautiful place on earth, watching the ceremony, a silence falls at the pivotal moment, just before my friend and his soon-to-be wife exchange their vows, probably ones they wrote themselves, and the only sound are the birds and the wind and maybe the faint whistling of a Frisbee in the distance, and I turn to him and challenge him to tell me that God's not here. And there are tears in his eyes.

Itamar Moses is the author of the full-length plays *Outrage, Bach at Leipzig, Celebrity Row, The Four of Us, Yellowjackets, Back Back Back, Completeness,* and *The Whistleblower*; the musicals *Nobody Loves You* (with Gaby Alter), *Fortress of Solitude* (with Michael Friedman), and *The Band's Visit* (with David Yazbek); and the evening of short plays, *Love/Stories (or, but you will get used to it)*. His work has appeared Off Broadway, at regional theatres across the country, and internationally, and is published by Faber and Faber and Samuel French. This piece was first delivered as the closing speech for the Association for Jewish Theatre Conference on June 10, 2009.

AMERICAN
THEATRE **MAGAZINE**

We invite you
to join us today and
receive all of TCG's
MEMBER BENEFITS!

Become an **INDIVIDUAL MEMBER** of Theatre Communications Group, the national organization for the American theatre, and receive a FREE subscription to **AMERICAN THEATRE** magazine. Receive ten issues a year—including five complete playscripts—PLUS unlimited access to **AmericanTheatre.org**, the online home for American theatre. Log in for up-to-the minute news, in-depth features, stunning visuals, exclusive videos, artists' commentary, and more—available anytime, anywhere.

YOUR MEMBERSHIP PACKAGE ALSO INCLUDES:

Discounted access to ARTSEARCH®, the essential source for a career in the arts.

30% DISCOUNT on all books from TCG and other select theatre publishers including works by Annie Baker, Caryl Churchill, David Henry Hwang, Tony Kushner, Lynn Nottage, Suzan-Lori Parks, Stephen Sondheim and August Wilson.

Discounts on theatre tickets across the country.

Individual Member Wire, a bimonthly email newsletter.

Access to Conference 2.0, TCG's online social network for theatre people.

FREE Membership with Fractured Atlas.

FREE Membership with the Performing Arts Alliance.

And more.

Join online at www.tcg.org

For over 50 years, **Theatre Communications Group (TCG)**, the national organization for the American theatre, has existed to strengthen, nurture, and promote the professional not-for-profit American theatre. TCG's constituency has grown from a handful of groundbreaking theatres to nearly 700 member theatres and affiliate organizations and more than 12,000 individuals nationwide. TCG offers its members networking and knowledge-building opportunities through conferences, events, research, and communications; awards grants, approximately $2 million per year, to theatre companies and individual artists; advocates on the federal level; and serves as the U.S. Center of the International Theatre Institute, connecting its constituents to the global theatre community. TCG is North America's largest independent publisher of dramatic literature, with 14 Pulitzer Prizes for Best Play on the TCG booklist. It also publishes the award-winning AMERICAN THEATRE magazine and ARTSEARCH®, the essential source for a career in the arts. In all of its endeavors, TCG seeks to increase the organizational efficiency of its member theatres, cultivate and celebrate the artistic talent and achievements of the field, and promote a larger public understanding of, and appreciation for, the theatre. For more information, visit *www.tcg.org.*